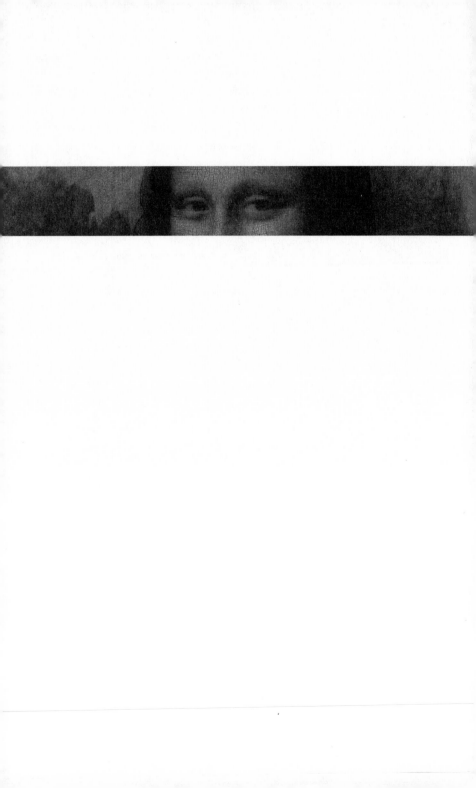

The Eye

An Insider's Memoir of Masterpieces, Money, and the Magnetism of Art

PHILIPPE COSTAMAGNA

Translated by Frank Wynne

NEW VESSEL PRESS
NEW YORK

New Vessel Press

First published in French as *Histoires d'oeils*
Copyright © 2016 Éditions Grasset & Fasquelle, Paris
Publié en France dans la collection "Le Courage," dirigée par Charles Dantzig
Translation Copyright © 2018 Frank Wynne

This work received support from the French Ministry of Foreign Affairs and the Cultural Services of the French Embassy in the United States through their publishing assistance program.

Library of Congress Cataloging-in-Publication Data
Costamagna, Philippe
[Histoires d'oeils. English]
The Eye: An Insider's Memoir of Masterpieces, Money, and the Magnetism of Art/
Philippe Costamagna; translation by Frank Wynne.
p. cm.
ISBN 978-1-939931-58-0
Library of Congress Control Number 2017964269
I. France –Nonfiction

TABLE OF CONTENTS

E^{The}ye

The Miraculous Bronzino

We talk about a person *having* an eye for something. I would like to talk about the fascinating and little-known profession of *being* an "Eye." The term might sound curious and surprising, but it would be impossible to explain in other terms what certain art historians do on a daily basis. If what we might call the "traditional" art historian—like the musicologist or the literary historian—is content to draw on a rich library and a vast image bank, the task of what I call the "Eye" is to establish the authorship of paintings by sight alone. His task is to see. To do so, it is crucial that he have direct contact with each work of art. Traditional art historians, musicologists, and literary historians construct complex hypotheses and conduct extensive research in order to expound their theories in books. The Eye, on the other hand, relies on dramatic coups de théâtre. His task, in short, consists of proposing a name. Every day, he is presented with unknown works of art. All too often, they are disappointing. But sometimes he is struck by something extraordinary, something as clear and irrefutable as it is unexpected.

He is an "Eye" in the same way that someone might be a "Nose" in the perfume industry. Noses identify scents and formulate perfumes. Eyes in the art world discover paintings and establish authorship at a glance. But there the comparison ends. If the great Noses are creators, artists sometimes capable of moments of genius, neither Eyes nor art historians generally can be considered to be creators. Eyes observe, and this observation triggers a process of memory that allows them to see. The process is not a form of genius but an acutely refined sense of analysis, an ability to break down the painting one is looking at into a collection of distinctive traits found in the diverse works of an artist.

It is this skill that enables the Eye to make discoveries. Unlike discoveries in mathematics, chemistry, or physics—those of Newton or Einstein for example, which are the product of the genius of an individual—the discoveries made by the Eye have more in common with that of Christopher Columbus. No genius was required. Merely a spirit of adventure and a happy accident, the result of a wager that he could find a new shipping route between Europe and India. The Eye is a miniature Christopher Columbus who roves the world of art, alert to any surprises. But whereas Christopher Columbus did not know what he had stumbled upon, the Eye on the other hand knows immediately. Like an explorer rediscovering Atlantis and knowing it can be nothing else. When an Eye is confronted with a work whose authorship he alone can identify, we say he has made a discovery. The more important the artist, the more important the discovery; and should the work in question be a masterpiece, executed

by one of the greatest painters in history yet overlooked for centuries, we might even say a "great discovery."

For an Eye, discoveries of this kind are very rare. He may search tenaciously for something, often without success, and then, without intending to, make unexpected discoveries. I confess that I have made at least one such discovery, completely by chance. It happened in October 2005, in the company of an Italian friend, Carlo Falciani, a specialist in sixteenth-century Italian painting like myself. We had been invited to Provence by an art collector in order to consider a painting that, though interesting, did not turn out to be the work we had hoped, and as so often is the case, the collector was left disappointed; in return, however, we made a discovery that would prove crucial to the history of art.

The previous day, we had visited the Musée des Beaux-Arts in Nice, where Carlo's wife, also an art historian, wanted to study a number of paintings. The Villa Kotchoubey, which houses the museum, is one of the last vestiges of the Côte d'Azur whose dying echoes and fading light are captured in *Tender is the Night* by F. Scott Fitzgerald, the Côte d'Azur where the cream of European society came to sojourn before the Great War. At the moment when, all around, apartment blocks began to replace the sprawling grounds of the great nineteenth-century mansions, the city bought this villa from a Russian aristocratic family and transformed it into a museum. Here and there between the facades, it is possible to glimpse a sliver of the blue Mediterranean. Not far from the international airport, perched high in the hills of the city, it is one of the last remnants of the Belle Époque. The ground

floor comprises a great hall with a gleaming granite floor bounded by marble columns and flanked by a monumental staircase and a covered courtyard.

Heading toward the great staterooms, one first passes through a long gallery whose walls are lined with fin-de-siècle paintings in keeping with the ambiance of the villa. Society portraits and oriental scenes, including *The Harem Servant Girl* by Paul-Désiré Trouillebert, plunge the visitor into the atmosphere of the period. At the far end of the gallery, the room is lit by a vast window. The sun, a frequent visitor to the bay of Nice, was high in the sky that morning, its rays piercing the panes at a steep angle. I remember we were chatting about this and that as we cast an inattentive glance over the collection, perhaps about the painting we planned to see the following day, when our eyes were drawn to a painting of Christ that hung at the far end of the hallway, a beam of sunlight falling upon the feet, glistening on nails that had a porcelain texture that to me was unmistakable. "Do you see what I see?" asked Carlo. Conversation gave way to a stunned silence. We were seeing the same thing. A providential ray of sunlight had revealed Bronzino's *Christ on the Cross*, painted by the artist for the Panciatichi family in Florence circa 1540, a work long since lost and vainly sought by connoisseurs of Florentine art of the period.

It is quite a large painting. At five feet tall and three feet wide, it resembles an altarpiece. It depicts Christ crucified in perfect pallor and realism. The right leg, into whose foot a nail is embedded, is turned slightly inward. The prominent cheekbones, the hollow cheeks, the deep bags under the eyes

are testament to a long ordeal. Even the slightest detail of the musculature is visible. The pastel pink loincloth intended to hide the Christ's nakedness, with its realistic folds, has fallen slightly to reveal narrow hips in which it is possible to make out the bones. Beneath the head, tilted slightly to the right, the reddish-blond hair spills in tight, perfectly defined curls onto shoulders of alabaster. The painter has gone so far as to indicate, with light brush strokes, the grain in the wood of the cross.

As our eyes moved up the body, led by the distinctive rendering of the toenails, and without exchanging a word, we could both hear the echoing words of his first biographer, Giorgio Vasari, an artist himself and contemporary of Bronzino: "For Bartolomeo Panciatichi, he painted a picture of the Crucifixion, which is executed with great study and care, insomuch that it is clearly evident that he copied it from a real dead body fixed on a cross." The scene is framed against an alcove of gray stone, the *pietra serena*, or "serene stone," typical of the material used in the construction of religious buildings and important civil monuments in Florence. A thin trickle of blood runs from the feet down the wood and soaks into the stone niche.

It was an indescribable moment. From Vasari's account of the painting, we might imagine a masterpiece. Knowing that as he painted it Bronzino had worked from an actual body, we might imagine it was a work of realism. But never could we have imagined a work so simple. We were convinced we were standing before Bronzino's masterpiece, and we were surprised. Bronzino's reputation is that of a court painter, one

who excelled in the depiction of wealth and the tactile rendering of fabrics. He is known first and foremost for an artificial style of painting, one underpinned by complex codes, whose riches are accessible only to initiates. His religious paintings often leave the viewer cold, while his portraits and the allegorical scenes drawn from mythology are bewitching. In this case, on the other hand, the painting spoke for itself. Had we not known from Giorgio Vasari that the artist had painted a Christ based on an actual corpse, we would have found it difficult to imagine him undertaking such a subject. How to make sense of a purportedly lightweight artist painting a Christ that invites pious contemplation, a work suffused with realism and spirituality, a work of death and suffering? Doubtless we needed to appreciate that life at court did not exclude profundity and a sense of the sacred.

In contemporary works on art history, it has become a commonplace to say that we know little about the lives of the Old Masters. This is not quite the case with Agnolo Bronzino. He was born in Florence in 1503 and died in that same city in 1572. Giorgio Vasari, who devotes only a few short but precious lines to him, says that he trained with Jacopo Pontormo. We will later return to this artist who is particularly close to my heart. He was, according to Vasari, a very exacting master who never showed any of his canvases to the young men in his studio for fear of divulging the secrets of his technique. How far can we trust this harsh portrayal? In criticizing Pontormo's approach, Vasari was perhaps attempting to disparage the schooling Bronzino received, one he doubtless wished he had received himself. Vasari was also a painter,

one whose training had been chaotic and who, in his life-time, could not lay claim to the status of his rival. Despite what he said about himself, Bronzino effortlessly assimilated every nuance of his master's art—indeed, as Vasari is compelled to acknowledge, surpassing him when he took over work on the Basilica di San Lorenzo, left unfinished on the death of Pontormo. When Bronzino was not painting, he devoted his time to poetry, where he won a reputation for his teeming imagination, composing witty verses of which the celebrated "In Praise of Onions" ("In lode delle cipolle") is among the most successful. He was a man of culture, who took part in the spiritual activities of the sophisticated city in which he was raised, and all evidence leads us to believe that he was homosexual.

The modern-day preconceptions we bring to our view of the sixteenth century made it very difficult to understand the painting. The Panciatichi family, for whom Bronzino painted it, were rich, powerful Florentine bankers, but they were also passionate advocates of a reform of the Catholic Church in accordance with Luther's objections. The *Christ,* in its asceticism, perfectly illustrates this desire for a return to the fundamentals of the faith. To recognize him as the author of this painting, one had to imagine Bronzino as a courtier yet religious, homosexual yet devout, an artist yet conscious of political matters. This was a view of sixteenth-century Florence that Carlo and I shared. This painting, therefore, was the missing piece of a puzzle, whose pieces we had gradually assembled and which was now taking shape before our eyes.

A great discovery is rarely accepted without arguments from other art historians, champions of alternative theories, sometimes jealous, sometimes simply blind. In this case, having the attribution recognized did not prove difficult, and we were able to secure unanimous agreement. We quickly communicated news of our new attribution to the handful of other specialists on Bronzino, who accepted it with the same enthusiasm as we had. All of these specialists were Italian, British, or American. The small world of art history was abuzz with the news, from Los Angeles to Saint Petersburg, Australia to Scotland. But, unlike those who shared our area of research, some of the great minds in the field, who had only a generalist's understanding of our period and our artist, found it more difficult to accept our proposal. To add to this, the painting, being part of a French collection, had been submitted to a number of important French curators, who now had to accept that they had misjudged it. In 1965, it was examined by Michel Laclotte, Sylvie Béguin, and Pierre Rosenberg, three of the greatest French art historians, all of them blessed with an exceptional eye. At the time, they were preparing a vast exhibition on sixteenth-century Europe and were reviewing all works in national collections. It was as though they had not even seen it.

This exhibition had been part of the general review of national heritage undertaken after the Second World War, intended to encourage the French public to rediscover great public collections. The crowning irony being that the cover of the exhibition catalogue featured Bronzino's most famous painting, a detail from the *Deposition of Christ* in the Musée

des Beaux-Arts in Besançon, which perfectly represented how Bronzino's art was seen at the time, art in which saints both male and female are dressed in finery and theatrically arranged, in which the body of the Christ is muscular, glorious, idealized.

If these art historians did not give the Christ in Nice the attention it deserved it is because, by 1965, there was already an idea circulating that the painting did not date from the sixteenth century. In fact, in 1986, Gianni Papi, an Italian Eye whom I respect, considered reclassifying the painting and attributing it to Andrea Commodi, a seventeenth-century Florentine painter. It was typical of Commodi's subjects, but Papi, in a monograph devoted to the artist, had carelessly relied on a blurred photograph in the picture library of the Kunsthistorisches Institut in Florenz. He could not take into account details that were crucial to a true understanding of the painting, such as the way in which the nails were drawn, something that had immediately struck us, nor that the supporting material was board made of thick poplar, which was not used after the late sixteenth century but was typical of the supporting materials used in Bronzino's studio. An idle stroll can be so productive. Carlo and I were able to study the painting from every angle.

Some time later, I attended an attribution meeting at the Institut National d'Histoire de l'Art in Paris. Hardly had I stepped over the threshold than I saw two of the Eyes from 1965 walking toward me. Sylvie Béguin, my former teacher at the École du Louvre, slight, elegant as always, her blond hair pinned into a chignon, was walking arm in

arm with Michel Laclotte, the founder of the Musée d'Orsay and first director of the Grand Louvre, the project to renovate and expand the Louvre under President François Mitterrand. I thought I saw an irritable expression flicker across the face of this man who first introduced me to Italian painting and for whom I have great admiration. With the ready wit and the haughtiness so characteristic of him, in an amused and affectionate tone that masked the stentorian voice that has intimidated so many people, he said, "You need to stop drinking, Philippe! You're starting to see things, and you're getting everybody all worked up with your ravings!"

At this point, Sylvie, her blue eyes glittering mischievously, in a trilling lilt that the art world still strives to emulate, replied, "You know, Michel, you have to learn to question certain judgments … Sometimes even the young can be right."

"Oh, shut up, Sylvie, young people are insufferable."

For his part, Pierre Rosenberg, Michel Laclotte's successor as director of the Louvre and a familiar figure notable for the iconic scarf he perpetually wore, felt less concerned by the oversight, having devoted the greater part of his research to French seventeenth- and eighteenth-century painting, and having made a number of sensational discoveries. He was of Sylvie's opinion—like her, he accepted that every Eye is attuned to its particular period and context, and cannot be reproached for failing to "see" a painting. A great work sleeps in the shadows; it comes before great minds who fail to notice, until some chance encounter brings it into the

light, and thereafter it becomes impossible to consign it to the oblivion whence it has just emerged.

Not until 2010, when he attended the Bronzino exhibition at the Palazzo Strozzi in Florence, did Michel Laclotte change his mind. The palazzo, in the center of the city, is one of the great Renaissance palaces. A perfect embodiment of the cold bourgeoisie of bankers and merchants who governed the city in the fifteenth century, it casts a monumental shadow over the surrounding streets. The facade is built of rusticated stone, the interior comprises several vast, chilly halls with vaulted ceilings and contours accentuated by pietra serena. Here, the painting was exhibited in a space utterly in keeping with the spirit of its conception. It was hung so that the Nice *Christ* was the first painting seen by a viewer on entering the room devoted to the Panciatichis, and directly opposite the *Madonna and Child* (the *Panciatichi Madonna*) painted for the same family. Between these two paintings, on the right-hand wall, hung the twin portraits of the couple—now housed in the Uffizi in Florence in the same room as the Madonna.

I was intimately familiar with the couple to whom Bronzino dedicated his *Christ*. I had written a thesis on the subject of sixteenth-century Florentine portraits, and Bronzino's portraits of Bartolomeo and Lucrezia Panciatichi had earned him a reputation as the greatest portraitist of the age. They are depicted as the epitome of triumphant mercantile bourgeoisie. Bartolomeo leans against the parapet of a loggia, facing the viewer, and—though he has his back turned to it—he dominates a cityscape that, although referring to no actual location, is clearly recognizable as a fantastical Flor-

ence from the architectural lines, the building materials, the pietra serena that adorns the architectonic elements such as masonry, corners, window frames, and pilasters. Robed in black, Bartolomeo at first seems austere, but his red, forked beard and the scarlet doublet one can glimpse beneath his coat temper this severity with a sense of life and suppressed passion. In his right hand, he holds a half-closed book, perhaps Baldassare Castiglione's *The Book of the Courtier*, published in 1528. This is certainly hinted at by Bronzino's pairing of this intellectual object with the sword Bartolomeo wears on his left—paper and steel being considered the quintessential attributes of the perfect courtier. He is depicted as a man of letters, and also of action, as attested by the vigilant black dog crouched beneath his left arm—a symbol of virility, fidelity, and nobility. The combination of black and red in his clothing evokes the Panciatichi coat of arms, visible in the background as a small escutcheon.

As for his wife, Lucrezia Panciatichi, she is depicted in an interior setting, seated in front of an alcove framed by two pilasters of pietra serena. She is the focus of the light of the painting. Her red dress and auburn hair accentuate her pale complexion and marvelously complement her opulent jewelry. The fabric in which she is arrayed is even more lavish and tactile than that worn by her husband; the sleeves of her doublet are a deep, rich purple. In addition to a string of pearls from which hangs a pendant, she wears a chain of gold and enamel about her throat emblazoned with the words "Amour dure sans fin" (Love is Eternal), an allusion to divine love. She seems to have been interrupted at her

devotions, since an open prayer book rests upon her right knee. The ring she wears on her left hand shows that she is a married woman. Husband and wife each represent different facets of Florentine life—the public and the private—while each portrait contains a reference to the sphere from which it is excluded: Lucrezia's haughty gaze and Bartolomeo's scarlet doublet.

These paintings, rich in symbolism and ostentatious opulence, sharply contrast with the visceral realism of the image of Christ, where nothing is hidden from view. Nonetheless, the tokens of Lucrezia's piousness and the alcove in her chamber are echoed in the *Christ*, in its alcove of the pietra serena and the red trickle of blood that spills from the feet of Jesus onto the stone. These wealthy merchants, these aristocrats, felt a genuine religious fervor. As it hung in their private *capella*, it must have seemed as though Christ was spilling his blood in the very heart of their place of worship.

Visitors to the 2010 Bronzino exhibition were unanimous in finding the Panciatichi room the most deeply affecting. The public, who had considered him a court painter, was moved to discover, next to portraits of great delicacy and unrivalled richness, a scene as simple and profound as this depiction of Christ crucified. They discovered a very different Bronzino, one known only to a handful of experts. Bronzino was finally revealed. An artist who, otherwise, might have seemed cold and mannered, was shown to have unsuspected depths. In this one room of the exhibition, which highlighted the religious foundations of the glittering social life of Florence, our entire vision of court life in sixteenth-century Florence

was reappraised. As he left the Palazzo Strozzi, fully five years after our first conversation at the Institut National d'Histoire de l'Art, Michel phoned me. "Philippe," he said, a hint of excitement in his voice, "I lay the dust of Canossa upon my face.[1] I have just seen the *Christ*; it is transcendent. France has a second masterpiece by Bronzino in its collections."

This time, he had *seen* it.

1 "Je mets la poussière de Canossa sur mon visage." (I lay the dust of Canossa upon my face): a reference to the Humiliation of Canossa—the arduous trek by the German King Henry IV to visit Pope Gregory VII to obtain the revocation of the anathema imposed on him.

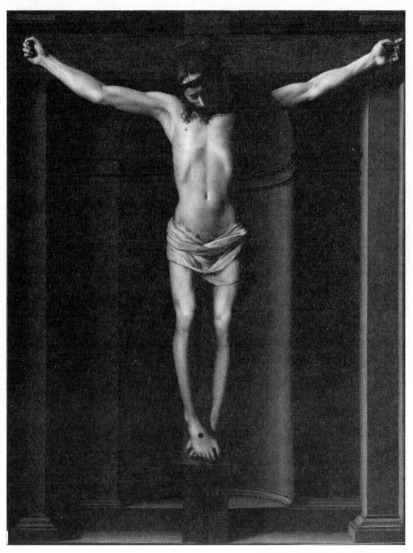

Christ on the Cross, Agnolo Bronzino
Collection Musée des Beaux-Arts Jules Chéret
Photography Muriel ANSSENS Copyright Ville de Nice

How I Became an Eye

rt history is considered to be an ideal field of study for young people from well-heeled families. And yet some of the most remarkable Eyes—including Bernard Berenson and Roberto Longhi, to name just two figures I will discuss later—did not hail from socially privileged backgrounds. Nonetheless, being imbued with a sense of beauty and having an intimate acquaintance with great works will always be indispensable to the development of a great art historian. If not steered toward it through education, an Eye may find his calling through an aesthetic epiphany, but sooner rather than later the museum will become his seat of learning. In my case, my upbringing played a definite role in my apprenticeship. My maternal grandparents raised me in conditions that proved auspicious to my talents. When very young, my sister and I were placed in their care after the death of our father, while our mother was studying medicine in Paris. Until the age of nine, I lived in a villa, furnished in the *grand bourgeois* style, that overlooked the city of Nice. My maternal great-grandfather had been surgeon to Renoir. On one of the living room walls hung his portraits of my great-grand-

mother and my grandfather's brother. I also remember the impression made on me by one of the paintings of a young Francis Picabia. Ours was not an intellectual family, but we were passionately interested in beauty. From a very early age, every Thursday was reserved for a cultural expedition, and my grandfather, with his passion for museums, regularly took me to exhibitions. A doctor like his father before him, he came from a traditionally anticlerical family in the Pyrenees. My great-grandfather Prat, the son of a schoolmaster from the region of Lourdes, had moved to settle on the Côte d'Azur when it drew travelers from all over Europe. It was here that he had met Renoir. And here that my grandfather had met my grandmother, a brilliant woman from a wealthy family from the Lorraine who had made their fortune in the nine-teenth century. Every year they left Paris to spend their winter in Nice. It was thanks to my grandmother that we possessed the magnificent pieces of furniture built by the finest eigh-teenth-century cabinetmakers. Despite living far from Paris and the great museums, I learned much from the exhibitions I visited as a child. And yet it was during the summer holidays spent far from such eminent institutions that I experienced the most precious moments of my childhood.

My brother, my sister, my two cousins, and I (the young-est) spent every August in the Charente, near Confolens. When we were not playing on the grounds or in the shade of the ivy-covered facades of the family residence built in the early twentieth century, we would go fishing or hunting for mushrooms in the surrounding meadow. These holidays were an expanse of unfettered freedom punctuated by a few more

serious outings. We would set off from the property known as Lesterie in grand style: with two automobiles and a bevy of ladies (my grandmother's bridge companions), in search of the traces of the Roman and Gothic realm that lined the route to Santiago de Compostela. Our favorite destinations were the Romanesque churches and medieval castles of the region, which were as famous as the châteaux of La Rochefoucauld, Mortemart, and Pompadour, for which my grandmother had a particular affection. We had no iPads or smartphones, and there were few guides to explain the history of the landmarks, so imagination played an important role in these excursions. We had only our instinct to make the ancient stones speak to us. We liked to dream about the designs, the gargoyles, or a pair of sparring lions on a capital. Our analysis was less than solid, we never followed through on our ideas, yet my memory of these outings is of joyous family celebrations. Despite not learning much, these discussions shaped our tastes and made us receptive to the effects of detail and sensitive to atmosphere. In order to temper the joyous character of the holidays, our grandparents sent us to the school in Saint-Maurice-des-Lions, the village that adjoined the property, for a few hours of lessons each morning. The school, which I remember as being all glass and wood, stood at the foot of a Romanesque church, of which we were very proud. Its every ornamental detail was known to us. I think that my reading of Dumas and Flaubert instilled a spirit of adventure and mystery that led me to appreciate these edifices.

The pride our families took in making sure they always had more beautiful and refined furnishings than the neigh-

bors resulted in unwittingly carving out a small area of expertise for us, which we put to use on visits to châteaux where we paid close attention to the furniture. Before the age of ten, my cousins and I could distinguish Louis XVI furniture from Louis XIII or Louis XV. But on these occasions, did we look at the paintings that hung on the walls? I don't think so. Painting didn't seem worthy of our attention unless it was an important master hanging in a fine museum. Such a waste. I sometimes wish I could return to these stately homes where one would be bound to make a few discoveries, having passed through as a child and noticed nothing.

The things I learned to look at in a playful or analytical way took on new resonance when my grandfather took me to the opening of the exhibition of André Malraux's *Musée imaginaire* at the Maeght Foundation in Saint-Paul-de-Vence in July 1973. That was the first profound artistic shock of my life. I realized on that day that art could transmit thought. André Malraux had juxtaposed Gothic and Romanesque works with classical and Khmer ones, thereby showing clearly that there was a koine, a language, a vocabulary that all art shared, and that identical motifs could be discerned across different eras and locations without the intermediary of influence, as works of the human spirit, indifferent to their place in time and space. When my sister and I arrived in Paris in 1969, to join our mother at our apartment on the Rue des Saints-Pères, the city already represented, despite our youth, *the* capital where we would fulfill our destiny: a place synonymous for my sister with emancipation, and for me with new access to the unsought realm of sights that the Maeght

Foundation revealed to me a few years later. Being torn away from our life in Nice was painful, but crucial to my development. From the time of my arrival till 1977 when I took my baccalaureate exam, I was to give myself over without restraint to works of art in all their forms, a connection that would prove essential to the training of my eye. To this day, I never enter a museum without going to see the galleries of African, Islamic, Asian, or Oceanic art, the sculptures and decorative arts, and I never leave a town without visiting the contemporary or modern art museums, for our culture consists of understanding these accumulations.

My adolescence in Paris was filled with visits to museums. In a few years I had seen all the institutions and all the exhibitions. My nanny Aline learned along with me on Thursdays, the day of our outings. We saw the most renowned and the least-known museums. We wandered through the studios of Eugène Delacroix and Gustave Moreau, each of us completely absorbed. I went into raptures at the Guimet Museum of Asian Art on Avenue d'Iéna, opposite the Museum of Modern Art, and again at the Palais de la Porte Dorée, which at that time was home to the Museum of African and Oceanic Art. I enjoyed their ambiance. It was an entirely new world for a provincial boy. I became passionate about the French eighteenth century, thus I adored the Musée Nissim de Camondo and the Musée Jacquemart-André. Thanks to my passion for history, I also enjoyed the Carnavalet museum. I still remember the aesthetic impact that Monet's *Impression, soleil levant* at the Musée Marmottan at La Muette had on me. I don't know whether the paintings in our house in Nice

had prepared me for it, or whether anyone had ever mentioned it to me. It hung with a few of his water lilies in the mansion, filled with Empire furniture. It was contact with Monet's late works at the Marmottan as well as the magnificent *Nymphéas* at the Orangerie museum that inspired my first interest in contemporary art.

In those days, the atmosphere in museums was very different. They didn't function as cultural instruments the way they do today; they were much more intimate spaces where it wasn't unusual to find oneself alone with the masterpieces. In the antiquities galleries of the Louvre, I lost myself among the Greek vases. The *Iliad* and the *Odyssey* haunted my dreams; I was fascinated by classical mythology, the loves of the Gods, and the more obscure Biblical stories, those great cultural codes that now seem so mysterious to many people. When my grandparents visited from Nice, they stayed at the Hôtel des Saints-Pères, and Grandfather Prat would take me to the museum himself. We would take the number 39 bus from Carrefour de la Croix-Rouge, or sometimes the Métro, howling with laughter as we raced to the middle of the platform in time to board the only red car—the first-class carriage. I was his traveling companion. He would say to me: "You will be a surgeon … either that, or a curator … I suspect you will be a curator."

He had truly understood me.

I did my best at school. I was more interested in being popular than in being a model pupil. My sister and I had little taste for schoolwork; I was interested only in history and geography. Aside from my trips to museums and galler-

ies, I was developing my aesthetic sense in every way. Now and then, we would go to the Comédie-Française on Thursdays. It was here that I first saw Racine's *Andromaque*, the sort of literary revelation that until then I had encountered only in Flaubert's *Salammbô*. Whenever we were on vacation we would take the 7:30 *Train Bleu* to Nice. We would settle ourselves in our wagons-lits, and the next morning, proudly disembark from the train to be greeted by our grandparents, our brother, and cousins, to whom we were eager to recount our life in Paris—something that they must surely have found exasperating. One day my paternal grandfather, an industrialist who was later awarded the Légion d'Honneur in Nice, took us on an airplane for the first time. Back then, the Caravelle flew to Nice from Orly-Sud, departing from gate zero. Since we were very young, he bought us first-class tickets. We were seated in the first row, across the aisle from a lady who told the stewardess that she would look after us. Waiting on the tarmac, our grandmother could not believe her eyes as we disembarked, the first passengers to step off the airplane, each clutching the hand of the elegant lady wearing a mink hat and coat. It was Maria Callas.

I regularly went to the opera, where each performance is like a painting, something that is also true of Racine's dramas. There was a symbolist quality to these experiences. They offered me a sense of all that was liturgical, sacred, and wondrous in art, a natural extension of my earlier passion for the Gothic. On Sunday mornings when we were sent to church, we would run off and seek refuge in Le Drugstore at Saint-Germain-des-Prés which opened in about 1965, on

the site where Armani is currently located. The interiors by the stylish decorator Slavik were typical of the period, the booths upholstered in leather and gold like the interiors of turn-of-the-century motorcars. Instead of going to the fine Gothic church where, rather than paying attention to Mass, I could have daydreamed in front of the great seventeenth- and eighteenth-century pictures, like Laurent de La Hyre's *Christ Entering Jerusalem*, or marveled at the nineteenth-century frescoes of Hippolyte Flandrin, we would sit, reading comics, in the basement of Le Drugstore until one day our mother caught us red-handed and decided she would no longer force us to go to church. Given our anticlerical family, it was ironic that she came to this decision so late, but there was a social aspect to religion that it was important we be familiar with for the sake of propriety. Furthermore, all our grandmothers had come from Catholic backgrounds. It was to this preoccupation with social conventions that I owe the most important insights I have ever received. When, in my first year at the Institut Bossuet on Rue Guynemer, I told the Father Superior that I wished to be excused from Mass since I did not believe in God, he replied, "You are fortunate indeed, young man, it is a marvelous thing to have certainties in life!"

He said it with such caustic irony that I was never again so sure of myself. In time, I made it my personal and professional motto, convinced that one must always be prepared to question everything rather than cling to received wisdom. For it to be recognized, an attribution requires evidence as well as intuition.

Le Drugstore was at the center of life in Saint-Germain-des-Prés. On Saturday or Sunday, we would sit in one of the booths and enjoy spectacular ice cream sundaes with whipped cream and little paper umbrellas before going to the cinema. My taste in film dates from this period, which was the height of the nouvelle vague. Despite our youth, we saw *La Maman et la Putain* and *Les Quatre Cents Coups*. Stanley Kubrick's *2001: A Space Odyssey* was as fundamental to my relationship with imagery as my discovery of the great works of impressionism. I remember how I felt during the scene at the end of the film where the protagonist explores a mysterious room, its antique furniture contrasting with the bare walls and the ultra-modern floor made up of squares of opaque glass in a metal grid that radiates an unsettling, uniform light, casting no shadows, since there are no windows, no lamps. I realized that a film consists of a series of images that can be considered as though they were paintings. *2001* was not so much a story as a spellbinding visual adventure. I spent two hours glued to my seat, frightened and fascinated. Having seen the minimalist room in the film, I was not fazed when I later saw Malevich's *Suprematist Composition: White on White*.

The year I arrived in Paris, my grandmother decided to sell a property she owned in the Lorraine that she rarely visited anymore. She called on François Biancarelli, a young Corsican antiques dealer, to sell off some of the furniture. This was how I first came into contact with an expert. On one of the landings in my uncle's house in Provence, chests of drawers, writing desks, and tables and chairs of every size had been lined up in preparation for the sale. François taught me

how to tell what was genuine from what was fake, and how to assess the condition of a piece. In the years that followed, François and his wife Dominique took me under their wing, and together we would visit provincial museums. We scrutinized pieces with a radically different eye than that of my grandparents or my nanny. Their profession made it essential that François and Dominique recognize and understand the things they saw. It was not enough for the Eye to *see*; one had to look, to question the objects. Aside from the pleasure they took in visiting them, museums were the perfect tool for training the eye. They took me to Italy. Later, I spent a month in Rome on a language course, staying with a colleague of my grandfather. I visited all the galleries, but they were not what interested me most. My fascination with Italy was an adolescent's fascination for the cinema: Fellini's *La Dolce Vita* or Visconti's *Conversation Piece* (*Gruppo di famiglia in un interno*), as they laid bare the atmosphere and the streets of Rome. This revelation would have been little different to that of a young artist visiting the city in 1802: it was my personal Stendhal syndrome, the psychosomatic disorder resulting from an intense experience of viewing art. The Baroque churches and the palaces where great collections of paintings covered every inch of the walls in a sprawling confusion ill-suited to the scholar, though not without a certain decorative charm, and where half-closed shutters protected the rooms from the heat of the day, were not easy places for a young man to truly appreciate the works. Yet, it allowed me for the first time to step into a setting that until now I had only glimpsed in the films of Visconti and Fellini. François,

whose Italian was excellent and who had a fine grasp of history, was a perfect guide to the country. I was so enamored by our excursions that, in my last year of high school, I chose to study Italian rather than English, a sensible choice that allowed me to pass my baccalaureate exam, as planned, in 1977 with excellent results in history. At the time, I had no idea how important Italy would become to me. Paradoxically, it was in the National Gallery in London—where I spent a month taking a language course and staying with friends of my grandparents—that I had a foretaste of what Italian painting could be, in particular the eighteenth-century views of Venice painted by Canaletto. I think *A Regatta on the Grand Canal* was the painting I liked most. The banks of the canal are lined with the facades of Venetian palazzi hung with brightly colored flags. Brawny oarsmen propel their solitary gondolas through the motley bustle of activity. From the cabins, ladies coolly survey the scene while the gondoliers wave white handkerchiefs, and on the larger boats, spectators sport dazzling finery of red, blue, and gold that shimmers in the summer sun. This image merges into others: the watery greens and the translucent skin of Manet's *Olympia* at the Courtauld Institute, the heart-wrenching music of Yehudi Menuhin at a concert the two women took me to at the Royal Albert Hall. Every evening I dined with them, and during the day I was free to go about my business. I visited every museum in the city, and trudged many a square mile.

With my baccalaureate under my belt, it did not occur to me to study anything other than art history. I still had the crazy notion instilled in me by my grandfather that I

might become a curator. There were only two ways of entering the profession. One was to attend the École Nationale des Chartes for the training of archivists and paleographers, which, given my exam results, was impossible; the other was to do a combined honors degree in art history and history at the École du Louvre and the Sorbonne. The École du Louvre trains the eye, and its art history course gives an overview of the subject essential to the expert. The Sorbonne, on the other hand, tends to divide subjects into specialized fields, but it does offer an additional component indispensable to any aesthetic education, in placing subjects in the context of human history, whether political, economic, social, religious, or technical. I wanted to study the eighteenth-century Venice that had besotted me since I first saw the Canalettos in London and the Tiepolo frescoes at the Musée Jacquemart-André. This was joyous painting that suited my disjointed temperament perfectly. To my disappointment, the subject was not taught at École du Louvre, so I ended up running between four very different courses at the start of the academic year. I quickly abandoned a course on the history of furniture—perhaps mistakenly—because it only involved studying the interiors of the Tuileries Palace and the Château de Saint-Cloud, both of which had been destroyed in 1870. I was not serious in my study of impressionism, letting lectures fall by the wayside when my weeks became too demanding. It was the beginning of a disillusionment with the movement that lasted until the age of about forty, when I began to reappraise it, largely thanks to a visit to the impressionist galleries at the Art Institute of Chicago. The other two courses had such a

profound impact on me that I would not have dreamed of missing a lecture. One of our finest thinkers, Gérard Régnier, better known by his pen name of Jean Clair, taught a remarkable class on Duchamp and Malevich. Despite my interest in the subject, I had not heard of either artist, something that attests to my family's dilettantish approach to art. This brilliant teacher introduced us to the notion of conceptual questioning. While many Eyes grow up imbued with intellectual ideas, this was something about which I was entirely ignorant. But the essential course was the one devoted to Piero della Francesca. When I first sat in the great auditorium of the École du Louvre, I knew nothing about Michel Laclotte, Piero della Francesca, or the Quattrocento, and I was less struck by the works of the celebrated central Italian painter than by Michel Laclotte's personality, which is really saying something. I was spellbound by his voice: the stentorian tones of a Great Man, the first I had had an opportunity to hear. At the time, Michel Laclotte was chief curator of painting at the Louvre, which he had reorganized at the request of André Malraux, then the minister of culture. His meticulously prepared lectures brimming with erudition suggested a relationship with art utterly unlike that of my family or even of François Biancarelli, who, though cultured, nonetheless approached it from the point of view of a salesman. I chose to take my end-of-year exams on Italian painting.

In the first week of my first year, in the chaotic comings and goings between the École du Louvre and the Sorbonne, I met two people without whom my life would be very different. Two people who stood out from the throng of new

students who gathered for our traditional gallery visits: Anne Fabre, whom I met in the Italian galleries of the Louvre, and Christine Poullain, whom I encountered at the Centre Pompidou. Given the work involved in studying for a combined honors degree, I don't know how we managed to spend so much time sitting on café terraces or in smoky bars, but the year slipped by and, though there was much studying, there were many other moments that cemented our friendship.

In the autumn of 1978, Michel Laclotte was no longer with us. He had been appointed to lead the team setting up the Musée d'Orsay, which was to be housed in the former Orsay railway station. He left, taking with him some of the Louvre's collection of paintings. I had lost my mentor. At his request, his position was taken by Sylvie Béguin, who was preparing an extensive Raphael exhibition at the Grand Palais. His argument was that, in teaching the course, she would be well prepared to stage the exhibition. I sat in the first row next to Anne Fabre at the first lecture, two frantic hours filled with an erudition that could not fail to win me over. I didn't miss a class throughout that year. Some months later, discerning readers of *L'Officiel des spectacles* or *Pariscope* would have noticed that a small exhibition devoted to the works of Perugino and his pupils (not including Raphael), organized by some of Sylvie Béguin's more industrious students, was being mounted at the Palais de Tokyo—at that time a sort of visitable storehouse for the Louvre in the building that had formerly housed the Musée National d'Art Moderne. Sylvie Béguin divided us into small groups and tasked us with scrutinizing the paintings from the school of Perugino, who had

been Raphael's tutor. We were to examine their condition and determine what restoration work might be required. This was my first direct, tactile interaction with works that, though any amateur would recognize them as minor, seemed very significant to us. Under the guidance of Dominique Thiébaut, a young woman appointed by Michel Laclotte to the department of painting at the Louvre, we wrote entries for the exhibition catalogue, learned how to use source materials and draft a bibliography. It was an exceptional opportunity. The result was well received by the public and our research would prove useful in the planning of the 1984 Raphael exhibition. The year that had begun with a disappointing event was to be one of the most crucial in my life. I moved from the Quattrocento to the Cinquecento, settled in Italy, and discovered, in my professor, a woman who was to be a friend and an advocate for the rest of my life.

By the end of that year, the only thing that Anne and I needed to become full-fledged art historians was to do the Grand Tour. With Anne behind the wheel (I did not yet have a driver's license), we set off for Italy in a Citroën 2CV to see all the things we had been studying. At our first stop, in Florence, we were able to see works we had already come to know from viewing slides, and thanks to the contacts of Sylvie Béguin and François Biancarelli, we were able to gain access to the sort of Italian houses we knew of only through literature. From here, we set off for Siena, where our car broke down, forcing us to continue to Rome by train. But before carrying on to the Veneto, whence we traveled to Nice via Milan, the real crux of our excursion was our visit to

Umbria and Emilia-Romagna. Thanks to the *Guida Rossa*— the *Red Guide*—an excellent book compiled by the Touring Club Italiano with the assistance of art historians, a traveler visiting the little churches in the Italian countryside can read entries on each one, describing its history and offering a brief summary of the works on display. The guide offers the possibility to embark upon a journey to the heart of the largest collection of paintings an Eye will ever encounter during his training, a profusion of visual information you take away, not knowing whether it will prove useful, though invariably it does. The little churches of the Italian countryside are filled with artistic elements that teach the Eye to move quickly, to dart from one room to another in a sort of memory palace, moving from the eighteenth century to the Trecento, to the Cinquecento, followed by the Quattrocento … In time, one can dispense with the *Guida Rossa* and begin to make one's own attributions. It was as a direct result of this journey that I would become an expert on certain artists mentioned in the guide, such as Vincenzo Tamagni—familiar to only a few specialists—whom I discovered some years later on my way to the beaches of Tuscany, and whose hand I now recognize with ease.

In the countryside, artworks are presented with no context and no attribution. Unlike a Poussin painting, which hangs in a gallery precisely *because* it is by Poussin, the frescoes of Piero della Francesca in the Basilica di San Francesco in Arezzo are there because they were conceived for this space. It is important that an Eye experience these works in situ. Otherwise, he would miss some of the most picturesque places

and settings. You pick up the keys at the local grocer's shop, walk to the church up a steep hill lined with wind-tossed cypress trees, push open the heavy door, search for the switch that turns on the small lamp, and suddenly you are faced with a fresco as famous as Piero della Francesca's *Madonna del Parto*, one that has survived the centuries and that still elicits the awe the artist sought to inspire in fifteenth-century pilgrims. It was easier to feel this sudden pleasure of discovery in the 1970s, before art achieved "celebrity" status. Nowadays, a visitor wishing to see a Piero della Francesca will usually have to pay and file past the glass-covered images as part of a group of five others, and on bad days, he may be tempted to leave without seeing anything at all.

When studying the Cinquecento, I was particularly drawn to Raphael's portraits. It was a passion shared by Anne Fabre, and we therefore proposed to write a joint thesis, an idea Sylvie Béguin enthusiastically accepted. Sylvie advised us to go to Florence to visit her Italian colleague, Luisa Becherucci, an expert in Florentine Mannerism, to discuss the planned thesis. A former director of the Uffizi Gallery, Luisa Becherucci had been the grande dame of the Florentine art world since 1944 when she published a book about the Tuscan Mannerists during the worst days of the aerial bombardment of Florence. We arrived at teatime to a murky apartment decorated in the style of a bygone age—circa 1880. "I don't drink tea," she told us. "Would you like some whiskey?" We could hardly refuse. We listened to her as we sipped our drinks, trying not to grimace, because we both hated whiskey. At the time, theses and dissertations were usu-

ally monographs. Portraiture had the drawback of being a historical subject, one that revealed more about the period than the painter, containing many works by minor artists, a body of work that was difficult to link, or even to attribute. In a sense, it was these very difficulties that made the subject even more fascinating. Luisa Becherucci, in any event, was extremely encouraging, and we decided to move to Florence to begin our research.

We needed to make a convincing case to our families, who saw this as a frivolous venture. Shortly before we left Paris, a friend who worked on Italian painting at the Musée Condé in Chantilly decided to come with us. The two women, who were more organized than I was, had already rented an apartment near the Duomo. They allowed me stay with them until I found a small place to rent on the other side of the Arno near Porta Romana. The Kunsthistorisches Institut in Florenz, founded in 1897, and the most important library devoted to Italian art in the world, quickly became our base. Here we could find the books we needed and make use of their invaluable picture library, without which we would never have completed our research. Between October 1980 and June 1981 we made photocopies of all the portraits, attempting to determine logical groups and orders. We had a stack of (blank!) letters of introduction, signed in advance by our tutor, and so were able to meet some extraordinary characters who taught us much about our artists and enabled us to gain access to the most sacrosanct areas of the museums of Florence where portraits and other paintings by them were to be found. We began the work of reattribution, which was

the fundamental work of an Eye, establishing groups based on those works that were already documented and correcting what seemed to us to be erroneous.

The following year, the Kunsthistorisches Institut closed for restoration work. It was a heavy blow. Several months earlier, the three of us had rented a new apartment on Piazza Santa Croce, in the Palazzo dell'Antella, a palace with a frescoed facade, where we were able to live lavishly despite our meager resources. We had become much more confident, we knew people, we had made friends, and our *terrazza* became a pleasant place to socialize. This was not time wasted; the history of art is made of such conversations. The closure of the "Kunst" forced us to radically change our habits. We fell back on the library and the picture library at the Villa I Tatti, The Harvard University Center for Italian Renaissance Studies. It was a somewhat less intellectual setting than the Kunst, but in this magical atmosphere straight out of the pages of an Edith Wharton novel, I learned to master the books and tools necessary for producing rigorous university work. Despite its prestige, the Kunsthistorisches Institut is devoted to a single discipline, whereas at I Tatti, I was surrounded by works on political and religious history as well as musicology, all crucial subjects for an accurate understanding of the portraits. The building, donated to Harvard by Bernard Berenson, is located outside the city, on a hill not far from Settignano. We would cycle there, and I must admit that at first we had to dismount and push our bicycles up the steep stretch leading to the gates. By the end of the year, we would arrive, hardly out of breath, at the broad expanse of land where we parked

our bicycles with a miscellaneous group of vehicles, from cars to the villa's little tractor. When not seeking to solve all the world's problems in the nearby olive grove, we continued our study of the portraits, analyzing the stylistic details of each, and coming to a deeper understanding of the specific restoration issues associated with those pictures that particularly interested us. Aside from the research we were doing for our thesis, we had been asked by the director of the Galleria Palatina to make a study of the Florentine paintings of the early sixteenth century that hung in the staterooms of the Pitti Palace, the home of the Medici family in Florence. This was an extraordinary opportunity for us, since we were permitted to physically handle the paintings, allowing our eye to penetrate the layers of paint. It became clear to us that a defensible attribution could not be based solely on a photograph; the physical materiality of a painting said much about its history. For the most part, the works from the Medici collection hanging in the Pitti Palace were in relatively good condition, and from this, it became evident that in certain cases, works had so deteriorated that one could not make an accurate assessment from the superficial image.

In 1982, it became clear that we would need to make a number of journeys beyond Tuscany. We were now familiar with the two major collections in Florence, at the Uffizi and the Pitti Palace, and needed to visit galleries in Rome, which were much more puzzling since they often contained complete collections gifted by cardinals and princes. While roaming the galleries of the Doria, Corsini, and Colonna Palazzi, the Galleria Borghese and the Palazzo Barberini, we

discovered many Florentine portraits. Rome of the fifteenth and sixteenth centuries, more grandiose than the capital of Tuscany, became home to many artists seeking commissions from its cardinals and popes, chief among them the Medicis, and to pursue their vocations under more clement skies. Thus we were able to familiarize ourselves in an amusing way with Baroque art of the seventeenth century by hunting for portraits. The churches where we would search for our portraitists' work, *Guida Rossa* in hand, were filled with a jumble of baroque altarpieces, frescoes, and sculptures also to be found in museums. The Palazzo Doria Pamphilj, with its rooms filled with paintings hung frame-to-frame, revealing not a patch of wall, containing no line of explanation and no labels, was an excellent hunting ground. As a good apprentice Eye, I took information sheets for each room and attempted to identify the works amid the clutter. Nothing significant came from it right away; I began by recognizing the Caravaggios, remembered from courses and books since those images were fixed in my mind. Then for the others I delineated the school, the place, the century, to narrow it down as close as possible to a single artist; it was a veritable game.

Often when a cleric achieved princedom, he would embolden his family by patronizing artists and building collections that were as varied as they were prestigious. Only in Italy can one still find this type of art institution. Elsewhere in Europe as well as in the United States, museums aspire to present encyclopedic collections. It's not that such cardinals' collections didn't exist in France, but the assets of Richelieu or Mazarin, once located in what is now the Bibliothèque

Nationale and the Palais-Royal, were incorporated into the collection of the king, which itself became the Muséum, now known as the Louvre, at the time of the French Revolution. The Musée des Beaux Arts in Ajaccio, Corsica, where I am currently director, is the last collection of this kind, assembled by Cardinal Fesch, Napoleon's uncle. But, of the sixteen thousand pictures he collected, only a thousand are currently to be seen in the city of his birth, in the museum built according to his final wishes. I have attempted to recreate the experience of seeing one of these ecclesiastical collections in one of the galleries. More academic art historians are involved with books to a greater degree and aren't as concerned with such a mixture of works. As a result, they often confine themselves to their own specific fields, while the Eye roams much more broadly. The Eye, by going to where the art is, increases his knowledge daily.

I must declare here that wherever we went, be it Rome, Milan, Bologna, or Venice, we enjoyed enormous privileges thanks to our tutor. Being certainly the most respected French art historian in Italy, her letters of recommendation opened all doors to us, and curators allowed us direct contact with works of art. When Sylvie Béguin would come to talk at a symposium in Italy, we would join her and she would introduce us to her colleagues. She was much liked, very friendly and always cheerful. Her charisma permitted us to come into contact with some very important figures in art history, whom we wouldn't have encountered in a library. For a long time these people had had the means of acquiring their own excellent book and picture libraries, and a certain

number were more inclined to publish the results of their own past work rather than undertake new research. I can say without pride that following their example, I happen to go back to the libraries less and less often myself. One gathers so much documentation during one's years of training that there's plenty to use later on. This is the sort of detail by which one can judge how far one has come.

In 1985, four years after my arrival in Florence, we submitted our thesis. From 1983 onward, I had started traveling outside Italy, in Europe and across the Atlantic, for my thesis, but also out of curiosity. I wished to see as many works as possible in person, in order to better understand what I was proposing. Florentine portraits had spread all over Europe following international conflicts and the fashion that emerged for Raphael. This led to some confusion and a number of misattributions, some overly flattering, when museums were being developed in the nineteenth century. This seemingly marginal line of research led me to do some quite important work in re-evaluating even quite well known works. Without the apprehension I feel even today, and which is invaluable in seeing works as though for the first time, I could not have been successful at this.

It was at first following my tutor, who took me on all her trips, that I began to discover what was for me a mythical realm: the English-speaking art world. I was gradually introduced to university professors, museum curators, and the art-dealing community. We historians have a necessarily complex relationship with these essential figures in the art world, the sellers of paintings, due to certain deviations in

our respective aims. Nevertheless, we work in tandem with them. New York was, along with London, the world capital of the art market in the early eighties. These great dealers were for the most part located in brownstones on the Upper East Side. I was particularly fond of one of them, the home of Piero Corsini, which was a hub for all connoisseurship on the East Coast, whether casual or professional. It should be mentioned that the then director of Corsini's gallery, Robert Simon, was the author of a thesis on Bronzino's portraits of Duke Cosimo de' Medici and was for years a seemingly inexhaustible source of information. Corsini, a dealer of Italian origin, was an adventurer at heart who frequented auctions in the most unlikely places on the continent. When he returned, often laden with extraordinary paintings, he regaled his friends with excellent dinner parties, for he was also a cook and bon vivant. He once brought back *Portrait of a Man* by Lorenzo Lotto, the brilliant Venetian painter of the sixteenth century, whose oeuvre was identified by an auction house three centuries later. Piero made me realize that it was possible to discover works of art. Art dealers, who have at their disposal all the means necessary for accessing collections, are often instinctive and able to wager everything on pieces whose origin is unknown to them. They are the chief discoverers of art. Because they don't necessarily know what they have on their hands, they require historians to confirm or adjust their intuitions. But while they need us, their own accomplishments must too be acknowledged. My own body of work has increased considerably as a result of encounters with these people.

Despite all the important social activity and research I was conducting, I dedicated one day every week to my oldest passion. American museums, although very different from European ones, still constitute an extremely valuable resource for my work. So in the morning I would make a beeline for the Florentine portraits, which still hang in the Old Masters section, before continuing on to the other Italian paintings. It was very important for me to then wander through the Egyptian and furniture galleries, and the rooms devoted to the nineteenth century. The ambition to show World Art is a key aspect of the way American museums are organized, and they continue to show more or less high-quality examples of it. Finally, I would come back to the paintings that were the motivation for my journey. It was essential that I bring writing materials to the museum. Because I sometimes forgot, I would use subway maps or entrance tickets as note paper and wouldn't hesitate to borrow a pencil from a guard. Sometimes I would make important discoveries. A few times, I came across Florentine portraits in the Venetian section. I would therefore need to take notes and imprint the image as precisely as possible in my memory, a photograph not necessarily being readily available. On most occasions, I had planned my trip in advance and arranged a meeting at the museum; I needed to be certain that the paintings I planned to examine would be on view. When I found myself somewhere by chance, however, I had to fight to see them. There could be drama on weekends because my only recourse was to write to the absent curator for documentation, which would often reach me in Europe after I'd returned. Fortunately, curators

tended to be very compliant with these requests. Because they hope their museum will obtain a spectacular attribution, or at least one closer to the truth, they wisely help out young researchers as much as possible.

I was able to discover that in the United States, the approach toward conservation was entirely different to that in France or Italy. In 1982, when I sought to see a couple of Florentine portraits owned by Yale University, a Ridolfo del Ghirlandaio and a Giuliano Bugiardini (two painters known only to specialists), I found that a large part of Yale's painting collection was kept in storage, having been ruined by restoration between the wars. American and British collectors, demanding gaudy pictures, didn't hesitate to jeopardize the art by having it restored to appear new, while our Italian and French restorers were more respectful of the passage of time. Works of art had been ruined in this way for decades. At the time of my training in the eighties, young American curators were beginning to complain about the state of their own collections. Observing this phenomenon made me see the issue in a new light and underlined the need to respect the work while restoring it.

An Eye must discover pictures that others don't know about; that is what establishes their reputation. My compulsive travels to roam museums were a mark of my vocation. I made a few minor discoveries, as young Eyes do. They are of little consequence to the general public, but mean a lot to us and allow us to become known for what we are. One day, in 1982 I think, my tutor handed me a photograph of a portrait and said that I must personally attribute it because

she wished to rid herself of the problem it posed for her. It was a supposedly mediocre work that had been discovered by a private collector who thought it had emerged from Bronzino's Florentine circle but knew no more. It took me a week to find that it was by Bertucci the Younger, a minor painter who was active in the sixteenth century in Ravenna. "I don't know who this Bertucci is, but I'll take your word for it."

At the Uffizi Gallery, Anne and I had also noticed that a portrait showing a three-quarter view of a man, his face in shadow, with a scroll in his left hand, bore a striking resemblance to a painting in the Metropolitan Museum of Art in New York signed Tommaso di Stefano, who was mentioned only two or three times in Giorgio Vasari's *The Lives of the Most Excellent Painters, Sculptors, and Architects* (*Le Vite de' più eccellenti pittori, scultori, e architettori*). Sylvie Béguin and Keith Christiansen, a Metropolitan Museum curator, were wholly convinced by this suggestion and proposed that we publish an article on the subject in a major Italian art journal, *Prospettiva*, founded by Roberto Longhi's pupil, Giovanni Previtali. It was to consist of two A4 pages and three pictures: the two portraits and a documented *Adoration of the Shepherds*. A novice's article. But the painting in the Uffizi emerged in the text with certain ambiguities that could have been seized upon to contest our proposed attribution. Having restored it, the Uffizi decided to attribute it to Rosso Fiorentino, one of the most brilliant of the Florentine artists of the same period. Some critics who disagreed used our article to dispute this attribution, so convincingly that the article became a landmark. It awoke an interest for Tommaso di Ste-

fano, who was previously unknown among historians. Even though Antonio Natali, the director of the Uffizi, who originally attributed it to Rosso Fiorentino, is not able to back the claim up, I must say that to this day I'm not sure I have fully come to grips with this artist. In the Patrizi collection in Rome there is another portrait signed by Tommaso di Stefano but in a different hand than the one in the Metropolitan Museum. Further scrutiny is required.

Our second article had a much more ambitious subject: the *Portrait of a Goldsmith* in the Pitti Palace. Luisa Becherucci, who helped guide our thesis in the early stages, spoke to us about it at our first encounter with the *Goldsmith*, a painting famous for its enigmatic subject and usually ascribed to Ridolfo del Ghirlandaio, a painter little known outside a circle of experts, saying that she was certain we needed to find another attribution because in her opinion it could not have been done by the son of Domenico Ghirlandaio. Upon the publication of a collection of articles about the painting—a Festschrift, as the Germans call it—we suggested that it should be reattributed to the Florentine painter Piero di Cosimo, a brilliant and eccentric artist who straddled the fifteenth and sixteenth centuries and was deeply affected by Leonardo da Vinci's aesthetic revolution. This suggestion generated much discourse and continues to divide opinion to this day.

Mina Gregori has a special place in the pantheon of those guardian tutors who helped me become who I am today. The Signorina, as her students affectionately knew her, was, and is, one of our great art historians. A former pupil of Roberto

Longhi, she holds the chair of history of art at the University of Florence. She provided us with instruction we could have found at the École du Louvre, but in a way that ran much deeper. It consisted of courses in attribution that had been enthusiastically recommended to me. Mina Gregori taught her students the methods of her mentor during fascinating demonstration sessions. She had an exceptional eye whose speed and discernment is shared only by the very greatest— her teacher Longhi, their compatriot Federico Zeri, and before them, Bernard Berenson—all of whom were able to span the centuries, from the thirteenth to the nineteenth, with the same acuity. These figures published on a mix of all eras. While an Eye of our own generation is capable of insight outside his area of expertise, he is only consulted and only communicates on what relates to his own century of specialization.

The year that Anne and I were ending work on our thesis, between 1984 and 1985, I received a fellowship from the Roberto Longhi Foundation. My links to Mina Gregori were getting closer at the time and she was president of the foundation; it was at her behest that I applied. Longhi, her late teacher, had owned a villa on the southern bank of the Arno, on a hillside not far from Florence, more or less opposite Berenson's Villa I Tatti. The relations between the Italian art historian and the American connoisseur were not ideal. Our proposed research was to be in the spirit of Longhian historiography, which attached a fundamental importance to attribution and reattribution, while the English language scholars were starting to detach themselves from what they

had created. It was a lean year for the foundation; only seven of us benefited from the stipends that year, though usually twelve were awarded. We worked in the villa, which we would have been happy to do had it not been for Anna Banti, Roberto Longhi's widow, a great writer but above all a real dragon, terrorizing us. I intended to use this year to fill a significant gap in the work Anne and I had undertaken on portraits. We chose the year 1530 as the limit of our study, the time of the end of the Republic of Florence and the establishment of the monarchy. This allowed us to demonstrate the transition at the beginning of the sixteenth century between the depiction of an open world with merchant-like figures in landscapes and a closed one, inhabited by aristocrats enclosed in their sumptuous interiors. This left Bronzino on the margins of our research, despite his being unanimously considered the greatest Florentine portraitist of the century. When Austro-German art historians of the nineteenth century dismissed Florentine art of the sixteenth, Bronzino's portraits were its only aspect they continued to acclaim. I decided once again to tackle the subject, for I was intimidated by the stature of the figure, yet recognized in him a monster to slay. A friend of mine who was a professor at the University of Florence, and who was working at the time on the early work of Alessandro Allori, one of Bronzino's disciples, was overwhelmed by the matter of the portraits. This field, which has since been made more approachable, thanks perhaps to me, was at that time a tangled knot. A large part of the works attributed to Bronzino in the nineteenth and twentieth centuries—court paintings of men in large ruffs and

the lavish clothes of the Medici period, and women adorned with pearl necklaces—came in fact from the studio of his pupil. We set to work on the first creative period of the disciple, which we knew only from the sources. By the end of the year I was able to assemble the corpus of his early portraits that had been unfortunately misattributed to his master.

The Longhi villa introduced me to team research. It was the first time I'd worked with a group of art historians who shared my passion for attribution. Our hostess would gather us together in the picture library adjacent to the house and we would amuse ourselves according to a scheme of Mina Gregori's to train our eyes in attribution. We took pictures from the library and tested our abilities, at the same time refining our collective vision thanks to our individual respective areas of knowledge. It was an elaborate version of the memory game where you must find pairs of cards from a shuffled pack. The outcome was different in that there were no doubles among the photographs, but it was a matter of establishing a link by identifying the common element. Naturally, such links weren't entirely obvious. Despite their playful nature, these sessions were mandatory. The congenial atmosphere was an integral part of the foundation's functioning and revealed the importance of collegiality when it comes to the negotiation of a proposed attribution. Having completed our work, the day invariably ended in a trattoria, where we set the world to rights over bottles of wine, possibly of not quite the best quality given our means, and simple, not altogether light, but typical Tuscan food. We fantasized about our lives to come, pretentiously seeing ourselves as the great art historians of the future.

Unlike I Tatti, which was more bookish, the Longhi Foundation was tailor-made for Eyes, which perhaps explains the intensity of the relationships among us. I remember many outings accompanied by Mina. These were always occasions for festivities and laughter, for our love of art was combined with significant joie de vivre. This side of our activities, despite their superficial appearance, perhaps contributed more that was valuable and long-lasting to our careers than the more purely academic exchanges. Such collaborations weave tight and enduring bonds. We all still work together, we provide catalogues of our exhibitions to our friends and they ask us to help organize theirs, we all invite one another to our talks. Of course none of this excludes serious academic work. Mina Gregori put on an unprecedented exhibition devoted to seventeenth- century Florence, which has always been over-looked in favor of the same period in Bologna, Rome, or France. She taught us a great deal in the course of the preparations and explained many essential matters. In some ways she thought of us as her children. She took us all to Naples, to the Museo di Capodimonte, where she had organized a large Caravaggio retrospective along with Keith Christiansen from the Metropolitan Museum. She demonstrated several important points that were crucial to the understanding of the oeuvre. For seven or eight hours, with the aid of an elegant red flashlight to underline the brushstrokes, she explained the artist's technique. We fully experienced each one of them. I believe that none among us ever looked at a Carravaggio painting in the same way again, for Mina had an incomparable sense of how to feel one's way in.

The stipends ended at the end of June, but we all had such trouble parting that we still had not left the villa at the beginning of July. It was a particularly sad time for me, perhaps because of my temperament, which made me play a major role in each of the groups with which I was associated. I suggested ending the year with a dinner on July 14th in the gardens of the house. We had Mina Gregori's approval, but she was terrified of suggesting it to Anna Banti. She was a real virago but one who, in her more tender moments, would come to me and speak of France, a country for which she had real affection. I secured her blessing for the 14th of July, and we organized the first dinner at the villa since the death of Roberto Longhi. It was an absolutely fabulous evening, and Ottavio the cook, with whom we had all become firm friends, regaled us with a feast. Was there an element of self-aggrandizement? When we departed the following day, I think we had all convinced ourselves we had become Eyes. That, of course, requires training that never ends.

The History of Eyes

The history of art has not always existed as a discipline. And what a curious discipline it is. There is an erudite and scientific aspect to it, as with the study of history, but it is intimately linked with pleasure, the pleasure of the eye specifically and the pleasure of the senses more generally. History of art in this form is a relatively recent invention. It only began to develop properly at the end of the eighteenth century. One could say its roots lie two centuries earlier in Giorgio Vasari's *The Lives of the Most Excellent Painters, Sculptors, and Architects*, which appeared in its complete form in Florence in 1568. The *Lives,* as it's more commonly known, was one of the biggest bestsellers of the sixteenth century. It was inspired by Roman historiography, Plutarch's *Parallel Lives*, and the works of Pliny the Elder, and relates the exemplary destinies of the great Italian painters, from the time of Giotto to Vasari himself, who was also an artist. His career began in 1530 when the Holy Roman Emperor, Charles V, overturned the Florentine Republic to establish a hereditary monarchy. Florence became a duchy ruled by the Medici family. Following a catastrophic start to their reign

(the first of the Medici, Alessandro, was assassinated by his republican cousin Lorenzaccio), Cosimo, a young man of eighteen, became Duke. Vasari became the young man's official painter and oversaw the renovation and transformation of the family residence, the Palazzo Vecchio. Cosimo presided over the start of one of the most bountiful periods in the city's history. In an attempt to harness all the resources of the *Fiorentinità*, the cultural identity of Florence, to gain support from his subjects, he encouraged the foundation of a literary academy of scholars and artists. The Accademia di Belle Arti di Firenze was charged with spreading the glory that the Florentines had acquired in the two forms of art they practiced best, rhetoric and the visual arts. Vasari set to work on his enormous historiographical project within the context of this prestigious enterprise. With the assistance of several members of the new academy, he assembled all the available information on the great painters of Italy and began to compile the *Lives*. One must speak of the authors of the *Lives* in plural, for despite Vasari's dominant role, the parts played by other members of the Florentine academy account for certain characteristics of the work. The ambition, in fact, was twofold: One aim was to make Tuscan, the language of Petrarch, Boccaccio, and Dante, the principal language of the peninsula, and the other was to enhance the prestige of Florentine achievements compared to the occasionally superb achievements of rival cities in Italy. To this end, the authors of the *Lives* permitted themselves certain inaccuracies. As for Vasari, he wished to rank drawing above all other forms of artistic creation. As well as being a characteristic element of Floren-

tine art, he considered it to be the method by which the artist came closest to the thinker, and set himself apart from the artisan. In drawing, the artist expresses his thoughts directly through his line. Vasari also presumed to suggest that the Venetians were, despite being fine painters, poor draftsmen, which is completely untrue. The *Lives* also contains some no doubt deliberate misattributions, which have created trouble for art historians over the years.

With the Enlightenment, a growing interest among ordinary men for this discipline developed and emerged under the direct influence of the powerful. For the English aristocracy, the Grand Tour of Italy became necessary for a proper education. This practice, which consisted of visiting Italy after having read Vasari, and meditating on the ruins of antiquity and the great works of the Renaissance masters, spread word about art throughout the educated classes of Europe. As a result of this steady influx of travelers, Vasari's text, having been expanded upon by local scholars, was further developed and extended to include the eighteenth century in order to reach a wider readership. Luigi Lanzi, a Jesuit who had become deputy director and antiquary at the Uffizi Gallery in Florence, undertook this work. He published a guide devoted to the collection in 1782. Later, in 1786, he wrote *The History of Painting in Italy, from the Period of the Revival of the Fine Arts to the End of the 18th Century* (*Storia pittorica dell'Italia dal risorgimento delle belle arti fin presso al fine del XVIII secolo*), which immediately became an indispensable handbook for travelers. Along with Vasari's *Lives*, his book became one of the two chief sources of information available to contemporary art connoisseurs. The

shock in Europe caused by the French Revolution provided the trigger for a new form of art history more in keeping with the interests of this new public.

The revolution promoted a widespread interest in art. To the revolutionaries, the art that had distinguished ancient Greece, Rome and the Free Republics of Italy was synonymous with any true doctrine devoted to liberty. One of the first acts of the French National Convention that governed after the toppling of the monarchy was to inaugurate a new museum of art, our own Louvre, with the notion that it was the duty of a republic to bring art to the masses. Throughout the eighteenth century, thinkers like Hume, Lessing, and Shaftesbury had suggested a link between beauty and virtue, morality and aesthetics, good taste and goodness. This idea of the intellectual and moral perfection of man through art guided the cultural politics of the new state. The Convention consolidated the royal collections as well as works taken from aristocrats and religious orders, placing them in the old Louvre palace. This led the way to the further plundering of art from countries conquered by Napoleon, for this involved a similar principle pushed to its limit and distorted: a state that wished to represent the very highest ideal of human progress was obliged to bring together the heritage of the world. So in the space of a few years, the most important works of Western art from antiquity to the Revolution found themselves in the galleries of the Musée Napoléon, as the Louvre was provisionally renamed under his rule. Paris, the capital of an empire in full expansion, consumed by hegemonic ambition, concentrated a treasure of dubious origins around the

Tuileries Gardens, and in doing so, endowed itself with the most fabulous tool ever devised for the training of an Eye. In many cases these works were returned after the 1815 Congress of Vienna. How many journeys might we have been spared, and what marvelous glimpses of the history of world art could have been accorded to us if they could only have been retained. The impassioned Romantics were able to witness them all together.

These political events led to the development of art history in its modern sense in France. Voltaire and Rousseau scarcely mention it. Diderot wrote about art but for the most part only of the works of contemporary artists shown in the official exhibitions known as Salons. His was a fashionable readership, more concerned with entertainment than knowledge. It was only with Stendhal that the two distinctive elements of modern art history, entertainment and erudition, finally came together. He was in fact France's first art historian. He had read Giorgio Vasari and Luigi Lanzi, saw art and learned to appreciate it, then communicated his appreciation. His *History of Painting in Italy* (1817), *Rome, Naples and Florence* (1817), and *A Roman Journal* (1829) express this new way of looking at art. "I had arrived at a point of emotion where celestial sensations given by fine art and passionate sentiments meet," he writes in *Rome, Naples and Florence*. "As I emerged from the porch of Santa Croce, I was seized with a fierce palpitation of the heart; the wellspring of life was dried up within me, and I walked in constant fear of falling to the ground." Not only does the writer explain what he sees, but he also describes what he feels, and communicates

the ability to feel. In 1989, an Italian psychiatrist, Graziella Magherini, suggested calling a psychosomatic condition she had observed among American tourists in Florentine museums the Stendhal syndrome. Such emotions were presumably more contained prior to the Revolution. It was almost as if one had to await this era to see works of art properly, as if the world of art had to become a sort of lost paradise for it to fascinate to such a degree. The story goes that Joséphine de Beauharnais, Napoleon's first wife, swooned for hours on end in Alexandre Lenoir's Musée des Monuments Français, where the vestiges of the Gothic and Renaissance monuments that had survived the revolution were assembled under the Directory. One cannot be sure that art sparked such emotion before the nineteenth century, but it certainly never did again.

Joséphine's tastes tended toward art that played upon France's mysterious past and was fed by the desire to revisit it. In the museum's garden, amid sobs and sighs, a neo-Gothic sensibility was being unveiled. England, too, was experiencing an intense fascination for her past as early as the eighteenth century, with the Gothic Revival in Oxford, but it was not until the mid-nineteenth century that this fashion became a phenomenon throughout Europe. John Ruskin, the English gentleman who introduced Proust to Italian art, began a series of iconic publications. *The Bible of Amiens* (1855), translated into French by Proust in 1904, *Pre-Raphaelitism* (1851), and *The Stones of Venice* (1853) are among his most beautiful writings. Like Stendhal, Ruskin was a great traveler. Witness his travel writings, in which he relates his experiences in a way that beautifully captures

his sensibility by illuminating it with an extremely refined expertise. In the nineteenth century, the spread of the railway allowed a greater number of women to travel. British and American female intellectuals from Edith Wharton to Virginia Woolf and Violet Trefusis began their Grand Tour at the National Gallery in London and completed it in Tuscany, Ruskin in hand. They settled in splendid villas, sometimes permanently. Our taste for the Italian primitives, the hard-to-identify painters who preceded Raphael, originated at this time. And it was through a desire to recognize them that the flowering of a science took shape at the same time as the new romantic sensibility—the science of attribution.

The history of Eyes and Stendhal's history of art began after Napoleon's Italian campaign, both linked to the deep regard for Italy's national heritage of two patriots. Giovanni Morelli (1816–1891) and Giovanni Battista Cavalcaselle (1819–1897) were the very first Eyes in the history of art. They undertook to exhume the country's past for the benefit of their countrymen. They were born into an Italy still reeling from the triumphant march of the French army, which carried with it tremendous hope and proclaimed a liberation they strove to pursue with intellectual and political activities. At the battles of Arcole and Marengo, it might be said that the very sound of the French armies as they marched brought down Venice—*La Serenissima*—the papacy, and all those antiquated powers that had kept their populations in a state of ignorance. Until then, the average inhabitant of the Italian peninsula would pass a Giovanni Bellini or a Piero della Francesca without so much as lifting their eyes. Morelli

and Cavalcaselle, filled with the ideas from the Revolution, insisted that the art that surrounded them could be used for the aesthetic and moral education of their fellow citizens and instill a pride that could potentially help rid them of the Austrian yoke stifling their independence. Having only read Vasari and Lanzi, they set about roaming Italy, buffeted by the political events shaking the country, with simple notebooks, making drawings and building a collection of sketches to systematically describe the artworks of Italy's past. Morelli and Cavalcaselle were the first to attempt a thorough history of art from within, not from the point of view of the one who experiences but the one who creates.

Giovanni Morelli was a singular character who portrayed himself as a barbarian from the Tartar steppe. He was a romantic figure who would read while smoking a hookah and had a particular fondness for Bavarian cuisine and Pschorr beer. He had the brilliant idea to rely on the concept of comparison, the *paragone*—between one type of art and another, for example, or between one artist and another—and apply it to details of the paintings themselves and thereby perfect a system of attribution. Morelli identified and classified the different ways of painting hands, ears, hair, and used that information to determine individual styles. This technique, which was remarkably innovative, is now sometimes mocked and jeered as "Morellianism." Relying on the movements of the human body, the shape of faces, colors and arrangement of draperies in order to recognize the creator of a work of art is, some say, a superficial way to approach a creator of genius. The traditional art historian has reservations about Morelli's

clinical scrutiny, who, not by chance, did not study philoso-
phy, painting, or history, but instead focused on medicine at
the university in Munich. Our discovery of the *Christ* in Nice
was a case of pure Morellianism.

Cavalcaselle took up Morelli's methods as a basis for
a study of the general history of art. His project was more
ambitious, though possibly less ingenious than Morelli's. The
latter had written a single book, published in German under
the pseudonym Ivan Lermolieff, a dialogue on the great
Italian masters (*Die Werke italienischer Meister*) in which he
outlines his methods and furnishes a series of attributions to
works located at the Galleria Borghese in Rome and other
exalted places in Dresden and Berlin, while Giovanni Bat-
tista Cavalcaselle had, with a wide-ranging ambition, written
many more than his counterpart. But he never quite managed
to hoist himself up to Morelli's intellectual level. Here is what
Morelli wrote to his friend Henri Layard, who had sent him
Cavalcaselle's *A New History of Painting in Italy*, written in
collaboration with his friend Joseph Archer Crowe and pub-
lished in five volumes in London between 1864 and 1871:
"He has a very practiced eye, the best I know, his studies on
the technical side of art are rich and deep, but I say he has not
understood the inner life of art." Morelli's scientific scrutiny
of the stylistic features of paintings clearly was not without
a spiritual element. Reading between the lines, Morelli's
critique of Cavalcaselle was that he lacked intellectual imag-
ination and was overly clinical. In the end, the connection
that historian Carlo Ginzburg made between Morelli and
Sigmund Freud in *Clues, Myths, and the Historical Method* is

based upon the fact that both were extraordinary scientists, the inventors of avant-garde methodologies that were often called into question despite their considerable descriptive powers.

Cavalcaselle was a more basic historian. His political activity during the insurrections that tore Italy apart in 1848 forced him into exile. Joseph Arthur Crowe, the son of a famous English historian who, having trained as a painter in France, lent his talents as illustrator and contributor to English liberal newspapers, shared modest rooms with him in London. Their first meeting, which took place in a mail coach in Germany, led to one of the most fruitful collaborations in art history. Cavalcaselle and Crowe began a series of revolutionary books, the first of which, *The Early Flemish Painters*, published in 1857, devoted a large section to attribution; it was drafted almost entirely according to notes they had taken and never mentions a work they had not seen in person. These publications rapidly became reference works. Baedeker, the great travel guide of the nineteenth century, brainchild of a small bookseller in Leipzig, and soon translated into all the main languages of the continent, drew freely from their writings on Flemish and Italian art, as well as their biographies of Titian and Raphael. Historians drawing up museum catalogues did likewise. Crowe himself took up the task of writing the catalogue of the National Gallery in London. This was Morelli's legacy. Thanks to the application of his method, museums soon became the training ground for all Eyes, attributions obtained by his method being almost as reliable as those documented on site in churches and great his-

torical residences. The last decades of the nineteenth century saw a frenetic slew of attributions on the back of new discoveries. Picture labels everywhere were called into question. The publication of exhibition catalogues followed one another in a frenzy, and each country boasted of its own cataloguers. This allowed a surge in works of a more purely theoretical nature, with the newly revised view of artists leading to fresh critical judgments. Amid such aesthetic and intellectual ferment there arose a unique figure, that of Bernard Berenson.

· FOUR ·

Our Holy Trinity:
Berenson, Longhi, and Zeri

B ernard Berenson really is a special case. Unlike his predecessors, he didn't come from the bourgeoisie but was the son of immigrants who were total strangers to the educated art world. His father, Albert Valvrojenski, a Lithuanian Jew who decided to leave his country for America in 1875, settled in Boston with his family when his son was ten years old. He then changed the family name to Berenson, and before long, young Bernard was frequenting the upper echelons of New England society. Having studied at Boston Latin School, he attended the recently created art history course at Harvard. Berenson remained grateful to the university throughout his life for the opportunities it afforded him. He bequeathed his entire collection and his entire fortune to it, and his own villa, called I Tatti, became the university's center of research for all academic work involving the Renaissance. Although I never knew him myself, since he died the year I was born, I have known people who knew him. They themselves, who had met neither Cavalcaselle nor Morelli,

had known people who had, for I am, after all, a member of only the fifth generation of Eyes. I was fortunate enough to have received a research grant from Harvard at Villa I Tatti for work that I will have occasion to mention again; I therefore owe him much.

Bernard Berenson is the true father of the modern Eye. Thanks to him, the discipline is not merely a matter of erudition. An Eye no longer just studies texts, developing new methods or amassing data, but is an expert at the crossroads of knowledge, commissioned by museums and universities, and increasingly solicited by the art market. He is also not a disinterested scholar as exemplified by Morelli or Cavalcaselle. He earns a living, but also contributes to the creation of remarkable collections.

Berenson presented the intellectual world with the image of the great aesthete who always dressed elegantly, straw hats in summer, fedoras in winter, and whose suits were dark or light according to the season. He seemed to have walked straight out of a Henry James novel. His small, white, pointed beard was a powerful reminder of Sigmund Freud's. Thanks to the kindness of Isabella Stewart Gardner, an eccentric American who fascinated Boston society, he was able to secure financial support for a trip to Europe, an educational necessity for Americans of social standing at the end of the nineteenth century. Just as English gentlemen were expected to make their Grand Tour of Italy in the eighteenth century, an American had to become acquainted with the Old Continent. As an admirer of Flaubert's *Salammbô* and Huysmans's *Against Nature*, he set off with the intention of becoming a

man of letters. His conversion to Catholicism, the church he felt an early attraction to, brought him close to the generation of French decadents who were interspersed with converts and prodigal returns to the faith of their ancestors. The villa's French library, entirely devoted to nineteenth-century French literature, still bears witness to this association. When Jean-Paul Richter, his tutor in art history at Oxford University, advised him to read Morelli, he set off on a path that was to change his life irrevocably; he met Cavalcaselle in 1889 and a year later, Morelli himself. Berenson then settled—permanently, it would turn out—in Florence and devoted himself to the history of art, taking with him his companion Mary Whitehall Smith. She was the wife of an art historian Berenson had visited in England; he had evidently received a very warm welcome. Whitehall Smith's husband, for reasons of propriety, refused her a divorce for many years, which forced her to employ the pseudonym Mary Logan, under which she wrote her own books, as well as becoming known as the meticulous and irreplaceable secretary to Berenson. During the years that followed their arrival in Italy, they served as guides to wealthy American tourists sent by Gardner, which gave Berenson the opportunity to travel all over the country and see works of art in their places of origin. In 1894, the year of his first book, he recommended that Gardner buy a small Botticelli, which can still be seen at the museum in Boston containing her collection. This museum is an unusual edifice, built in the Gothic Revival style, blending snippets of Venetian palaces with medieval cathedral gables, and Louis XIII salons with Orientalist ones—the jewel box where she

kept some seventy works, mostly acquired on Berenson's advice. The reputation of his eye grew with the publications and acquisitions that followed. In 1905, a year before the start of one the most fraught relationships in the history of art, with British art dealer Joseph Duveen, he was able to purchase Villa I Tatti, located on the left bank of the Arno at Settignano and that he had been renting.

At the time that Bernard Berenson settled in Florence, the United States was assiduously turning its gaze toward Italy. The Metropolitan Museum in New York and the Museum of Fine Arts in Boston, which had just opened, were in a full flow of acquisition, while the two great American universities, Yale and Harvard, were each beginning their own museum collections. Professors pushed the institutions to purchase art, and wealthy private citizens felt the need to amass collections of their own to proclaim their social success. These collections would be donated partly or in full to their city's museum of fine art or the university where they had studied, representing the rise of a generation that had emerged from an immigrant population. These new buyers led the traditional art market, based in London, to seek experts able to authenticate paintings and assess their value. Until then, buyers tended to be English connoisseurs who sought to furnish their stately homes with fine works of art. The Americans, whether from a desire for status or a lack of education, were more interested in purchasing names than works of art. Attribution was considered more important than the intrinsic value of their acquisition. Even today I wonder if certain purchasers really see what it is that I authenticate for them. I have reached

the fairly simple conclusion that they don't see much at all beyond their displays of wealth and social prestige. There was a growing temptation to connect mediocre pieces to Old Masters, and even pass off fake ones as authentic. The desire to dissemble was born along with this, and Eyes were thus able to make their first appearance on the art market. Until then, the big eighteenth-century English auction houses, Christie's and Sotheby's, and the Hôtel Drouot in Paris, which opened in 1852, only called on the expertise of auctioneers to prepare their sales. In exceptional cases they would use artists as advisors, thereby continuing the tradition of the inventories of cardinals and princes, whose contents were often determined by painters. But the enormous number of transactions, combined with the explosion of forgeries, required the appearance of a new kind of adviser, caught between a collusion of artistic taste and the interests of unprecedented amounts of money. It was an opportunity for men of Berenson's talent. And so it was that Lord Joseph Duveen recruited him. This English art dealer of Dutch Jewish origins, who had grasped the fact that American wealth was able to buy up the heritage of impoverished noble European families, was in the habit of stating that "Europe has a great deal of art, and America has a great deal of money." Throughout the first half of the twentieth century, he constantly opened new galleries to furnish the great American magnates with art: the Fricks, Hearsts, Morgans, Rockefellers, and Andrew Mellon. His philanthropy—including donating funds for the gallery to house the Elgin Marbles at the British Museum in London— earned him the title of First Baron Duveen of Millbank in

1933. At the time that he called on Berenson, the latter was so renowned for his publications and decisive contributions to collections that securing his services amounted to granting him a blank check.

As a former fellow of I Tatti, I must say something on the subject of Berenson's honesty, which some have questioned due to his earning an enormous fortune through the sale of Europe's heritage to buyers from across the sea. It is true that a few forgeries were discovered among the paintings he authenticated, some in the collection of Gardner herself, but the most serious misgiving to beset Berenson's work may safely be rejected. Berenson himself had been a victim of forgers. Among his Sienese and Florentine paintings of the fourteenth and fifteenth centuries, schools of which he was a devotee, are certain works whose authenticity is doubtful. There is a particular fifteenth-century painting in the style of Botticelli, about which I find myself at a loss to understand his mistake. To modern eyes, such errors seem egregious, though in fact they ought simply to remind us that no Eye, however exalted, is infallible. What's more, expertise has increased immeasurably since his time. While this doesn't entirely exonerate him, all the forgers of the era tested their skills on him. If their fakes were not unmasked, they could consider themselves decent forgers. The real question to ask is about his relationship with dealers. Berenson kept such close ties with them that unscrupulousness could be suggested, but in fact we should conclude that he guided them well since he helped create some of the greatest collections. How much were the paintings valued at? Did Berenson receive commis-

sions that were too high? None of this really matters all that much anymore. The Gardner collection, just like the John G. Johnson collection at the Philadelphia Museum of Art and the Henry Walters collection at the heart of the Walters Art Museum in Baltimore, attest to exceptional good taste, and each contain several undisputed masterpieces that would be impossible to purchase nowadays without an enormous fortune. The collections have all benefited from Berenson. All that remains to say is that Berenson is the key to understanding the vocation and paradoxes of being an Eye: for the first time in history, Morelli and Cavalcaselle's techniques allowed a man to make large profits, albeit at the risk of overshadowing his true role of expert.

For Berenson was a remarkable, though atypical, art historian, one of the greatest across the board. From his first years in Florence to the end of his life, he never ceased to observe works of art in churches or museums, and always availed himself of the very latest methods of reproducing them. He didn't use his notebooks to make sketches, as his predecessors did, but would note the impressions that a piece made on him before approaching the administrator of the museum or gallery in question to obtain photographs. In this manner, he assembled one of the oldest and most ample picture libraries ever created. Berenson would work on the photos, noting more or less precise attributions in his big, loose handwriting on the backs—"Early Botticelli," "Sano Di Pietro" or simply "Venetian School"—before classifying them according to an elaborate and ever-evolving system whose main constant was that of complexity. He organized photographs into cat-

egories, which he further subdivided until assigning them to individual artists. He didn't hesitate, in arranging and rearranging, to rely more on intuition than certainty, as the annotations attest. To this day, when an art historian wishes to consult Berenson on a work that he has never conclusively attributed, he can go to the villa and observe how the relevant pictures in Berenson's picture library are arranged, something he rarely fails to do. The art historian can thereby see the final arrangement of the photography resulting from the work of Berenson's lively and shifting imagination.

A few decades before the beginning of Berenson's work, in 1860, the German art historian Johann David Passavant created the first ever catalogue raisonné in the history of art, devoted to Raphael. This new kind of work arose from an ambition of clarifying the details about an artist's oeuvre since the number of attributed works was manifestly too high, and it was necessary to make distinctions among works whose authorship was beyond question, those that the expert thought to be attributed to Raphael, and those he rejected. The catalogue raisonné was divided into three sections corresponding to the three choices of attribution, and each entry was carefully argued. Berenson's works pushed the logic of the clarification even further, taking the form of simple lists of pieces attributed to a series of artists of the same school in alphabetical order. Each entry contained only a list of titles and their state of conservation, *E* for Early, *L* for Late. It was, if you will, an enormous *unreasoned* catalogue, the whole principle resting on Berenson's authority alone. Without the need to justify anything, he was able to encompass

a far larger body of work than if he had been constrained by the customary procedures of cataloguing. Every Eye I know can't help looking upon this time as the golden age of the discipline. After having seen what I needed to in a piece, I have often asked myself what the point is of seeking out further reasoning and justification for relying on my intuition. How simple it would be to merely give an answer. Pairs of pictures, if grouped correctly, are generally recognizable immediately. This is why no real Eye could do other than envy Berenson. He wrote what we all wish we could have written: "I am telling you, believe me." This did not stop Berenson from writing a monograph on Lorenzo Lotto, an unusual Venetian painter who was not yet recognized as the genius he was. *Lorenzo Lotto: An Essay in Constructive Art Criticism* (1894) is a manifesto by the father of connoisseurship, overtly based on Morellian principles, but intimately linked to history.

The lists were compiled into as many volumes as there were schools in Italy, according to Berenson's criteria. The first volume, to which he owes his glory, was *Venetian Painters of the Renaissance, with an Index to Their Works* (1894), published at the same time as his consort Mary Logan's own first book, *Guide to the Italian Painters at Hampton Court, with Short Studies on the Artists*. A comparison of the two books convincingly leads one to the conclusion that she played a large part in editing Berenson's. Thereafter, and always with her aid, Berenson wrote *Florentine Painters of the Renaissance* (1896), *Central Italian Painters of the Renaissance* (1897), and finally *North Italian Painters of the Renaissance* (1907). Later on, Berenson revisited the books and altered certain

propositions. Thus, *Central Italian Painters* was revised three times, in 1903, 1909, and 1918. It was in 1932 that Berenson summed up all his work and republished it, minus certain lesser artists, in his great work *Italian Painters of the Renaissance: A list of the principal artists and their works, with an index of places.* This was the first book about the history of art in English to be translated into French and Italian. *The Drawings of the Florentine Painters* (1938), another quite remarkable summation in three volumes, was only translated into Italian. It tackles a tricky subject, drawing, in a quite exceptional way, a subject that in my view any real connoisseur should be as well versed in as painting. And yet if his illustrious predecessors or his most important successors knew their way around the world of pictorial creation, unlike him, they never thought, or think, of taking on drawing. Berenson, thanks to his extraordinary sensitivity, at a time when there really wasn't an established method of studying them, managed to make ingenious connections between drawings, to identify categories and sub-categories amid the teeming stock of Italian works in the Uffizi Gallery. His relationship with dealers also allowed him to benefit from privileged access to a great many other items in collections in England, America, and the rest of the world. I must say that although I was trained according to the art historical methods of Roberto Longhi, I feel very close indeed to Berenson, with whom I share a proclivity for drawing.

Berenson, despite his characteristic gravity, was the opposite of the bookish intellectual. He was a man of the senses and of sensibility. He established one of the finest

libraries of the discipline, which represents a second bequest of value to our science. The field of the history of art was in full bloom during this time and every year saw the appearance of numerous publications in France, England, and Italy that he acquired systematically. He received art history journals, like the *Gazette des Beaux-Arts*, which was created in 1859 under Napoleon III and contained texts accompanying engraved reproductions of works of art a few years before the invention of the printed photographic reproduction. There was also a whole series of very scientific Italian journals concerning the systematic cataloguing of archives, a typical nineteenth-century practice. Works were published with supporting documentation, all amounting to a true aggregation of knowledge. But there still wasn't a publication that dealt with the real principles of connoisseurship, a discipline that would fall upon Berenson to found.

Connoisseurship, until Berenson, signified the competence of one who could settle controversies in the fine arts, and more widely, in any question relating to good taste, including gastronomy. This word, with its French consonance, was used in a somewhat ironic way in eighteenth-century British circles. The connoisseur was blessed with prestige, but his knowledge had something mysterious, perhaps something uncertain about it. Indiscreet souls, who might struggle to follow him, might be tempted to accuse the connoisseur of being a charlatan. Berenson took up this idea for the magazine that he founded with his friends Roger Fry and Herbert Horne, *The Burlington Magazine for Connoisseurs* (1903). The term designated the aptitude to for-

mulate judgments of taste, but also Berenson's own talent to identify masters. This ambiguity was based on the idea that a painter was characterized by a je ne sais quoi, a barely discernable element that amounted somehow to beauty. This word, encompassing positivism and aestheticism, appealed to Berenson's dandy temperament. Hence the principle of a science based on lists, which would remove him from the lot of the common scientist, trapped by argument, and endow him with the grace of a genius. The magazine emphasized the importance of the composition of groups of paintings, of reattribution, and all the canonical gestures of connoisseurship from which today's Eyes emerged. Berenson published an article in the magazine on thirteenth- and fourteenth-century Siena that remains authoritative. But the magazine did not restrict itself to this scientific aspect. Roger Fry, the brilliant member of the Bloomsbury Group to whom Virginia Woolf devoted a biography, lent *The Burlington Magazine* a more literary quality. His audacious reports complemented Berenson's meticulous work.

The eclectic collection of works of art assembled by Berenson with its very assured sense of taste can still be seen in his villa, which is partially open to the public. All the Italian schools are represented, not just the Sienese and Florentine ones that were fashionable at the time. As befits his inclinations, many primitives are displayed there as well as a few paintings of the seventeenth and eighteenth centuries, which only really interested him as part of the furnishings. One can see superb French decorative pieces of the eighteenth century, Italian tables and chairs of the seventeenth

next to other objects that enthused him, including examples of oriental art: Indian statuettes, Japanese bronzes, Chinese porcelain. The way these objects are displayed show his particular affection for them. He owned at least two undisputed masterpieces: the central portion of an altarpiece by Stefano di Giovanni, the famous Sienese painter of the fifteenth century—the other parts of which are at the National Gallery in London, the Louvre, the Musée Condé in Chantilly—and a *Madonna and Child* by Domenico Veneziano, a very curious painting with a metallic tone, in which the figure of the Virgin stands out before a brocaded background, a typical example of the art that arose at the crossroads of the schools of Florence and Central Italy, in the tradition of the *Pittura di Luce* in which Piero della Francesca excelled. Whether by chance or cunning design, John Singer Sargent's *Portrait of Isabella Stewart Gardner* echoes the Domenico Veneziano by placing the subject before a similarly red and gold backdrop that serves as her halo.

When Berenson died in 1959, his secretary undertook to republish revised versions of his four great lists accompanied by photographs from the I Tatti library in order to disseminate the material. Throughout his life, intellectuals and figures from the art and business worlds had frequented his residence. According to his wishes, his entire estate was bequeathed to Harvard University, which remains its custodian today. With the picture library, books, his personal collection, and the house with its fine renaissance garden, it is perhaps this place that brings us closest to the man. His portrait would not be complete without mentioning his passion

for gardens, and this villa, its architecture and surroundings, allows us to understand the exceptional character of its erstwhile owner.

English speakers who, like Berenson, decided to settle in Italy at the turn of the twentieth century were not scarce. They would live sumptuously in seventeenth- or eighteenth-century villas perched on hillsides in picturesque surroundings, like the iconic property formerly inhabited by Galileo where Violet Trefusis would receive guests under the title of the Lady of Ombrellino. The gardens of these large dwellings were then transformed. Berenson's house, which at first did not compare with these ambitious residences, soon became a genuine villa thanks to the numerous additions of loggias in pietra serena and large rooms for his library, and the size of the garden that recalls that of the Villa d'Este at Tivoli, instead of a true Florentine garden. Fountains, hedges, an orangery, an avenue of cypresses, the whole dream image of Italy is there. Outside of a few stage-managed vistas, nature has been respected and left alone. Lila Acheson Wallace, an American famous for her fortune and fondness for flowers, to whom we owe the bouquets in the Great Hall of the Metropolitan Museum of Art in New York and the restoration of Giverny, left a considerable sum to Harvard for the upkeep of I Tatti's gardens, where each year bulbs are studiously planted in the beds and meadows of the villa so that when spring comes, they explode into spectacular bloom in a manner that would seem chaotic if not so minutely researched, forming a veritable little impressionist garden where nature is given undaunted reign. Bees hum, recalling the master of the house, who with

his initials and a little conceit, designed its coat of arms: a red bee on a white background with the intertwined letters *B. B.* on the upper part of the escutcheon. Berenson eventually expanded I Tatti's borders into the neighboring land, taking in vineyards, olive groves, and meadows to become an ideal and idealistic working farm where members of its community are expected to eat, harvest, and assist in pressing the olive oil, in order to perpetuate the spirit with which Berenson himself inhabited the land. Today it would be possible to get the impression that the art of the garden was his real passion, his other great preoccupation, from which he didn't profit, but which earned him many friends and associates. He made many trips across Europe for it, and the aristocratic arts patron Charles de Noailles, who created a superb garden at his villa in Grasse, was among the regular visitors to I Tatti. I think I must underline this particular sensibility that allowed Berenson to "live his garden." A connoisseur must be able to enter into the life of a painting, and if he were merely to see it as a picture, were he not so sensitive, he would be unable to understand it. Paintings are material objects, just like the material impressions aroused by an exuberant garden bursting with flowers, insects, heat, the flow of water, and the droning of insects.

Is there a certain irony in this? The villa was not turned into a school of connoisseurship, despite the great man's legacy. If Eyes, very fortunately, are welcome there, there are very few in evidence, and after a generation of great art historians, the American tradition of connoisseurship has vanished. It is as if Harvard rejected the very essence of the activity that

made Berenson famous and recast the institution as more respectably intellectual. Now it is mostly researchers specializing in the Renaissance and the confluence of musicology, literary history, history of art, and traditional history who go there, and there is a sense of pedantry profoundly at odds with the spirit of its founder, which can only really be explained by the fact that I Tatti considers attribution to be its original sin. The discipline of being an Eye is no longer taught there. During the year I spent there in 1998 and 1999 with Carlo Falciani, the only other representative of Berenson's legacy, we were able to introduce our colleagues to the rudiments of the founder's art. Even then, we were less in demand for our eye than for our teaching of the sixteenth century, which owed more to Roberto Longhi, Berenson's greatest rival, than to Berenson himself.

By happy accident, or by a judiciously pretentious streak, the art historian in whose house I studied under Mina Gregori acquired his home directly opposite his American colleague's, on the left bank of the Arno river where he spent a large part of his life, having long held a chair in history of art at Florence University. Like his rival, he turned the building into a villa, the Villa Il Tasso, along eighteenth-century lines, and it now houses the prestigious Longhi Foundation. In his youth, Longhi cut a figure you could deem Italian. Despite a prominent nose, he had rather fine features, slicked-back hair, a small moustache and very often a cigarette in his mouth. Like Berenson, Longhi had an exceptionally gifted eye, at home in all Italian art from the thirteenth century to his own era. He had no taste for avant-garde futurism or modernism, but was

a staunch defender of realist painting from between the wars, in particular that of Giorgio Morandi, the great dreamlike realist whose landscapes and still lifes breathe impenetrable significance. In opposition to his sensual colleague, Longhi was metaphysical. The thing that probably united them most was that neither was progressive. Longhi's sympathy for fascism, which he doubtlessly perceived as a movement for Italy's renewal, got him into quite a scandal after the Second World War when he was publicly taken to task for his proximity to several dignitaries of the Mussolini regime.

He was an Eye, but also a genuine innovator, a connoisseur of art who, like Morelli, had a grasp of the intimate, whereas one might be tempted to associate Berenson more with Cavalcaselle. Roberto Longhi was very close to the literary milieu of the university, and his wife, Anna Banti, was a remarkable writer, as her beautiful book *La camicia bruciata* demonstrates. Longhi himself was a writer with a magnificent command of language, challenging but superb, with ornate prose and neologisms that required a glossary. For this reason, he would never have been content to publish lists of paintings. They had to be elucidated with intelligence. Thanks to his extraordinary and original sensibility, Longhi was able to attract attention to painters that had been forgotten in their own era but were now universally admired, like Caravaggio, the School of Ferrara, or Piero della Francesca, to whom he devoted foundational texts.

Between the wars, Roberto Longhi was linked to Alessandro Contini-Bonacossi, one of the biggest art dealers at the time, who sold Italian works of art to wealthy American

industrialists and was the personal supplier to Samuel Henry Kress. After several years working in stone quarries, Kress had the idea of opening a chain of five-and-dime stores with his brother. The concept was to sell small items whose price would not exceed five or ten cents. In a few years, the Kress brothers, embodiments of the American dream, had amassed one of the biggest fortunes in the United States, and each year Samuel would invariably undertake a tour of Europe, starting at Baden-Baden, where he would take the waters, followed by a different artistic Italian town every time, driving there in his Rolls-Royce. With the audacity that successful art dealers seem to have in common, Contini-Bonacossi took an adjoining cabin on the ship that transported Kress to Europe on three occasions, hoping his charm would do the rest ... and it did: with the complicity of Kress's lady companion, who was to receive a Bulgari jewel every time he closed a deal, Contini-Bonacossi succeeded in selling a first batch of paintings to the wealthy American. The prices he asked were very high but the paintings very fine, and no fakes ever slipped in among the pieces he proposed. Naturally, Longhi, who authenticated or attributed the pieces, was the recipient of substantial commissions. Between 1930 and 1940, the Kress collection become enormous. Some of the paintings sold by Longhi and Contini-Bonacossi were displayed in the art museums of the cities where the main five-and-dimes were located. Others were bequeathed to churches and universities near the major branches. The Kress donation to the National Gallery of Art in Washington in 1941 was the largest ever made to the institution and constitutes its heart, alongside

the Mellon and Widener bequests, two other collectors of similar caliber. Contini-Bonacossi was from a Jewish family, originally from Ancône in southern France, and he was later ennobled as a count by the king of Italy. He liked to tell the story that he owed his fortune to the generosity of a priest who gave a valuable stamp collection to his first wife, Vittoria, at the time when she was running a gentlemen's outfitter in Milan. One may be forgiven for casting doubt on this charming anecdote, given the sheer size of his subsequent financial success. But with the help of Roberto Longhi, he contributed to the enrichment of American public and private collections even more than the diabolical duo of Berenson and the "Baron of Millbank." The foothold Roberto Longhi had at the university never prevented him from benefiting from commissions on the sales of paintings, and he even used his leverage with the authorities to extract many masterpieces from princely Italian collections and send them to the United States. Contini-Bonacossi and Longhi also no doubt aided certain dignitaries of the time to obtain stolen works, hide them during the war, sell them for their own benefit, and protect them when it was all over. Certainly not all has been said on that subject, and I leave it to the younger generation to shed light on it. As for older art historians like me who owe much to Longhi, we prefer to concentrate on the enormous quality of his scholarly contributions.

Roberto Longhi's writings, unlike those of Berenson, were always mindful of historicity. Longhi always shows the moral issues in Caravaggio's work, relating chiaroscuro and the grotesque to a loss of reality, while actually, this painter of

poverty, filth, and misery is replete with realism. Longhi simply demonstrated that this was a spiritual realism. Caravaggio didn't despise nature but felt the need to represent an inner nature from which emanated a metaphysical breath, just like Morandi's still lifes that Longhi also championed. Longhi had understood that Caravaggio was one of the artists who most pushed back against corruption and debasement. The painter died on a beach, murdered by a young man to whom his attentions were too ardent, like Pier Paolo Pasolini some three hundred and fifty years later. The renowned Italian film director had attended Roberto Longhi's lectures on his favorite painters at the University of Bologna and even devised a thesis devoted to contemporary Italian art under his direction, but only completed a few chapters.

It has always seemed to me that as a result of Longhi, Caravaggio's painting was fully illuminated. His inimitable style, the works he left us are all perfectly described thanks to the texts Longhi published. However, this work has so increased the market value of the artist, whose paintings are valued at between eighty and one hundred twenty million dollars, that we are now witnessing a surge of misattributions that mix copies and studio works with the established oeuvre. In the current sales catalogues, I no longer see the Caravaggio as explained to us by Mina Gregori in Naples in 1985, in the huge Museo di Capodimonte, backed up with her red pointer, in front of paintings that she had spent nine years studying under the direction of Longhi. Since then however, even she has not refrained from adding to the hype that has so obfuscated her painter.

The rigor of Longhi's method led to his founding the most lasting school for Eyes there has ever been. After a year studying at the Longhi Foundation, students find themselves the beneficiaries of a remarkable scientific tradition, which begs to be further perpetuated. In France, where his first disciples introduced his method of instructing students, the École du Louvre has yielded concrete results. That his history of art has managed to embed itself so deeply in institutions is because, while it recognizes the place of attribution, it isn't "attributionist." Longhian art historians do research and explore archives, produce catalogues raisonnés and comparative studies on painting and all the arts with which it might enter into dialogue: literature, music, or sculpture. Longhians have generally undertaken one or more biographies of artists and attempted to better place them within their period, to make sense of their oeuvre in the eyes of history. The work I did with Anne Fabre, for example, could not have been undertaken if we hadn't read Castiglione's *The Book of the Courtier* and other works of that period that were less well known but indispensable to the placing of works in perspective within a system. Similarly, without a sense of the historical reality of the sixteenth century, and the state of Florentine bourgeoisie at the time, I would never have been able to identify Bronzino's *Christ*. Roberto Longhi's journal, *Paragone*, carries the imprint of his method. If Berenson's *Burlington Magazine* illustrated all the principles of connoisseurship, *Paragone* espouses a much more general program of intellectual investigation that one could call cultural. Its title takes up an old trope in the history of art—that of compar-

ison—and invests it with a new meaning; it categorizes the publication according to color, *Paragone* Literature in blue and *Paragone* Art in orange. The confrontation or comparison was originally an elevated critical discussion between artists of different disciplines. Its first embodiment goes back to the fourteenth century with the debate between the Sienese painter Simone Martini, then in service to the Avignon papacy, and the poet Petrarch, author of *Il Canzoniere* and the *Sonnets for Laura*. The painter had produced a portrait of the poet and his beloved at the latter's request. In thanks, the poet then used the portrait to argue that poetry was superior to painting, for despite all his talents, Simone Martini was not able to imbue his subjects with life. This quarrel hung over painters throughout the fourteenth and fifteenth centuries until it finally found an answer in the shape of the *Mona Lisa*, a painting which, to this day, deserves all its plaudits for one precise reason. Thanks to Leonardo's genius, it was the first portrait to have been suffused with life. The painter had the idea to have his model smile. Thus ended the first *paragone*, which found echoes later in history in words as famous as Napoleon's, for whom "a fine sketch is worth more than a good speech." Benedetto Varchi introduced the *paragone* in a second form. This fascinating republican figure of the sixteenth century left Florence for Venice upon the accession of the Medici but, despite his aversion to the city's monarchic regime, returned to his original home after the founding of the literary academy ordered by the young Duke Cosimo. Between 1547 and 1548, he interviewed Florentine artists to find out which discipline, painting or sculpture,

could be considered superior. Most artists batted for their own side, but the great painter Pontormo extolled the qualities of both, and affirmed that if one thing counted above all, it was drawing. Michelangelo, for whom this *paragone* could have been invented, having the reputation of being as great a painter as a sculptor, pushed the mischief yet further by declaring that the thing that counted above all was the idea. It fell to him to resolve the debate. Michelangelo put an end to it, declaring that the role of drawing, as he was fond of saying, was to express an idea. Pontormo, following him in insisting on the supreme dignity of drawing in the *paragone* of the fine arts, echoed this view. With Longhi, the term *paragone* found its third meaning, in a critical sense, no longer as a confrontation between different disciplines but as method of general intellectual investigation. The journal's subtitle, *rivista mensile di arte figurative e letteratura* (monthly magazine of figurative art and literature), implies the application of critical comparison across the board: of one discipline with another, one artist with another, an artist's works or a school or an oeuvre delineated between themselves to permit knowledge to arise. Morelli's comparative method, concentrating on detail, is here enlarged into a general approach of the Eye, as attentive to an artist's oeuvre as to his thoughts and vital intellectual status.

Longhi's foundation, unlike Berenson's, remained focused on art history, bolstering the tradition of connoisseurship and the training of the eye in the task of attribution. Thanks to its solid foundations, the various chairs in the history of art at Italian universities were held by his closest

disciples. Upon his death, a rift among his pupils weakened the bonds of solidarity of this network. The new generation of art historians—there have been two generations between Longhi himself and us—has attempted to heal these wounds, but they were deep. We live in peace now, but we must never forget that Longhians with their lust for power have shown themselves to be implacable. Federico Zeri (1921–1998), a contemporary of the first generation of Longhi's art historians and the most flamboyant of the Eyes to succeed him, was repudiated by his teacher and inhabited a marginal position at the university until he died. It is to this fascinating figure I now turn.

At the time I arrived in Italy, Federico Zeri was a kind of sacred monster. Going to meet him represented the culmination of my training. He was eccentric, but astonishingly erudite. To students, he represented the best opportunity to further their research, most notably thanks to his taste for investigating marginal areas of art history. I didn't dare approach him throughout my first year. He wrote a thesis on Jacopino del Conte, a minor Florentine painter, student of Andrea del Sarto, at the University of Rome during 1943 and 1944, under Pietro Toesca. He belonged to a class of Eye fascinated by the minor masters, for whom it is imperative to mix the resources of local erudition in the great tradition of art history. Jacopino del Conte was the successor of a generation of Florentine masters exemplified by Andrea del Sarto, Pontormo, Bronzino, and Bandinelli in the first half of the sixteenth century. Vasari speaks of him as a fine portraitist.

Zeri lived at Mentana, near Rome, and placed strict conditions upon all initial meetings. One had to call between seven and eight in the morning on a weekday, after which time he was supposed to not be at home, even though he spent a good part of the day on the telephone, humorously giving nicknames to figures of Roman high and low society from the worlds of art, politics, and business. I knew several of his secretaries who delighted in recounting his successes and misadventures. He enjoyed passing himself off as Wanda Budelai, a supposed journalist from the *Corriere di Viterbo*, a local paper from a town near Rome. One day, he called the Villa Medici to announce that Wanda Budelai would be unable to attend the private viewing of an exhibition to be held there unless the event would include a cocktail party, as nothing was mentioned on the invitation. "Professor, we haven't planned anything," replied the secretary, "but you know you are always welcome here." "Wanda non può più chiamare!" (Wanda can no longer call!), he shouted to his secretary, after hanging up the receiver. It was merely a trivial setback given the conceit he would permit himself to liven up his day.

We visited him on a spring day. We must have intrigued him already, simply by virtue of doing our research as a pair. The subject of our thesis, Florentine portraits of the sixteenth century, involved one of his own areas of interest and I think he took a shine to us. Perhaps his difficult relationship with other Italian art historians led him to show goodwill toward new blood. His house in Mentana was perched on a hillside in a rather lackluster Roman suburb.

It was a modern house in the style of the 1950s, lacking the charm of the residences of Berenson and Longhi. As an enthusiast of Greek and Latin epigraphy, Zeri had managed to decorate the facade with marbles, graffiti, and frieze fragments, a process repeated on stone monoliths in the garden. Like Longhi, he possessed a fascinating collection of objects, sculptures, and paintings. Antique busts, medieval statues, baroque furniture, and sixteenth-century tapestries lent a more Roman than Tuscan aspect to his dwelling. On the salon walls hung two large tapestries from a cartoon by Salviati representing spring and autumn in azure and pale green, then orange and purple, all interlaced with gold. He left these to the Villa Medici, seat of the French Academy in Rome. The visitor passes through hallways, stairs and corridors before arriving at the place where he meets the master: the library. Nowadays, art historians still have libraries that often cover the walls of their apartments, but generally speaking they are, like mine, somewhat small in scale. Therefore, one could not help but be impressed as you crossed Zeri's library, to be received in the final room, filled with boxes covered with green cloth containing his impressive photograph collection. Zeri knew how to put his guests at ease even before their arrival. He would first explain how to take the bus, then, once you had reached Mentana, would send his chauffeur when you phoned from a village bar, where regulars drank coffee or came to refresh themselves with a bottle of Crodino aperitif, no matter the time of day. The drive took two minutes. It was his version of coming out to meet you, for he was a corpulent man, and

suffered from gout. He greeted Anne and me warmly, and we, emboldened by our year of study, were carrying much material of which he knew yet nothing. We all sat in his picture library, where he provided a thorough commentary on the photographs, pointing out many details we hadn't noticed. We made attributions together for hours, linking documents, regrouping items, and reconstituting bodies of work. This collection of portraits interested him enormously and it proved to be a highly valuable day, for it showed us how the man worked when alone. The experience marked us so much that for months afterward we were unable to look at our portraits without Zeri's eye. At the end of the afternoon he enjoined us to come and see him regularly. Some said he was unfriendly, but every time we met later on, he would ask me how my research was proceeding.

One day, when I happened to be attending a book launch on the ground floor of the Palazzo Corsini, a splendid Baroque palace on the banks of the Arno in Florence, amid walls entirely covered with frescos, Zeri made an unusual speech in which he didn't merely praise the book, much to the chagrin of the author and publisher present. He was still as bulky and had trouble walking, likely still suffering from gout, but after his talk, a little out of breath, having spotted me in the audience, he made his way to greet me, but also no doubt to escape a woman who was about to flatter him. "Caro Costamagna!" he exclaimed, "What are you working on at the moment?"

I told him I was studying the portraits of the young Alessandro Allori for the Longhi Foundation. He listened to me

politely, then walked away gesturing at his temple and crying "La gente è pazza!" (Some people are crazy!). I didn't know what to think, and people must have seen me blush, but he admitted to me afterward that he actually found the subject very interesting. Since that day, his words have come to me often when I wish to gently chide a promising student.

Although, unlike most of Longhi's students, he never became a professor, everyone called Zeri *il professore*. After he had completed his thesis, he spent time working at the land inspectorate in Rome and was given the task of surveying and preserving its heritage. He left the position soon after. Having no experience in art history as an intellectual discipline, Zeri worked on the margins of the university. During the fifties and sixties, Zeri made the acquaintance of two colorful personalities, J. Paul Getty and Vittorio Cini. The extremely rich Italian count wished to sell some paintings that Alessandro Contini-Bonacossi, Longhi's dealer, had failed to sell to Kress. Zeri, acting as adviser, attempted to effect a sale. They succeeded in selling them to J. Paul Getty, an acquaintance of Count Cini. Zeri later sought refuge far from Italy, which at the end of the sixties had come to seem strange and depraved to him. The oil baron lived a lavish life on the West Coast of the United States and in his English castle. He built a flashy Pompeiian villa in Malibu, which now serves as one portion of his own museum, along with the Getty Center, a travertine-clad modernist complex perched on a hillside in Los Angeles.

Zeri would visit Getty once a month. Count Cini, who repaid Zeri's services meagerly, became terribly jealous of this

arrangement and convinced himself that Getty had yielded part of his oil empire to his adviser. This was quite untrue, for Getty was a miserly man who provided guests at his English manor house, Sutton Place, with coin-operated telephones. But he had an ambition to become a great collector, and caught between the desire to acquire unique pieces and the dread of being cheated, he required a right-hand man. Zeri was a very entertaining figure who enlivened the exalted social events that took place around Getty till his death in 1975. To Zeri's dismay, J. Paul Getty had left the running of his villa to another of his friends, and the collection, the creation of which he had so contributed to, escaped his control. He remained resentful, which came out during the kouros controversy, when a Greek marble statue that Zeri had always insisted was a forgery was acquired by the foundation that Getty created. Toward the end of his life, Zeri was the guest of Sydney Freedberg, a student of Berenson's at Harvard University, where, following a career on the periphery of the most respected institutions, he finally received the honors he deserved.

Despite his jeremiads, Zeri lived his life largely sheltered from material concerns. None of the lives of these three Eyes had been entirely sumptuous, but they had all tasted the charms of opulence: the receipt of substantial fees and great personal advantages. Thanks to the social whims of Count Cini and Getty's megalomania, Zeri achieved a certain affluence. Beyond this material aspect, collectors and dealers had led to his seeing an enormous amount of new art, and thereby making discoveries. He liked minor masters

and possessed the gift of grouping them. The joy he felt in attributing work to artists no one had heard of was considerable. These results were always published in very clear, readable, but extremely erudite magazines, rather than in the biographies so dear to Roberto Longhi. Zeri succeeded in identifying a very odd group of minor painters of the sixteenth century that he called the "eccentric Florentines." The series of essays he devoted to them in the *Bolletino d'arte*, an art history magazine financed by the Italian Ministry of Culture, are among my favorite endeavours in the field. Other articles were published in his magazine, *Antologia di Belli Arti*—which he founded with his friend Alvar González Palacios—and, when the time came, were collected in book form. One of his most famous books, *Diari di lavoro* (Work Journals) includes his articles on connoisseurship published in 1976. It opens with these words: "At this time of the decline of connoisseurship (so marked in the world of the university), it is not pointless to suggest once more the validity of the old attributionism." Just as Morelli had done for the Galleria Borghese in his time, Zeri catalogued art collections created by Roman princes, like those of the Galleria Spada or the Galleria Pallavicini, or American museums, like the Italian paintings at the Metropolitan Museum of Art in New York or the collection of the Walters Art Museum in Baltimore. In a nod to history, Zeri also catalogued the Morelli collection at Bergamo. It was an activity that Berenson and Longhi were much less attracted to, even though they didn't hesitate to put themselves at the service of collectors should the need arise.

Zeri turned to the English-speaking world, almost certainly because Longhi did not consider him worthy to be counted among his successors. This demonstrates two very different public characters. Longhi was attached to his country, his native land; he considered himself an Italian art historian. Zeri, on the other hand, occupied a position of detachment from Italy because he was not properly recognized by his peers. If one enjoyed the prestige of a major intellectual grappling with his time, the other had the charm of a public character who liked to make people laugh, who knew how to tell amusing anecdotes and outrageous stories, and was a charming guest on television programs. Once the media tycoon Silvio Berlusconi got involved in politics, Zeri became more acerbically polemical, worried for Italy's future. Despite this telegenic manner—he was the only Eye to really possess such a talent—it didn't matter which public or private collection he had contact with, he was always received not only as a celebrity but also as the tremendous Eye he actually was. He probably represents the last of that line of experts who is comfortable in any era of the history of art, from its beginnings to the last decade of the last millennium. When he died, his house and library were all bequeathed to the University of Bologna, the only institution to have awarded him an honorary professorship. He was the sort of person one wanted to hug—though he would have hated that—the sort of person one is delighted to have met once in one's life.

From Morelli to Zeri, Eyes have had a choppy ride through history, faced with political or commercial compro-

mises, some more problematic than others, each one making his own mark on the history of the discipline. Every aspiring Eye must deal with them and their legacy in some way. Despite the central role New York plays for the art market, it's surprising that the United States possesses no school of connoisseurship—that very English word which is used to designate the science of attribution. And yet an ephemeral branch of the discipline did develop before promptly disappearing, and there remain a few heirs. Zeri's contemporary, Sydney Freedberg (1914–1997), had submitted his thesis on Parmigianino to Berenson in 1940, and acquired a chair in history of art at Harvard upon his return from Italy. Berenson, it is often said, did not teach much, preferring to selfishly keep his gifts to himself. This is true, but there were exceptions. In the event, Freedberg, a man who possessed the unusual poise and elegance inherent to that generation of professors of the great American universities, had become, with Berenson's help, an expert on sixteenth-century Florence. His great work, *Painting of the High Renaissance in Rome and Florence*, proposed a powerful vision of Italian art. Freedberg trained many art history students at Harvard, where he specialized in connoisseurship and attribution. For the study of artists at the beginning of the sixteenth century, he assigned a series of monographs to his students that allowed them to discover their qualities as Eyes. But these specialists, each one very capable in his or her own field, limited themselves to the study of their own artist and never looked beyond. Is this a characteristic flaw of English-language scholarship? Whatever the answer, it is far removed

from the methods of Berenson, Longhi, and Zeri. It's clear that connoisseurship did not last long in New England. I Tatti no longer trains Eyes; the tradition is lost, and only a few accomplished Eyes are left in Britain and the United States, in museums for the most part.

Restored Paintings and Outright Forgeries

T raditional art historians don't recognize Eyes. They consider their work to lack intellectual rigor and to rely on the senses rather than cognition. They therefore are unaware of all that is exacting and scientific in our work. If we are able to form an opinion in a matter of seconds, it is because during our years of training we developed mechanisms founded on judgment and categorization, which lead our eye to be able to recognize things instantly. Such processes fascinate contemporary scientists like neurobiologist and art buff Jean-Pierre Changeux, who has lectured for years at the Collège de France on the link between art and the brain. And such questions haven't only been considered recently. The Friulian humanist Giulio "Delminio" Camillo (1480–1544) had a solution to what occurs in the instruments of attribution that are the eye and the brain. This intellectual contemporary of Vasari, who was close to the materialist circles of Venice, to Lorenzo Lotto and Pietro Aretino, succeeded in securing backing from Francis I of France for a

project that would have seemed highly eccentric to anyone else. Camillo thought it possible to construct a large amphitheater for the king, which would be able to demonstrate the functioning of the mind. It would be as if, nowadays, Harvard or Stanford commissioned a researcher to construct a mechanical model of the brain. This project was to be what Camillo referred to as a "constructed soul." He conceived of an enormous wooden box in the center of which would be the spectator. Between the center and the sides would rise seven tiers divided by seven pillars where words and pictures corresponding to every conceivable thought would be grouped. Rather than being communicated by phrases, an idea would be produced by means of assembling images. The images would be accompanied by Latin words underneath them; a complete text could be composed translating this idea. A rhetorician and reader of Cicero, Camillo wished to provide Francis I with the tools required to think by means of images instead of words. This, too, would allow him to communicate without knowing Latin, the Renaissance humanist language he lacked. Francis I wished to surround himself with the most remarkable characters of the day, and in the context of the rediscovery of learning that characterized the Renaissance, this would allow all possible human thoughts to be formulated. Camillo was a Faustian, a notorious figure whom people accused of charlatanry. There remain no traces of the construction of his theater in documents from that time, despite Camillo having devoted the last fifteen years of his life to it, save a brief description of the project in a 1544 letter from an associate of Erasmus to his master. A few days

before his death, Camillo dictated a tract to his pupil called *L'idea del teatro*, by which we know the principles of his machine. This text was rediscovered recently and attracted the attention of researchers of cognitive science, who were greatly inspired by it and found parallels with their own theories about the operations of the human mind.

As mad as this idea might sound, as soon as I had heard of it, I thought immediately of how the art historian's mind operates by means of his eye, and I have explained my own activity along those lines ever since. The assembly of images, in the case of the art historian, exists within his head. The brain methodically organizes our memories of paintings. It classes them by century, by school, by artist, by an artist's stylistic periods; the picture library, an essential component of any art historian's library, reflects this work. Picture libraries are in fact a kind of memory theater that art historians have unwittingly constructed over time. When I received my education, picture libraries were the only way to access methods of attribution.

There were different kinds, among which one had to make a distinction between individual and institutional picture libraries. Following developments in photography in the latter half of the nineteenth century, Eyes stopped working by means of notebooks and sketches as Morelli, Crowe, and Cavalcaselle had. It became possible to collect photographs of the works they had seen and arrange them in groups. Thus, while a notebook was only useful for the Eye that produced it, and the information held within only came to life once transposed into a monograph or catalogue,

picture libraries could give immediate voice to thoughts and visions. Berenson, Longhi, and Zeri's picture libraries allow one to understand their personalities. The first contained few pictures of works produced later than 1550, while Longhi's was particularly strong in seventeenth-century paintings. Zeri had collected pictures of works by the minor painters he liked in his library. Although they were selective, they aimed for universality. They took into account a unique and highly intelligent interpretation of Italian art from the Trecento to the Settecento. Parallel to the birth of the individual's picture library, great institutions were being founded that expressed the visions of scientific communities. The first of these kinds of institutions were German. Encyclopedic in character and not necessarily reflecting an individual vision, these are the product of collective research and opinion, and their primary use is as an almost limitless source of information. The first among them, the Kunsthistorisches Institut in Florenz, is an exceptional source of information on north and central Italian painting. Images of all the frescoes and altarpieces are housed there. It was founded in 1897 by German academics, among them Max Jakob Friedländer (1867–1958) and Aby Warburg (1866–1929). A few years later in Rome, another great art historical institution, the Bibliotheca Hertziana, was founded in 1912, thanks to a donation from a patron, Henriette Hertz (1846–1913), to the Kaiser Wilhelm Society. These two institutions, which are now part of an enormous scientific association, the Max Planck Society based in Berlin, collect the opinions of their visiting art experts about the creators of certain unattributed works. Then a steering

committee decides to classify the pictures according to the proposals it considers the most credible. This facilitates the organization of a titanic quantity of data. The picture library of the Kunsthistorisches Institut in Florenz contains over 610,000 images, whereas those of Zeri and Berenson, among the largest private picture libraries ever assembled, contain tens of thousands. English-language scholars soon followed this path. They have enormous research facilities like the Frick Art Reference Library in New York, founded in 1920, an indispensable stop when researching works that have appeared on the art market or been documented in American private collections. The Frick library contains over a million pictures. But the biggest of all is in London. The renowned Courtauld Institute, now located in Somerset House where one crosses from the Thames to the Strand across courtyards in the shadow of majestic Doric columns, is also home to the Witt Library, a vital resource containing over two million pictures. Just like its New York counterpart, this picture library is useful to art historians trained in France and Italy in discovering new paintings, most notably the many Old Masters in English stately homes.

The evolution of an Eye's vocation has made large individual picture libraries a thing of the past. For years now, the grasp of the history of art in its entirety has been the preserve of big institutions, which invest more but think less. Individuals have created much more limited picture libraries based on their own specialized fields, their personal areas of connoisseurship, intended to respond to individual requests. In this context, the preservation of the great individual picture

libraries of I Tatti, Mentana, and the Longhi villa is even more vital. Only they can teach what the art historian's vision must be. That was where an Eye of my generation went to acquire his method. Throughout visits to museums and meetings with dealers, we collected photographs of paintings we saw, before going to the Longhi or Berenson picture libraries and comparing our own intuitions with theirs. We would also go and see specialists in the same field play at assembling and then disassembling groups of pictures. Everyone has his own vision, though the images are the same; we don't group them in the same way. Carlo Falciani and I were very devoted to such games when we shared a desk at I Tatti. As a result, he and I share a common vision, which is why we could agree about Bronzino's *Christ*.

I have stated that picture libraries could be seen as the realization of Camillo's dream theater. I could also posit, to switch metaphors, that they allow us to imagine our own memory as a piece of furniture. We store similar pictures in drawers that reflect categories of our mind. The remarkable thing about this is that it isn't a given that historical considerations like the artist, the school, or the stylistic period should correspond to something visual, and yet they do. This is because the school, the artist, or the period an artist lives in all leave a mark on the pictures that we can then classify.

At the time of Morelli and Cavalcaselle, sketches filled the role of photographs and permitted scholars to remember the paintings they had seen. But the way they drew the works was not impassive; it implied a certain way of seeing,

a choice of determining elements. The building of a corpus, the game of the pictures with the support of photographs, is a tradition that was transformed and enriched in the hands of Berenson and Longhi. As a photograph is entirely neutral, the vision is extracted only at the moment that one plays with the images. The famous picture of André Malraux at home in 1954 with the floor entirely carpeted with photographs of artworks demonstrates this process. It is in assembling pictures in this way that we see what we see. The only way to apply this method correctly is to have taken care to see a certain number of these works in person. The photograph is a reminder of the visual elements that are only visible in the actual piece, like the brushstrokes, to which we'll return later. Getting to know a painting by looking at a reproduction in no way compares to using one to recall looking at the original. Because the process occurs at the level of the memory, the picture being in black and white should not be a hindrance, indeed it may even be an advantage. Colors say much about a painting, but they are also the least faithful element. Better to scour the memory for a detail than to be misled by a deceptive reproduction. In short, when an Eye uses a picture library, he employs a three-part process. He must already have seen the work in a church or museum in order then to remember it with the aid of a reproduction, and finally file it in the relevant section of the picture library. These memory games still occupy the students at the Longhi villa. Unfortunately, one doesn't see great art historians like Federico Zeri receiving guests with tea and cookies, and of course the photo box, anymore.

The appearance of the large-scale picture library has caused curious changes too. They are more accessible than in the past—you can visit Zeri's at the University of Bologna, Longhi's and Berenson's at their respective villas—but meanwhile the business of the picture game has become less convenient. For these Eyes, photographs were merely tools, and they used them without fear of wear and tear, whereas in our hands they have become precious documents in an archive. It's harder to access the actual items now; these institutions prefer to supply photocopies, which damage easily, or microfilm, which is fine as a prompt but can hardly be worked on. You can end up looking at blurry photographs and wind up like Gianni Papi, who saw nothing in the *Christ* of Nice. The final evolution in this regard was when Zeri's picture library was made available online. It can now be consulted from home, but one must be cautious about the seductive nature of such activity. It's very handy for locating a new painting, or comparing Zeri's copy with others that are available, but it is out of the question to rely on it to identify characteristics of an artist's style, to attempt on a computer what we do on a library tabletop.

We find ourselves currently in a period of transition. Eyes of my own generation are the last to have established classic picture libraries, and our work has been changed by technology. We will be able to leave our picture libraries to posterity, but they will be incomplete, which means that an individual's vision will be not be preserved the way their predecessors' have been. What will it mean to be an Eye in the future? It's hard to say. Morelli and Cavalcaselle worked in essentially

the same way as Berenson, Longhi, and Zeri at a time when technological advances were transforming the everyday life of Eyes. In this new era of change, it is vital that the new circumstances are properly absorbed. It doesn't matter what state they find themselves in, future Eyes will only be in a position to perform their tasks if they take the trouble to go and see the actual art. A cause for optimism is that young art historians are continuing to show interest in the calling, and that at barely twenty years old, some are already being identified by their peers as "attributionists." Furthermore, the Longhian manner of attribution is being continued in Italian universities. It is for the students to mold this tradition to the new technological tools.

The part that groups of photographs play in attribution demonstrates that it is a deeply intellectual practice. There is a tendency to connect them with the vagaries of personal taste, whereas in fact the eye transcends taste all the time. The best evidence of this is that it finds its own pleasure in minor masters devoid of aesthetics. Having passed the first hurdle of the recognition of form, the Eye must move on to the subject of the painting to pursue his theory. He must nevertheless beware of preformed conclusions. When Canadian art historian David Franklin claimed in a monograph on Rosso Fiorentino that the technique of parallel brushstrokes was the stylistic mark of the painter, he was wrong. This could be interpreted as a failure of the eye, because parallel brushstrokes are not consistent in Rosso and can also be found in certain Pontormo paintings. There certainly are consistent techniques that characterize an artist—and this is even the

guiding principle of the Morelli method, the cornerstone of our vocation—but one single element is rarely enough to establish proof. The more criteria there are in a work, the more chance there is of being able to confirm an intuition, and since this process isn't mechanical in nature, it can occasionally yield surprises, as in the case of Bronzino's *Christ*. When we discovered it, our eye had been attracted to the feet. We recognized Bronzino's work, but we had to take in the entire picture in order to ascertain its period and school, and consider the actual technique, the type of brush, the underdrawing. With time, the Eye develops an ever more extended matrix of criteria. It arises from a long-exercised desire to recognize the painting. This is where Morelli's notion of detail is brought into play. It is criticized because it is ill understood. An artist and the substance of his work cannot be reduced to his manner of painting ears, but if we look for details, we get there. We look at the eyes, the hair, the fingernails, a brushstroke. We apply all the criteria successively, and the more there are that correspond to our search, the more certain the attribution. If a number of the criteria are absent, it may be supposed that our original thought was erroneous. More often, it happens that either the quality turns out on examination not to be sufficient to warrant an attribution, or that we discern a different hand or even a different school than the expected one. In the latter case, incompetence can be due to lack of knowledge. So we show the picture to colleagues who might be interested. Sometimes, one persuades oneself that one was right after all, and someone better informed can come along and thwart the verdict.

Old Masters have a recognizable "brush." We talk of a painter's brush to designate an element of technique that aids attribution. This cannot be formalized and requires an Eye to recognize it. Microphotography can help, but there is no substitute for looking directly at the canvas. This is not to say that the brush is invisible to the average viewer, simply that it takes an Eye to remember and locate it. Throughout days like those with Mina Gregori at the Museo di Capodimonte in Naples in 1984, anyone would be able to discern Caravaggio's brush. Her red pointer underlined all the things that characterize it and isolate it from other painters in his style. Thanks to her explanations, anyone at all could see it, but only Eyes were capable of finding it again. One has an affinity with certain brushes and not with others. I tend not to spend much time on painters of still lifes. When an expert explains them, I can see, but if I don't seek to absorb them and find myself before another still life, I am faced with the same void. I can tell differences among French, Dutch, and Spanish still lifes, but I am rarely capable of discerning the brush of a specific artist. One of the things that draws me to attributing works to Pontormo, for example, is that I know his brushstrokes, which are swift and supple, especially around the eyes, as opposed to his pupil Bronzino, which I recognize, too, whose brushstrokes are much more minute. Pontormo's are visible to the naked eye from afar. With Bronzino, you have to observe up close with a magnifying glass. Bronzino is practically a miniaturist, despite the scale of his pictures. The brush, which could be said to carry the painter's fingerprint, can't really be formalized. One must beware of generalization

and remember to consider each work as a unique case. A true expert on a particular painter becomes so by inhabiting his personality: he lives with it and thus sees beyond such details. Because of all this complexity, the gifts of science have thus far been beneficial but never really invaluable. Science illuminates but cannot replace the eye. It is not required to tell if a painting is in poor condition or has been restored. Infrared reflectography can be used to discern overpainting, but such studies only endorse what the historian has already seen. On the other hand, they can be useful for determining how much restoration is required. In the English-speaking world, some museum curators think that the laboratory will compensate for their lack of eye, and this will permit them to attribute effectively, but such scientific studies only ever really give them commonplace information that they tend to make much of. Scientific analysis is bound by parameters that don't necessarily prove decisive. For example, one cannot say if Pontormo or Bronzino used a certain blue rather than another. Pigment analysis has nothing definitive to say on the subject. Since surprises are always possible, one must beware of arguments that rely on science. In truth, there is one case in which science is useful when it comes to color: that of Prussian blue. It is a deep blue-black pigment, tending slightly toward green, that wasn't invented till the very beginning of the eighteenth century by two alchemists in Berlin. It is based on a solution of ferric chloride and potassium ferricyanide, which makes it one of the only synthetic pigments in the world, most pigments being of vegetable or mineral origin. This is a useful pointer to the historical origin

of a painting, but does not suffice to date it properly. A painting containing Prussian blue does not necessarily date from after the beginning of the eighteenth century. In some cases a simple touch-up could have occurred using the pigment. One must therefore know how to interpret a scientific result; otherwise, a discovery will come to nothing. As for other colors, they have been the same for centuries, manufactured according to timeworn techniques. It's all very well giving them names like Pompeian red, but this color existed long before ancient Rome; it was found in abundance at Pompeii and named after the first excavations there in the eighteenth century. In the workshops, the techniques of mixing the colors—a task that was given to the *garzone,* the assistants, in their first weeks of apprenticeship—was essentially identical from one artist to another, and studying them yields few precise results.

The most interesting scientific innovation in my view is infrared reflectography, which provides evidence of the painting's past, changes of direction, alterations to the composition, all the artist's hesitations. Also, new figures appear, entirely new backgrounds that can't be seen by the naked eye. But the crucial element for attribution is the underdrawing, which can be compared to the artist's preliminary drawings. An underdrawing, which is revealed by the infrared camera, can confirm an attribution. This is particularly useful in the case of Florentine painters who drew abundantly.

In painting, there is no fail-safe way to date a piece. In a different discipline, thermoluminescence is capable of placing the molding of terracotta to within a century. It can distin-

guish indubitably between an ancient piece and one from the eighteenth or nineteenth centuries, but precise dating is beyond its grasp. If one needs to know if a terracotta piece dates from the fifteenth or sixteenth century, it will always be down to the expert to determine. Yet another case is that of sculpture, often involving materials, stone or bronze, that, by their nature, cannot be accurately dated. The structural elements of a painting can give clues to its origin. In northern countries, oak was favored, whereas in Italy, they preferred poplar. Moreover, canvas was only used in much later works. But information like this must be approached warily. The differences between periods in painting is patently obvious to an Eye, and even to people less well versed in attribution. Curiously, between the seventeenth and nineteenth centuries, confusions in style are possible and you have to look at the canvas, which will tend to be finer if it's from the nineteenth. Things become more complicated, however, because a seventeenth-century canvas might have been transposed onto a nineteenth-century one. When a painting was damaged, it would be detached and laid onto another canvas. This risky practice involved heating the painting in order to remove it. This would soften and flatten it, and damage it beyond repair. Only an Eye can tell if he is dealing with a painting still on its original support or one that has been relined. Therefore, one must not rely too much on scientific analysis. It provides an extra rhetorical element in the presentation of a discovery and gives the attribution an impersonal character. We present an intellectual approach in our articles, but in order to present an attribution properly, we have to appeal to Morellian

proof. If people can't see, we must speak to them of the touch of a brushstroke around a fingernail or the way the grain of wood is depicted. And instead of relying on scientific reports, far better to cite a few documents. It must be understood that there is something there that lies beyond the realm of the communicable. In our article on the *Christ* in Nice, Carlo Falciani and I started by describing a sunbeam. To make art historians attentive to the nuances that we saw, we suggested that the sun and chance could reveal them.

When it comes to drawings, knowledge of different techniques allows one to establish not only the era but the region, the school, and the artist's studio, as well as his identity if he is anonymous. If the drawing is on blue paper, there's a good chance that it's Venetian. If it's drawn with a mix of black chalk and red chalk, it will most likely be Tuscan. Even though such preconceptions are dangerous, as a rule, they remain likely conclusions. Furthermore, if an artist of the sixteenth or seventeenth century uses a brush to draw, there's a good chance that he's a sculptor. But these are generalizations and one can always find counterexamples. The evolution of paper manufacture over time means that it's possible to date some drawings fairly accurately. From the sixteenth to the eighteenth century, as we move through time, the paper gets thinner, whereas typical sixteenth-century paper is rough and carries the marks of folds from the drying process. Everything relating to the line itself, on the other hand, is much harder to determine. Drawings have often been reworked, sometimes completely. One gets the sense at times that the spontaneity of the first draft is missing. In France, the king's

painters redrew Old Master drawings, wishing to emulate their lines. A drawing from the fifteenth century was almost systematically retouched, sometimes several times, in the seventeenth, eighteenth, and nineteenth centuries. This all renders attribution much more difficult. It takes an Eye to sort out the original from the copy or the retouched. Then there were restorations. Sometimes drawings have been truncated and joined to other sheets. If lines cross over or extend beyond the original, then the drawing has been retouched. For older drawings, restorers used white highlighting in order to contrast with darker lines. A certain idea of an artist's work might have arisen, and if the drawing didn't correspond to it, it could be altered to fit it. Sometimes, an Eye will notice that a drawing is too fresh: it will have undergone a recent drastic restoration.

One is much more conscious nowadays of the risk of making a mistake as a result of restoration. It was a matter that went almost unmentioned in Berenson, Longhi, and Zeri's work. They would have been perfectly capable of identifying a Pontormo, but didn't concern themselves too much if it had been reworked in the manner of Bronzino. Nowadays, we are aware of the fashions and norms of taste that have been imposed on paintings in different eras. We no longer impose alterations on works to give them a style they don't possess, as Mario Modestini, the Kress collection restorer, did. Neither can we indulge in the fantasy of returning the dazzle to a painting that has lost it over time, or deny the accidents they have undergone in their history. One of the more famous examples of such aberrations is the

sad fate of a Pietà by Fra Bartolomeo that I, along with a good number of visitors to the Palazzo Pitti in Florence, was particularly attached to. Works by this classical Florentine painter of the sixteenth century, a contemporary of Raphael, were in particular demand in the seventeenth century among wealthy dignitaries in the city on the Arno, to hang in their galleries, occasionally modifying them to conform to the aesthetic mores of the exhibition space. Fra Bartolomeo's Pietà, which had pride of place at the gallery of the Grand Dukes of Tuscany, had been removed from the church of San Jacopo tra i Fossi. Its upper portion had been cut off and a black background painted in. In 1988, the curators of the Pitti decided to use the scientific resources at their disposal to exhume the original pigments and bring back the landscape and the figures of the two saints who now lacked heads due to the truncation, when the picture they already had was marvelous. They didn't go so far as to attempt to replicate the part that had been removed, but the resulting work was deplorable. They now have an extremely worn painting, with the top missing to boot. This magnificent work of art was ruined because, in the spirit of scientific accuracy, they chose to ignore the effects of the passage of time. At no point had the painting been disfigured in its style. The black background was simply the mark of its passage from the center portion of an altarpiece to an exhibit in the Grand Ducal gallery. Similarly, in collections that conformed to the aesthetic tastes of the seventeenth century, circular works of art had been converted to square, or formats enlarged. There is nothing tragic in this. It must be understood that the effects

of the passage of time on a painting are not a scandal but a part of its life. The removal of the black background in the Pietà amounted to an unwarranted negation of the history of a piece that had been admired by visitors throughout the eighteenth, nineteenth, and twentieth centuries. Its renown had even led it to be requisitioned by Napoleon's army and exhibited at the Louvre under the empire.

Thanks to the demands of the art market and possibly a lack of education, British and American conservators acquired the habit of over-restoring paintings that were hundreds of years old. This practice reduces them to nothing. I recall Bellini's *Portrait of Doge Leonardo Loredan* at the National Gallery in London. In the seventies, I was overwhelmed by it. When I saw it again at the beginning of the nineties, it had become a mere image, lost its depth: it had been restored. It is a kind of madness to suppose it possible to revive a painting's original luster by exposing the paint. The removal of the original varnish removes the mystery that the artist had intended, and the painting ends up resembling a flat image on the Internet. Without going into the debate that divides the northern and southern schools of restoration, British and American restorers find themselves trapped by the demands of the market. American collectors wish to acquire Old Masters that appear to have been painted yesterday. We also have their naiveté to thank for the rise of the forgery industry. If there is a way to identify a real work of art, there are ways of detecting fakes. We return to the notion that perception, when it comes to a painting, is a matter of perceiving all. When forgeries are introduced onto the market, a battery of scientific

expertise, which does nothing to contradict their attribution, always accompanies them. The thing that allows an Eye to see through them is something much more elusive, something almost physical. Whenever I am confronted with a fake, I know it immediately. One day, in a darkened room on the Faubourg Saint-Honoré, a foreign dealer-collector active in Paris asked me to authenticate, in front of two potential buyers, a sixteenth-century portrait that was an obvious fake. The dealer was presenting it as a completed version of a superb black chalk drawing by Pontormo at the Uffizi of a man in a turban. The drawing is of such a high standard that it could be seen to be final preparatory study for a lost painting. The painting gave me an extremely uncomfortable feeling. The flesh tones were coldly impersonal and the pattern of surface cracking, or craquelure, too regular for it to be an original.

A fake always leaves an unpleasant impression, a feeling of discomfort. This occurs at the level of the picture itself, rather than the structural materials, which forgers always make sure conform to the supposed period of the painting. The element that must be obtained artificially is the aging of the paint layer. In order to give the illusion of age, they cook their pieces in ovens, and the resulting pattern of cracks is strangely uniform, compared to the one that would be produced over time. The impression that the craquelure is too regular often follows the feeling of discomfort from the first look at the painting and tends to confirm the suspicion of forgery. Another recurring error in fakes is the color. Scientific tests wouldn't find anything amiss, or at least not often. The forger Wolfgang Beltracchi, an extremely talented restorer

who forged 1930s paintings and Flemish still lifes, went as far as to produce counterfeit period photographs with his wife Helene, who posed in costume with his paintings. He was arrested as a result of having used an anachronistic white in one of his paintings due to a shortage of materials. A forger will tend to reproduce the same composition of pigments as the original artist. Unfortunately for them, the subtleties of the original are rarely reproduced accurately. The colors are more or less warm. I can recognize a forger of Pontormo by the texture of his cold and milky pigments that are lacking in the painter he tries to imitate.

Forgeries fascinate the art historian. They don't just involve his eye; the challenge extends to the thought that the painting expresses. Federico Zeri was obsessed with this question, to the point that in his *Diari di lavoro*, he devotes an article to a forger who became an artist, and whose body of work he examined. It was entitled "Il falsario in calcinaccio" (The Forger in Plaster) because of the gypsum base that permitted him to recreate entirely fictional fragments of fifteenth-century fresco. His work was very convincing, but the fascinating thing about him is that the fakes are imbued with a metaphysical quality that belongs to artistic modernity. You can see in them the vision that was held in the 1920s about Sienese artists of the fifteenth century. The plaster forger's inventions and compositions represent the subject matter of the Italian academies of painting of the time.

The article that Zeri devoted to this forger was a landmark. He started with a *Madonna* and soon discovered other paintings in Rome, Warsaw, and Washington that were

indubitably produced by the same hand and attributed to a fifteenth-century Sienese painter. Zeri had discovered what he believed to be an Old Master and ended up finding out his true identity. It was actually Umberto Giunti, a Sienese painter who was born in 1866 and employed as a teacher at the art school by Federico Icilio Joni. Joni was another famous forger who was taught to paint by a local artisan and, despite his criminality, soon made a name for himself in this respectable institution. All becomes clear when you understand their situation in the light of Joni's *Le memorie di un pittore di quadri antichi* (Memoirs of a Painter of Old Pictures) which was published in 1932 and describes this small world of art forgers responding from within these tiny Italian towns to an America in search of the peninsular dream.

As for me, I am attempting to track down the forger to whom I owe a supposed Salviati and a supposed Pontormo. I had heard of a restorer who is extremely talented in the execution of copies after drawings. I'm convinced that I owe this painting to him. He uses drawings to create pastiches of Old Masters. I am waiting to see a few more of his paintings in order to group them and do more research on this character. I have a certain admiration for him. I can understand that if you are capable of painting perfect replicas for the American or Asian markets, it's possible to make the leap from selling a copy to selling a fraudulent item, conceived with the intention to mislead. In the case of the forgers from the beginning of the last century, scientific data could help prove that the paintings did not come from the fifteenth century, but none were necessary since our eye and education had already

revealed it to us. What's more, all this analysis would have been useless in understanding the character of the forger.

The savoir-faire of an Eye goes beyond a purely scientific technique of authentication and is accompanied by a deep knowledge of an artist and his milieu. There are traditional art historians who consider the work of attribution to be a waste of time. To them it constitutes a method foreign to their purpose, which is to formulate a theory. But with all due respect, such knowledge is indispensable. If they are not aware of it, they're likely to encounter disruptive elements that will get in the way of their theory. The case of *The Faun*, supposedly by Gauguin but actually the work of British forger Shaun Greenhalgh and bought in 1997 by the Art Institute of Chicago, led to some curious interpretations of the latter's intentions. In the reverse scenario, each true discovery can be used to formulate new theories, something we shouldn't prevent ourselves from doing. It would now be unthinkable to consider Bronzino's career without taking into account the *Christ*.

The history of art is not just a matter of illustrious painters. Each school is replete with mediocre artists responsible for a production line of works. Identifying them could lead us to demystify the work of the Old Masters but also teach us the methods of the various schools. Eyes are the only art historians who are just as interested in the masters as their disciples and studios, and that is what makes them necessary for a proper understanding of painting.

Talking About Painting

To have been awarded a grant by the Longhi Foundation is, in and of itself, a form of recognition to the novice Eye. To the Italians, visual knowledge is something to which they alone hold the key. They are magnanimously prepared to pass it on to a few carefully selected initiates, but they believe that the rest of the world is incapable of training the eye. This does not mean that the school of Longhi is not involved in an exchange of ideas beyond its walls. On the contrary, it strives to provide its pupils with contacts around the globe and greets international guests with legendary Italian hospitality.

The key words for an Eye seeking to gain recognition are discovery and publication. It is by offering something new, thanks to his vision and his singular personality, that he gains respect and makes a name for himself. But in doing so, it is important to ensure that his published papers have a coherence, and to avoid kowtowing to the art market. Even if an Eye feels supremely confident, publishing a series of disparate articles can make it seem that he is motivated not by a thirst for knowledge but by a hunger for sensationalism, which is

the surest way to make foolish mistakes. Better to gradually expand his field of competence and develop his authority over time. The admiration of collectors, heirs, and art dealers, whom he is better placed than anyone to advise about those works on which their fortune and fame depend, can become more enticing than the respect of the academic community. This largely intellectual group considers someone who makes attributions a strange bird, while collectors, heirs, and art dealers, whose delight or disappointment hang on his every word, cannot do without him. As tempting as the prospect of being quickly able to wield such power may be, the Eye must be careful not to sacrifice his reputation. Academic recognition is the guarantee of his integrity. If our reputations depended only on the approval of the art market, we might be suspected of peddling our knowledge, especially when the Eye is starting out and, even acting in good faith, is likely to make mistakes. Though we may be fascinated by Longhi, Zeri, and Mina Gregori, this does not entitle us to offer our opinions on works from the eighteenth to the twentieth century. If we are to make mistakes—and that is inevitable—we will have done so free of suspicion, and within our own field of expertise, where we have begun to establish a reputation.

In the course of my work on portraiture, I discovered a number of minor masters to whom I wanted to devote a series of detailed, specific articles. A true Eye is fascinated by issues relating to a body of work that are primarily of interest to the specialist. It is evidence of his love for the profession. While awarding a new attribution to a great artist might seem self-interested, establishing a list of works by Jacopino

del Conte, Jacone, or Giovanni Stradano is something an Eye does for the love of knowledge itself.

When Letizia Strocchi, in charge of our attribution sessions at the Longhi villa and with whom I had developed a close relationship, asked me to collaborate with her on a symposium on the work of Andrea del Sarto to mark the five-hundredth anniversary of his birth in 1986, I willingly accepted. Such anniversaries are the heartbeat of the world of research. Symposiums are always joyous occasions, with discussions between specialists working in the same field, but they also afford the opportunity to be noticed for one's contributions. Andrea del Sarto—the great proponent of the pictorial revolution in Florence instigated in the early sixteenth century by Leonardo da Vinci, Raphael, and Michelangelo—learned composition during the transition in Italian painting between the "flat image," whose most sublime expression may be found in Sandro Botticelli's *The Birth of Venus,* to three-dimensional imagery true to life. Leonardo da Vinci developed atmosphere, life, and molded objects to shape their perception, suffusing them with faint shadows, whereas before him, the use of perspective had been something external, something artificial, even mechanical, that could not breathe life into the figures.

In true Florentine fashion, Andrea del Sarto adapted to this revolution. Standing in front of any of his paintings, an Eye will immediately recognize the Florentine brushwork. There are many factors that explain this. The first, unquestionably, is his line, his contours, which denote an exceptional draughtsman, the hallmark of Florentine art. The second is

his color palette, which is slightly acidic; the flesh tones are harsh, there is a certain coldness to the figures. This sublime dispassion prefigures the most fascinating aspect of his successors, the Mannerists, yet does not conflict too much with the classical style. For a researcher with an interest in sixteenth-century Florence, Andrea del Sarto is someone who cannot be ignored. It was in his studio that the Florentine school was born. This symposium marked my last collaboration with Anne Fabre. We presented the lesser-known pupils of Andrea del Sarto known to us from our work on portraiture. Taking the group of "Florentine eccentrics" mentioned in the paper by Federico Zeri, we expounded our vision of the works of Pier Francesco Foschi, Jacopino del Conte, and Jacone, the three most interesting of Andrea del Sarto's minor pupils, while more practiced art historians discussed the celebrated works of the undisputed master of Florentine classicism.

According to Vasari, Jacone was more fond of spending time in taverns than in his studio. Indeed, many of his drawings are spattered with wine stains. There were times, when he let himself go, that he ended up a tramp. One day when Vasari was returning to Florence by the Porta Romana on horseback and in full courtier's livery, he discovered Jacone crouching against the gate, his clothes in tatters, clearly drunk. He immediately reproached the artist for this terrible waste. Jacone maliciously responded, "Meglio vivere a la filosofica qua vestirse di velluto." (Better to live as a philosopher than to dress in velvet!) Everyone knows that Vasari, though an exceptional architect and designer, did not exactly

shine as a painter. One might criticize Jacone, on the other hand—as Vasari does—for the bizarre Madonnas, the children in acrobatic poses, the grimacing faces. Personally, I find them enchanting. Moreover, it is clear that Jacone was an excellent draughtsman. Foschi, for his part, took over the running of Pontormo's studio after the death of his master. He rubbed shoulders with Bronzino, and was easily influenced by the artists around him. His works, curious puzzles given the admixture of so many influences, are nevertheless easily recognizable thanks, in particular, to the modeling of the faces, the form of the hands, the folds of the draperies. Ah, the noble virtues of the Morellian technique. Compared to the more famous pupils of Andrea del Sarto (Pontormo, Rosso Fiorentino, Francesco Salviati), the painters we focused on had been all but forgotten by everyone except perhaps Zeri. He published a number of papers on Jacopino del Conte, the artist whose work he knew best and who had long been much misunderstood. Born in central Italy, Jacopino del Conte divided his time between Florence and Rome. His success in his own lifetime was such that he worked for every pope between 1530 and 1598. Vasari speaks of him as an unrivaled portraitist and points out that, from 1568, beginning with Pope Paul III, he painted the portraits of all the Supreme Pontiffs, a great number of bishops and cardinals, and ambassadors and noblemen visiting the papal court. He also painted the portraits of members of Roman noble families, including the Colonna and Orsini families, men of letters, and gentlemen and ladies of quality residing in Rome. During the same period, he accepted commissions

from Florentines living in exile in the papal capital, fleeing the disastrous rule of Alessandro de' Medici. Zeri had been the only person capable of making sense of a body of work that had remained obscure until then. Anne and I attempted to complete these studies, expanding them in terms of the portraiture that had brought him such fame in his lifetime. In doing so we were able to propose a new group of paintings attributed to him, and our sense of his style was revivified.

On the day of the symposium, the living room was full. The recent death of Roberto Longhi's widow had made it possible for us to use the villa for the event, to once more be among the magnificent furnishings she had jealously shielded from the public eye during her lifetime. The audience members, seated as best they could, listened attentively to the lectures. Separated from the dining room by a glass door, Federico Zeri was engaged in passionate debate with a guest. Just as Anne and I were about to speak, Zeri pushed open the door and stood, arms folded, on the threshold, despite his corpulence and the pain occasioned by his gout. It is true that we were about to broach a subject that he understood better than anyone, but it was also an opportunity for him to see whether we had understood the lesson he had given us at Mentana. At the conclusion of our presentation, he came over to join us and agreed with most of the points we had made, though he could not resist taking us to task over a Madonna in the Musée des Beaux-Arts in Nancy, which we thought we could attribute to Jacopino del Conte. He had seen it in person, and categorically rejected the attribution; the style was too "soft" to be by Jacopino's hand. He was

doubtless right, but I have yet to find the obscure pupil who could have painted it.

It is never pleasant to be contradicted, but I am grateful to Zeri that he did so personally rather than simply shrugging his shoulders, which is often the embarrassed reaction to an attribution that lacks coherence. One must learn to accept objections as a mark of appreciation and value those art historians who care enough to engage in debate, for anything is better than indifference. It is true that we had allowed ourselves to get swept up in the excitement of the discovery, and we should never have offered an opinion about the painting without first submitting it to direct examination. It was a youthful mistake. Even so, Zeri's objection was an important recognition of the work we had done. Research into the minor Florentine masters experienced a new boom in the late 1980s, thanks in part to us, though even now it is far from complete. It remains fertile territory where new talents will be able to prove themselves, if they are prepared to tread warily.

In the same year as our presentation at the Andrea del Sarto symposium, I published my third article, reappraising the juvenile works of Alessandro Allori, on which I had worked at the Longhi Foundation with Simona Lecchini Giovannoni, a charming professor at the University of Florence. This was the work that had prompted Zeri to call me a madman, but the article marked an epoch. A single example will be enough to make it clear how crucial such a reappraisal was. There is a portrait in the Uffizi depicting a woman with a cameo inscribed ROMA MDLIX (Rome, 1559); she is seated in an armchair decorated with figures that draw on the

works of Michelangelo. On the table next to her is a repro-
duction of Michelangelo's statue of *Rachel,* part of the design
for the tomb of Pope Julius II. The painting, known as *Lady
with a Cameo,* was attributed to Bronzino, despite the fact
that it had been definitively established that he was not in
the city in the year in question. There is, however, evidence
that Alessandro Allori visited the city, specifically to paint the
portraits of the family of Signore Montauto—a Florentine
banker who managed Michelangelo's affairs in Rome—in
particular, that of Ortensia de' Bardi da Montauto. It did
not take a particularly astute eye to identify the sitter and the
artist, but my predecessors had felt such a need to steer the
unfamiliar toward the familiar, and Bronzino's status had so
eclipsed that of his entourage that they had allowed them-
selves to overlook the valuable inscription. It is true that one
of the things that complicated the early work of Allori was
the inability of specialists to explain the shift from his youth-
ful style, marked by the studio of Bronzino, to the late works
in his career. Unlike those artists whose hand can be recog-
nized at any stage of their career, Allori did not paint in the
same style throughout his life, and he rapidly moved away
from the influence of his master. My work, then, was to dis-
tinguish the hand of the young Allori from that of Bronzino.
I demonstrated how fluidly Allori adapted to his environ-
ment. When, in the middle of his reign, Cosimo de' Medici
brought Flemish painters to work for him, Allori adopted
certain characteristics of their style, adapted the technique of
painting on copper, and developed a much finer brushstroke.
At the end of his life, on the other hand, influenced by the

Venetians and the northern Italian artists, his paintings displayed the hazy shading technique known as sfumato, linking him to the succeeding generation of artists at the end of the century. The result of this work was an article unearthing the portraits attributed to Allori in contemporary sources. Some of these conclusions are so self-evident that they are now presented by researchers as common knowledge. This might seem frustrating, but the fact that art historians make use of my research without even citing it is one of the greatest signs of success. A piece of research has finally done its work when its conclusions are adopted by all as being patently true.

During this long investigation, I discovered other Florentine artists who had been contemporaries of Allori, about whom I would go on to write papers. Among them were Carlo Portelli and Giovanni Stradano, two artists in Vasari's circle employed by Cosimo de' Medici during the restoration of the Palazzo Vecchio. The latter, a Flemish artist, was one of Vasari's most brilliant collaborators, and many of his paintings were mistakenly attributed to his contemporaries Allori and Pontormo. Such misattributions were easily rectified, for if his Flemish name—Stradanus—had been Italianized, his style bore the marks of his northern origins. One such portrait I believed mistakenly attributed to Allori was in the Frances Lehman Loeb Art Center at Vassar College in Poughkeepsie. The portrait depicted a young man, standing, dressed all in black. He was a member of the Capponi family, rich courtesans belonging to the same milieu as the Panciatichi. The man's name, Niccolò, together with the date of his death (1579) was inscribed on the memento mori, a clock set on

the table next to him. The portrait had marked similarities to the work of Allori, and it was understandable that it should have been attributed to an artist whose fame as a portraitist was firmly established. But the more I examined the details, the more it seemed to me that it displayed those stylistic traits typical of Northern European painters, which had made them prized portraitists. Moving on to Princeton, I wanted to examine a portrait kept in that university museum's reserve collection, depicting a member of the same family, Luigi Capponi, also dressed in black, with a short beard typical of the period, seated in an armchair, against a gray background. The portrait had been painted twenty years earlier than the one at Vassar. I was startled to notice astonishing stylistic similarities between the two works, something all the more curious since this portrait was attributed to Jacopo da Pontormo. After some research, I managed to establish the reason for the astonishing resemblance. Luigi was none other than the father of Niccolò, and when his son died, the head of the family commissioned the artist who had painted his own portrait and asked him to create a posthumous image of his son. Though separated by two decades, the earlier portrait, painted from life, was clearly visible in the second, a subtly imagined homage based on a model. It was amusing to note in both paintings, despite the common naturalistic style, the greater atmospheric depth in the portrait of Niccolò, linked to a tendency toward sfumato found in the later works of Allori and characteristic of Florentine art of the period. I wrote an article on the subject, which appeared in *Paragone*. A comparison of the two works left no doubt as to the iden-

tity of the artist: Stradano. The attribution to Pontormo was deemed to be as fallacious as that of Allori. Stradano painted in the naturalistic style typical of his birthplace, aging the faces, whereas Bronzino, Allori, and Pontormo had a tendency to make faces look more youthful.

In the course of a series of papers, less systematic and theoretical than my work on portraiture, I was asserting myself as a keen Eye adept at recognizing sixteenth-century Florentine art.

For a long time, I approached artistic giants only indirectly, whether Pontormo, Andrea del Sarto, or Bronzino. In part, this had to do with my fondness for new discoveries, but it may also be explained by hesitancy in the face of a genius I did not wish to profane. There was something wholesome about this modesty. Thanks to my many detours, I developed an original perspective on my favorite century. It was precisely this perspective that later allowed me to bring a fresh eye to the works of the greatest artists. If one is not familiar with their contemporaries, however minor, one can be tempted to think of them as utterly apart, superior, timeless, an appealing notion based in no small part on mistaken beliefs. A genius must also be judged against his contemporaries. This is something the Italians instinctively understand in favoring a conscientious treatment of even obscure areas of the history of art. In contrast to France, where our cult of the classics dooms us to repeating what great specialists have said about the heroes of the Renaissance, and to glossing over crucial works we have not yet fully understood, in Italy, professors encourage students to write theses on artists from

the places where they themselves grew up: in doing so, they bring them into contact with the considerable local knowledge that has accumulated around minor masters. If an art history student at the University of Bologna wishes to write a thesis but hails from Capri, the professor sends him back to his hometown, to the archives and the churches; his dissertation will therefore bring truly useful information to those who read it, and considerable photographic documentation. Thanks to this system, students and professors spend their whole lives studying. It is this approach that makes possible an indispensible work like the *Guida Rossa*, where each new edition is updated based on the work of researchers, and it explains why many of the finest Eyes are Italian. It is never possible to know too much about minor painters; without such knowledge, it is easy to be tempted—as has so often been the case—to systematically attribute works to well-known artists. This does not mean that one should spend a whole career limiting oneself to secondary artists. But one should never outgrow a curiosity for works neglected by art history and the market.

In 1989, my work as an art historian took an important step forward. Only three years after defending my dissertation on portraiture, the art expert and editor Roberto Contini asked whether I would be willing to compile a catalogue raisonné of the paintings of Pontormo, who had been Bronzino's master. In doing so, he gave me my first opportunity to tackle a monster. The Milanese publishing house where he worked wanted to put out a definitive monograph to mark the five-hundredth anniversary (in 1994) of the birth of this

artistic genius, and I would therefore be joining the line of distinguished authors of catalogues raisonnés that began with Johann David Passavant's work on Raphael. Catalogues raisonnés play a very important role in how experts view the life and works of artists. They are an opportunity to make fundamental reassessments. This is perhaps why the best of them have been written by historians who also have an eye. They require an extraordinary degree of research. One must be prepared to approach everything without prejudice and with a hunger for new discoveries. Such a proclivity, common to all true Eyes, and one that has always motivated me, can lead to errors, but those not prepared to look on their artist with a fresh eye run the risk of confirming earlier mistakes, which would be worse still. Roberto Contini knew this, and this is doubtless why he called on me. In addition to my knowledge of portraitists, my work on the output of the young Allori and the minor masters contemporaneous with Pontormo had prepared me for this challenge.

Jacopo Carruci, known simply as Pontormo, was born in 1494 in Pontorme—then a humble Tuscan village, now part of the small town of Empoli—and died in Florence at age sixty-two. He was one of the most famous artists of his time. Though long forgotten, he was rediscovered in the twentieth century by the American art historian Frederick Mortimer Clapp. In his spare time, Clapp wrote elegiac and mournful post-symbolist poems. Perhaps it was his taste for the accursed genius that led him to ignore the great and the glorious in favor of unearthing this misunderstood genius of Florentine art. The account he offers of his first encounter

with Pontormo, barely a page in length, is one that any art historian who has studied the artist would be proud to have written.

> When early one morning, some years ago, I went into the church of Santa Felicita in Florence, I did not know that I was taking the first step in a task that has since then occupied all my leisure. It was in the autumn, and I imagined—it seems to come back to me—that on such a sunny day it might be possible to see an altarpiece at which I had often peered in vain in the darkness of the Capponi Chapel. I was not mistaken. The light, slanting through the upper windows of the nave, was falling even into that dimmest of corners and, in the fugitive splendor, for the first time I really saw Pontormo's "Deposition."
>
> The moment was one of unexpected revelation. As I studied the picture with amazement and delight, I became conscious not only of its beauty but of the blindness with which I had accepted the prejudice of those for whom Andrea del Sarto is the last great Florentine artist and his younger contemporaries, one and all, mere facile eclectics whose work Vasari

summed up in the frescoes of the Palazzo
Vecchio.

I had discovered Pontormo. Little by
little I made my way through the neglect
into which he had fallen, and he became for
me a living person. His solitary aloofness
appealed to me, his disdain of patronage,
and the passion with which he pursued the
phantom of a more creative, a more per-
sonal form of expression than the graphic
arts are perhaps capable of affording.[2]

These few lines, and the work that led him to write them,
mark Clapp as the modern art historian who "discovered"
Pontormo. Consigned to oblivion, Pontormo's salvation
rested on a lone man devoting his whole life's work to the
cause. The altarpiece that was the subject of Clapp's first flush
of excitement had been painted between 1525 and 1528, far
off the beaten track of Baedeker, in a chapel belonging to the
Capponi family, who had located their crypt in the Floren-
tine church of Santa Felicita. The work, a Pietà, is framed
against a dark-blue background where a group of veiled
women are mourning the dead Christ, his body supported
by Nicodemus and Joseph of Arimathea, young men with
blond curly hair. They look out at the viewer, but the grief-
stricken Nicodemus and the parted lips of Joseph radiate

2 Frederick Mortimer Clapp. *Jacopo Carucci da Pontormo, His Life and Work*
(New Haven, Yale University Press; 1916), pxiii

terror. The artist, depicted in the background of the altarpiece, casts a despairing glance at unknown spectators while an angel hovers tenderly above. A pale gray winding shroud lying crumpled on the ground evokes the garden of Gethsemane, while the Virgin Mary, about to faint as the body of her son is laid on her lap, distracts the women from the figure of Christ as Mary Magdalene rushes to wipe her tears. The faces have languorous, sensual expressions, which, together with the acid colors (pale pink, sky blue, gold, soft green), lend the whole a surreal atmosphere.

Clapp was enchanted by the image, and his view broke with the historiographical canons established by readers of Vasari and Lanzi. It had long been thought that Andrea del Sarto had been the last great Florentine artist. Indeed, in the nineteenth century, the Swiss art historian Jacob Burckhardt, in describing the pictorial world of the sixteenth century, used Vasari's expression *maniera nuova* as a decadent artistic tendency, a "mannerism," an epithet that the puritan, bourgeois public would later apply to these painters. This view was difficult to dispel, and Clapp's discovery remained a secret for almost forty years. Only in the 1950s, with the rediscovery of the artist's personal diary covering the years 1554–1556, by which time he was an old man and painting his last great masterpiece, the unfinished frescoes of the Basilica di San Lorenzo, could Pontormo pass from death to life, from obscurity to fame, and attain the rank of icon. This sudden reversal owed less to his painting than it did to scatology. Poor, sickly Pontormo had spent two years documenting the changes his diet had upon his bowel movements. His *Journal*

was first published in its entirety by Clapp himself, but it was only after World War Two that great minds like Carlo Emilio Gadda and Pier Paolo Pasolini saw it. They read it as a statement addressed to the men of the twentieth century who had suffered through fascism, concentration camps, and the brutal humiliations of the flesh. To them, Pontormo's *Journal* was a bible, and it was through them that the artist rose, within a few short years, to the status of a pop culture icon. I can remember having lunch in a restaurant in New York City's Soho district where the walls were papered with enlargements from the *Journal* and the artist himself was depicted as an immigrant worker. This, in a restaurant called Il Mezzogiorno, must have seemed to be a joke in the best possible taste, but I cannot imagine the effect the food would have had on the delicate constitution of the poor artist. From Clapp to me, thanks to this reversal of fortune, Pontormo was elevated from the role of decadent pariah to that of the most prized of the Old Masters, with the countless new attributions that this entailed.

Despite the excesses of this passing fashion, Pontormo owes much to the Italian neorealists. Which is better? For a great artist to be brought to light, albeit through a temporarily distorted lens, or for him to continue to languish in obscurity despite his considerable talent? Moreover, I should say that the interpretation of him by the neorealists was often insightful and intelligent. In *La Ricotta* (1963), a short film in which Pasolini turns his attention to the Passion of the Christ and its pictorial interpretations, the *Deposition* that so entranced Clapp is recreated as a *tableau vivant*. The theat-

ricality of Pontormo's image, which Pasolini considers to be an expression of the rustic soul of Italy, and his discomfort at the respect that the work should inspire in him, gives rise to a farcical scene where the two characters holding the body of Christ let their precious burden fall. There are gales of laughter and a madcap voice shouts, "Che peccato!" (What a sin!) Incomplete as this view of Pontormo's painting may be, it perfectly captures its ability to unsettle. It borders on the profane. Thanks to the craze triggered by the publication of his *Journal*, the first exhibition devoted to his work took place in Florence in 1956, and others followed. In the first exhibition, many of the paintings were privately owned, for the most part by Florentine aristocratic families whose collections had been little studied and consequently were full of surprises. My role as "cataloguer" was born of necessity: I needed to give a clear overview of the artist, respond to the aesthetic excitement his rediscovery had generated with scientific rigor, and decide on a clear group of paintings from the nebulous assortment linked to his name, since the output attributed to him was incomprehensible. And I had to show that, despite current thought, Pontormo was very attentive to religious matters, and exhibited an aesthetic and intellectual sensibility typical of his city and his time.

I therefore sought to bring to light the Pontormo we needed to rediscover. I drew attention to the fact that the frescoes in the Basilica di San Lorenzo—surely the Florentine counterpart to Michelangelo's *The Last Judgment* in the Sistine Chapel, that seething mass of raw humanity yearning to adore the Savior—far from being an exaltation of the rustic soul of

the Italian people was a defense and an exemplar of a different way of worshipping Christ, focused on eliminating the intermediaries between God and Man. It was best expressed in a little book by Valdés, *Il Beneficio di Cristo*, in the possession of Cosimo de' Medici's steward and chief counselor. It is a work as central to the reform of Italian Catholicism as Luther's *Ninety-Five Theses* to the German schismatics. When Vasari wrote the *Life* of Pontormo in 1568, after the Council of Trent, just as the Counter-Reformation was beginning and with it the struggle against reformist ideas, he was fully aware of the heterodox elements of the frescoes. He described them as "strange," though they espoused the same ideas as the frescoes painted by Michelangelo in the Vatican some years earlier, whose scandalous nude features had since been covered over. If he did not expand upon the intellectual underpinning of the frescoes, it is because he did not wish Pontormo's masterpiece to attract censure. These frescoes, left unfinished by Pontormo, which his pupil Bronzino was tasked with completing after his death, were destroyed in the eighteenth century by the sanctimony of the last Medicis. They are now only a memory, although a number of preparatory sketches give a fair idea of what they looked like. Only an artist with the audacity of Michelangelo survived the period almost unscathed. Pontormo died believing that his reformist ideas had triumphed. This is something that needs to be borne in mind to understand that the rejection of his work was linked, first and foremost, to his political ideas, later masked by the so-called aesthetic audacity burdened with the name of "mannerism," which is nothing less than defamation.

I drew attention to the curious character of Pontormo's painting, underscoring the influence of Dürer's work on his style, since those seeking alternatives to the Catholicism practiced in Italy tended to look to Germany. In this sense, Clapp or Alfred de Musset, who well understood the gothic aspect of Pontormo's painting, were closer to the truth than the Italian neorealists, who tended to refute the influence of the highly academic Master of Nuremberg. Yet the words of the character Césario, an advocate for Pontormo in Musset's 1883 play *André del Sarto*, perfectly expresses his development: "Long live Gothic art! If the arts decay, the antique cannot be rejuvenated. *Tra deri da!* We need something new."

In contrast to his essay on Bronzino, Vasari documented the life of Pontormo in great detail, and it would appear that many of his works are yet to be rediscovered. One need only add that his copious drawings offer an excellent idea of what some of the missing paintings would look like, and it is easy to understand the desire for discovery his work still generates. In order to write my catalogue, I needed to make numerous journeys to personally examine the paintings we were considering adding to his documented works. On those occasions when I could not see the works in person, I judiciously removed them from the list of known works.

In doing so, I made a number of mistakes, but it was wiser to adopt this approach, since considerable sums of money were at stake. In this respect, the word of City University of New York art historian Janet Cox-Rearick proved particularly invaluable. She had published a catalogue raisonné devoted exclusively to Pontormo's drawings and in doing so was able

to reassess many of the works listed by Frederick Mortimer Clapp since, between 1914 and 1964, when her catalogue was published, the approach to attributing drawings had changed considerably. Janet Cox-Rearick is one of the last living examples of American connoisseurship: trained by Sydney Freedberg, she was noted for the intransigence with which she exercised her role as "Madame Pontormo" in the small world of art history. Fellow researchers warned me that I would have to get along with her, because her subjects were her personal fiefdom, and she was sparing in her support, preferring to work alone, going so far as to dismiss pretenders in a particularly haughty manner. Warily, I arranged to meet with her in New York, and within two minutes, all my fears were dispelled. From the moment we met, we got along famously. She was very tall and blond, the epitome of WASP beauty, and she worked with me with evident affection and pleasure, ever ready to help when I had difficulties. For a time, my research was threatened because ongoing renovations at the Uffizi meant I no longer had access to their drawings. I could not access the photographic library, either, and my work on the catalogue raisonné was jeopardized. Janet gave me complete access to her photographic archive. Thanks to her, I was able to complete my work for Roberto within the stipulated deadline. And, although I proved that one of the drawings in the Metropolitan Museum of Art, which she had excluded from her brilliant book, was an original and spectacular Pontormo, she bore me no grudge. It was at her recommendation that, ten years later, I went to work at I Tatti, devoting myself to the study of Bronzino.

Thanks to my elucidation of the way that Pontormo's style had evolved, I found that I was able to precisely characterize each phase in the artist's career. The catalogue I had published became a touchstone for the art market. Those works that I had listed as having previously been attributed but then rejected were reappraised, and people began to bring me other paintings they believed might be by Pontormo's hand. Surprisingly, it turned out that a number of those I had excluded, having been unable to examine them directly, proved to be genuine, and all of them suffered from serious conservation issues that made them impossible to appraise by the use of photographs alone. In the 1930s, when Pontormo had not been in fashion, restorers working on his paintings had given them the style of Bronzino. This made it difficult to see Pontormo's brushwork at first glance; only a detailed examination of these restorations, in the presence of the painting, made it possible to see what was before one's eyes. Such tragic mistakes by art restorers explain why a number of the works that Clapp himself found sublime are no more than a memory. The large altarpieces were preserved, but the works in private collections were too heavily reworked. The history of a painting can hide its inherent characteristics. The state of conservation is crucial. It took me some time to realize that the disagreeable feeling I had in the presence of a number of works could only be ascribed to restoration. This was notably the case with Pontormo's *Portrait of a Lute Player* which I had seen only in photographic reproduction. It had been exhibited in Florence in 1956, and had not been seen since. I attempted

unsuccessfully to track it down. It was said to have been in the collection of the Guicciardini family, but I could not find the painting in any of their homes in Florence and Tuscany. In the photograph, the brushstrokes were reminiscent of Pontormo, yet there was something caricatured about the style that made me wonder whether, yet again, it might be by his contemporary, Jacone. I included the portrait in the catalogue raisonné but with the customary reservations. Three or four years ago, I happened on the painting again. It was in a collection in Monaco. I made a special visit so that I could see it. Standing in front of the portrait, I felt the same unease I had when looking at the photograph. There were strange shadows and the material was strange. I came to the conclusion that it had been reworked. The shadows were not by Pontormo, but neither were they by Jacone. I was probably dealing with a painting that had been restored in the 1950s or 1960s. The portrait had been repainted, reworked, retouched; the eyes looked like the work of Bronzino. Beneath the repainting, it was possible that the work was still in good condition, but various tests proved little. I argued that further corrective restoration may be beneficial, but came with significant risks. At my suggestion, the owner agreed. The greatest art restorers in Florence worked on it. What emerged was a genuine Pontormo that looked exactly as I had expected. The clumsy shadows had been removed, the contours of the eyes now had the vigorous brushwork characteristic of the master's style during the last Florentine Republic, between 1528 and 1530. The colors were more vivid, the folds in the fabric more clearly

defined. The painting was exhibited in Hanover in 2012, where it was acknowledged by all.

My work on the catalogue raisonné earned me academic standing, which I owed to the trust placed in me by the Milanese publisher. Dealing as it did with an artist much sought-after by collectors, the catalogue meant I was much in demand by the art market, and elevated me to a new position, one not without drawbacks. I needed to learn to manage my relationship with art dealers. Furthermore, having gone from being an outsider to an acknowledged expert in the eyes of my peers, I suddenly found that I was expected to offer an opinion on any painting presented to me. Now, if I were to make a mistake, it would be difficult to refute. This is the inevitable fate of any established Eye once he rises from the rank of promising researcher to a member of an elite circle that includes Berenson, Longhi, and Zeri. Suddenly, he has the right to challenge the masters. But even as he attains that privilege, everyone else dreams of only one thing: to see him lose face. It is the beginning of a life of hectic activity, where one often misses the youthful years of innocent contemplation, but one that affords the prospect of great adventures.

Black Chalk, Red Chalk, Quill, Highlights

Unlike painting, where by dint of work and practice the Eye learns to be discerning, drawing is extremely baffling. Almost all the great artists produced drawings. Sometimes they copied works that they admired, sometimes they made sketches, setting down an idea that they might or might not use later. They also made preparatory drawings for most of their paintings. For this, they had a number of techniques at their disposal: quill, silverpoint, lead point, black chalk, red chalk known as sanguine, white highlights on paper that was natural or dyed (usually blue) or prepared by laying a colored ground on the paper before beginning the drawing. This ground could be purple, orange, brown, yellow, or blue. As I explained earlier, one must always consider these issues carefully, since drawings will often have been reworked, recolored; sometimes fragments of paper have been pieced together, making them the work of restorers rather than original drawings.

Today, drawings are stored in cabinets, but first they will have been mounted using a cardboard sheet with a cutout known as a passe-partout, and there may be an attribution, with a signature and a date, written directly on the mount. This is, in a sense, the last domain where an Eye can get some sense of the intoxication that must have accompanied Berenson's early work. If we had to publish a paper on each new attribution, it would be never-ending: there are too many drawings; it would take an eternity, and would take up too much space in art journals. Consequently, most of the time, we simply write a name on the mount, to be considered at a later date by the directors of the collections and art historians. If these opinions, years later, are considered significant, they may be discussed when a new catalogue raisonné or collection catalogue is published, and people the original attributors have never met will come up with arguments to support our intuitions, just as connoisseurs working today do so with Berenson's insights.

An Eye studying a drawing is often faced with sketches that bring to mind other works or well-known drawings. At such times, he needs to know whether these were created by the artist or whether they are later copies. Moreover, it sometimes happens that several identical drawings are all proposed as the preparatory drawing for a painting, in which case a chronology needs to be established. Assessing a copy is also a delicate matter: from the fifteenth century, the apprenticeship of a young artist began with copying elements of his master or of major artistic figures. Hence, the earliest drawings by Michelangelo are based on works by Giotto and

Masaccio; those of the painters at the court of Louis XIV are based on works by the Carracci brothers, Guido Reni, or by Raphael. The French court had special emissaries whose responsibility was gathering examples for the king's painters, something that partly explains why the Department of Prints and Drawings at the Louvre comprises more than 150,000 works, making it one of the largest in the world. Based on the model of the royal collections, enlightened amateurs throughout France began to assemble remarkable collections, which often provided the basis for graphic arts collections of the fine arts museums like those in Rennes, Lyons, Besançon, Grenoble, or Orléans. Such collections offer the ideal environment to familiarize oneself with the distinctive world of drawing, and train the Eye in those unique exercises that lead to understanding.

It was Sylvie Béguin, for whom I was working in 1983 while she was preparing the Raphael exhibition, who noticed the difficulty I had in getting my bearings in this domain. She took me on my first visit to the public library in Rouen to see a collection that contained many copies, and not always of the best quality. Thanks to her insightful comments, I came to understand how to identify them, and how to recognize the continuous, uncertain line that typifies copies. From that moment, I began to visit the drawings departments at prestigious galleries like the Louvre and Uffizi. Works in such departments are divided into three categories: original, anonymous, and copy, which are in turn subdivided by school and by era. Although the attribution of a drawing is much more complex than that of painting, the fundamental prin-

ciples remain the same. Drawings are categorized into ever more precise sections, making it possible to eventually arrive at a definitive attribution. Nonetheless, in the drawings departments and the holdings of museums, one sometimes encounters calamitous errors in judgment. It is not unusual to find an Italian loose-leaf sketch in a box of French drawings, or a seventeenth-century drawing filed with primitives. There are those classified as "anonymous" that are actually the work of a master but do not relate to a known painting, there are originals that are in fact copies, and vice versa. This detective game can consume endless hours.

It was in 1984 that I first met Catherine Goguel—research director at the Centre national de la recherche scientifique (the French National Center for Scientific Research), attached to the graphic arts department at the Musée du Louvre. We were both attending a symposium on Raphael at the Longhi Foundation in Florence. She took an immediate liking to me. Beautiful, charming, ebullient, she had just completed a prolonged study on the drawing of Vasari and his entourage in the Louvre, which she knew better than anyone. She received regular invitations from around the world to discuss her research. She took me to symposiums in Europe and the United States, where she acted as ambassador for the French school of Eyes, bringing to her work considerable erudition and good humor.

Since drawings cannot be exposed to daylight for longer than three months and light levels during exhibitions must be maintained at a maximum illumination of fifty lux if the paper is not to bleach and crumble, they are rarely seen by

the public. Hence, every temporary exhibition is important, since afterward the drawings will be returned to their drawers for at least three years. The catalogues that accompany such exhibitions are thus of extreme importance, allowing a glimpse of exclusive collections that few are familiar with, and to which even fewer have regular access.

And so, in 1990, Sylvie and Catherine, having access to many distinguished experts, decided to mount an exhibition of Italian drawings from the collection of the Musée des Beaux-Arts in Rennes. The greater part of the museum's holdings comprise a collection confiscated during the revolution from a nobleman of the ancien régime, the Marquis de Robien. For me, it was an opportunity to take my first scientific steps into the secretive and almost inaccessible world by contributing to the catalogue for the exhibition. With great magnanimity, Catherine dealt with works from the seventeenth century, thereby allowing me to deal with my preferred domain, Florentine drawings of the sixteenth century. Though I would not claim to have expertise in drawing, this experience made it possible for me to publish and to begin to establish a reputation in the field.

Shortly afterward, I surprised everyone with a lecture given during a symposium at the Kunsthistorisches Institut in Florenz on the subject of sixteenth-century Tuscan art. The public expected me to present Florentine portraits from the early part of the century; instead I presented drawings. I had gathered together the drawings of Giulio Clovio (1498–1578), a miniaturist of Croatian origin, whose political significance was much understated, perhaps because of

the diminutive dimensions of his works. Clovio's works are almost magical, scaled-down versions of the titanic figures of Michelangelo, taken from his drawings, frescoes and sculptures. In 1540, in Rome, he entered the service of Cardinal Alessandro Farnese, the grandson of Pope Paul III. Clovio dedicated his individual art to the Italian Reformation of the Catholic Church, championed by his master. In his *Lives*, Vasari calls him a *piccolo e nuovo Michelangelo*, a Michelangelo of the miniature. And it is true that Clovio draws his inspiration from the most "spiritual" works of the great sculptor, notably the drawings he did for the leading proponents of the Reform moment.

I had discovered two of Clovio's drawings, surprising in size, though filled with tiny figures. One, a depiction of the *Last Judgment* in the Uffizi, had been attributed to Alessandro Allori, an attribution I could not accept, despite the influence of Michelangelo's drawings on Allori, whereas it entirely fitted the aesthetics of Clovio. I framed this discovery with beautifully detailed drawings executed by Clovio for the Medici. These drawings were further evidence of Cosimo de' Medici's commitment to the reform of the church early in his reign; that he should commission an artist whose works—given their size—could be transported as symbols of the ideas he was defending was not insignificant.

Bolstered by these minor successes, I decided to continue to study drawings, and in particular the role of the copy in the education of great artists. It was a subject dear to my heart, and one that I approached empirically by consulting the archives labeled "copies," in particular those drawings

based on works by Michelangelo. I made a small but interesting discovery in the Louvre, in a box of drawings by the Florentine sculptor Jacopo Sansovino (1486–1570). There was a red chalk drawing of a young man, whose contorted body was copied from the pose of a figure in Michelangelo's *Battle of Cascina*, though the stroke was more similar to the style of Andrea del Sarto. This was a sketch by Sarto, who had later used the figure in the background to the *Annunciation* painted in 1512, which now hangs in the Pitti Palace. Though it lent nothing to the composition, it was a reminder of a time when visual allusions to the *Battles* of da Vinci and Michelangelo—the *Battle of Anghiari* and the *Battle of Cascina*, respectively—were common in Florence and served, in the words of the sculptor Benvenuto Cellini, as a "school for the world" (*scuola del mondo*), because of the crowds of artists who came to study them. The drawing in the Louvre, a preparatory sketch for an *ignudo*, one of the decorative nude figures Michaelangelo featured seated on the Sistine Chapel, was also a youthful study that Andrea del Sarto included as an allusion to his own composition. The drawing was removed from the box marked Sansovino and refiled with the works of its actual creator. In my article on this little discovery, I compared the use of copies of Michelangelo's drawings by Andrea del Sarto and Allori. I also mentioned a third artist, Francesco Salviati (1510–1563), who copied numerous artists from preceding generations, and indeed made the copying of Michelangelo's drawings commonplace long before the foundation of the Academy of the Arts of Drawing in 1563. I made use of the hours spent studying copies, which allowed

me to recognize the stroke distinctive to each artist.

A few years later, Catherine Goguel began working on *Salviati or bella maniera,* one of the finest exhibitions of the 1990s devoted to an artist of the Renaissance, held at the Villa Medici in Rome and the Louvre in Paris. Once again, she asked me to join the art historians working with her, an opportunity to be part of a team of experts in drawing and painting. The work of Francesco Salviati demanded no less. Vasari considered him one of the greatest artists of his time, a jack-of-all-trades who devoted himself not only to painting and drawing but to engraving, tapestry, decorative objects, and illuminated manuscripts. He was born in Florence and apprenticed in the studio of Andrea del Sarto, but he also worked in Rome, in Venice, and in France, steeping himself in various schools, particularly the works of Titian and of Jules Romain, whom he encountered in Venice and Mantua. Like Jacopino del Conte, though treated even more unjustly, Salviati represents that painter without a school, misunderstood because his work does not fall into a particular tradition; he was nevertheless unquestionably one of the greatest artists of the sixteenth century.

Catherine needed people with multiple skills to tackle this difficult body of work. As a result, she expected me to draw not only on the experience I gained during my work on portraits but also on what I learned working with her on drawings. We had a muddled catalogue raisonné of Salviati's work, and a collection of articles that since they dealt only with specific points in his career, did not offer an overview to the development of his style. His body of work was further

encumbered by implausible theories. After three or four years of research, a highly innovative collection of pieces that challenged the received notions of schools of art was presented to the public, who, for perhaps the first time—thanks to the myriad drawings on show—could begin to grasp how the studio system worked and understand the evolution of the style of an artist like Salviati.

This undertaking remains, to me, the epitome of the adventure of connoisseurship. Without Catherine's acuity for drawings, without my knowledge of painting, and most especially, without the sense of camaraderie cultivated by the curator, it would have been impossible. Connoisseurship really is best served by team effort. Before publishing a new attribution or discovery, the expert benefits from first speaking to a colleague about his intuition. Depending on the reaction of that colleague, that initial intuition may be reinforced or modified. While art historians who specialize in painting seldom discuss their opinion before publishing papers, those in the world of drawings—secretly afraid that they may be mistaken—believe it is indispensable to discuss their ideas with others whose opinions they respect before penciling a tentative attribution on the mount.

The suggestions that we put forward as a team also allowed Salviati to make a great leap forward on the art market. His sophisticated style, though it lacks the simplicity and the universality of major rediscovered artists like Caravaggio and Vermeer, found favor with the public. There was nothing of the craze that had greeted the discovery of Pontormo's *Journal*, but after the exhibition, a number of Salviati's works

sold for record prices. Catherine's discovery was not a single painting, let alone a particular masterpiece, but an aesthetic personality that until then had been profoundly misunderstood, a body of work that, as a team, we had been able to highlight and significantly enhance. We realized the importance of our contribution when people less familiar with the corpus expressed surprise about some works we believed were absolutely genuine. The Eyes acknowledged that we brought the true Salviati to light, although, even today, there is some resistance that makes us smile. It gave us great personal satisfaction to feel that we had moved art history a step forward. It was also an excellent example of what a deep understanding of drawings can do in terms of reappraising an artist's visual perception.

However, though a grounding in drawings is essential for an Eye's training, the two domains of painting and drawing have, for financial reasons, little overlap. Those who love drawings tend to steer clear of issues that concern painting, which they consider showy, while those who specialize in painting rarely trouble to verse themselves in drawings. Roberto Longhi and Federico Zeri showed little interest in the subject. Bernard Berenson, alone among the great art historians, married the knowledge of drawing and painting, as attested by *The Drawings of the Florentine Painters* (1903), the first systematic study of the drawings of a particular school by an art historian. Until then, such knowledge was more often the field of artists and collectors, who wrote the artist's names on the drawings they preserved. This was how Vasari came to build up an impressive collection of drawings, which he put

in the volume *Libro de' disegni*, where each one was framed by the decorative repertoire characteristic of mannerist style: grotesques, hermae, urns, pillars, nudes. Such extraordinary scholarship made him a precursor of the connoisseurs, anticipating their predilection for inscribing the mounts with the names of the presumptive artists. Even such scholarship, however, did not prevent him from making occasional mistakes, making him truly one of us.

It might be said that Philip Pouncey, an Englishman born in Oxford in 1910, invented the method of attributing drawings in its modern form. Of a younger generation than Berenson, he first decided to devote himself to art history after attending an exhibition at the Royal Academy of Arts, a sweeping survey of Italian painting from 1200 to 1900. He compiled a catalogue of fourteenth-century Italian paintings for the National Gallery in London, where he worked from 1934 to 1939. World War Two temporarily interrupted his work and after a brief diversion in British military intelligence, his devotion to drawings came full circle: he was asked to compile a catalogue of all the Italian drawings in the Department of Prints and Drawings of the British Museum. This mammoth work, published in three volumes, took more than twenty years to produce. Pouncey was distinguished by a talent possessed by no one before him: an ability to recognize, with almost unerring accuracy, the preparatory drawings for any painting, whether by great masters or anonymous hands.

A great admirer of *A New History of Painting in Italy* by Crowe and Cavalcaselle, Pouncey divided experts in drawings into three categories: those who see immediately, those

who see when they are told what to see, and those who see nothing at all. Despite its apparent simplicity, this categorization is a testament to Pouncey's deep intelligence, since it summarizes all possible situations that an Eye can be faced with. When someone tells us: "This is a drawing by Salviati," when it would never have occurred to us, we curse ourselves as being in "Pouncey's third category." Usually, it means that the person speaking to us has a much greater understanding of the artist, and that we need to go back to our studies. Although these categories are common to Eyes whether they specialize in drawing or in painting, the two worlds rarely mingle. Is this simply a matter of taste, or does the ability to recognize a drawing depend upon different mental skills, different compartments of memory than the ability to recognize a painting? If so, then Sylvie and I are among the few people to have access to both compartments.

For all of these reasons, the world of drawing has remained apart and, curiously, is often considered a woman's world. And it certainly has had its grandes dames, in drawing departments in Florence, Rome, Budapest, and Frankfurt, and in the Department of Prints and Drawings of the Louvre. Is this because the stakes—whether in terms of power or money—are lower? These grandes dames are exceptional Eyes, but have not necessarily attempted to train themselves in painting. Though they may be able to assess a drawing better than anyone, their observations when it comes to a painting are sometimes not better than those of a university student. Similarly, the great collectors of drawings are rarely great collectors of paintings; they represent a separate cat-

egory, one frequently much more pleasant than the latter. They appear at every exhibition, at every sale; they are passionate about matters of attribution, whereas in the world of painting—including art historians, collectors and dealers—one often gets the impression that they lose sight of the works themselves, that they are more interested in speculating than in understanding and appreciating. While a drawing may be expensive, prices never reach outrageous levels, which means the field does not attract those interested in making fortunes.

Jak Katalan, whom I count among my friends, is an atypical collector. An artist by training, he covered the walls of his New York loft with drawings. Hooked by the thrill of discovery, he quickly became an art historian himself. He has published papers on a number of very interesting discoveries, and in doing so enhanced his collection. Having started out buying expensive drawings, over time, he began to focus on more neglected artists, preferring to acquire beautiful drawings by anonymous artists and then make the attribution himself. Such collectors, driven by knowledge, tend to be those who bequeath their discoveries to departments of drawings. Jak Katalan set up a charitable trust bequeathing his collection of Italian drawings to the National Gallery of Art in Washington, D.C. It is a distinctive assemblage and highlights that drawing is one of the few fields that reflects more the particular vision of a collector than of a curator.

After these first forays, I made a number of discoveries in the world of drawings. In 1993, some years after the Salviati exhibition, while I was in New York working on the translation of my Pontormo catalogue, I often visited the Department of

Drawings and Prints at the Metropolitan Museum of Art, where I perused unattributed drawings, precisely in the hope of making a discovery. It was here I rediscovered a drawing published by Janet Cox-Rearick as a copy, which was in fact a genuine Pontormo. It was a red chalk drawing, a study for an altarpiece, with numerous pentimenti or revisions, all in the singular, vibrant hand of Pontormo. These corrections ruled out the possibility that it could be a copy. The reattribution of the drawing coincided with a new curator taking over at the Met's drawings department, one who had previously filled the same role at the J. Paul Getty Museum in Los Angeles, where he had spent extraordinary sums on drawings by the great Florentine artists of the sixteenth century: Andrea del Sarto, Salviati, Pontormo, and Bronzino. He considered the Met post to be the crowning achievement of his career. The only problem, in his view, was that the collection did not contain a Pontormo. My discovery earned me great esteem from this man, who was generally stinting with praise. I also discovered a red chalk drawing of a landscape, catalogued among the French eighteenth-century drawings, which I immediately recognized as the work of another mannerist, Domenico Beccafumi (1486–1551), who might be considered Siena's answer to Pontormo. I noted my opinion on the mount and left without saying anything. Imagine my surprise when, some time later, a curator published his discovery of a Domenico Beccafumi at the Met, presenting the attribution as his personal triumph. He felt obliged, however, to include a footnote stating that Philippe Costamagna, a French connoisseur, had independently arrived at the same

conclusion; this is something that is simply not done. But this formerly promising young man, whose eye was little admired among his elders, needed to have himself validated with a publication.

The two last discoveries are more recent, and relate to the painter of the *Christ* in Nice. Unlike most Florentine artists, many of whose drawings have survived, Bronzino left only a few sketches and even fewer finished drawings. Did he draw very little? Was part of his output lost? Lost to fire, perhaps, as happened to the drawings of Anthony van Dyck, whose work was consumed in a blaze that ravaged the atelier of cabinetmaker André-Charles Boulle in 1720? Any hypothesis is as valid as any other, except one that suggests that he was a poor draughtsman. The handful of examples that have come down to us prove the contrary.

One day, two British art dealers, great friends and regular visitors to Drouot's auction rooms in Paris, brought me a black chalk drawing depicting a leg and asked whether I thought it was a Salviati. This was just after the Salviati exhibition, when his work was everywhere. The line was delicate and possessed great finesse, the execution was flawless, but I immediately recognized the unquestionable traits of Bronzino, though this had not even occurred to them. As a rare example of Bronzino's drawings—though it was simply the study of a leg—it was later exhibited in the context of a retrospective of his drawings at the Metropolitan Museum in 2010.

A bit of art world rivalry prevented me from discussing my other discovery on that occasion. A famous British art

dealer had shown me a preparatory study of a face for a portrait of Stefano IV, the famous Colonna *condottiero* (?–1548), and lieutenant to Cosimo de' Medici. It was a black chalk drawing on a large sheet, and the resulting portrait was one of Bronzino's most successful. Heavily bearded, in full armor, the condottiero posed in front of a column (which evokes his name, *Colonna*, and symbolizes his power) on a background of pink drapery. The detailed nature of the drawing showed it to be a highly accomplished preparatory work, while the control of the line ruled out it being a copy. Certain differences between the drawing and the finished portrait suggested to me that this was the last study of the subject before Bronzino began work on the painting. In such cases, the attribution is certain, but in this particular instance, for reasons entirely unrelated to art, the drawing was not included in the New York exhibition, and was the subject of much gossip within the art world. This did not prevent me from including it in *Master Drawings*, the only academic journal devoted entirely to drawings, and most specialists in the work of the artist concur with the attribution. For my part, I still haunt departments of drawing. I leaf through the drawings mounted on passe-partouts, I identify the artists and inscribe their names in pencil in the hope that the most important opinions will be noticed, and that they will be mentioned in the company of people as illustrious as Philip Pouncey. This is my way of paying tribute to the utopian nature of our profession, the simple act of inscribing a name, compiling a list.

Enigmas and Investigations

Once an Eye gains a reputation, art dealers, heirs, collectors call on us to find out what it is they have in their possession. We spend much time traveling, often to no avail. If, sometimes, we make startling discoveries, like Bronzino's *Christ*, our work as investigators, like that of detectives, is not made up simply of sensational finds but also of routine ones. Like detectives, we have our networks of informants, we have to jostle and maneuver to get our hands on rare works. This thrill of discovery, which we attempt to channel by focusing on enhancing knowledge, does not leave us desensitized. The *Raising of Lazarus*, declared lost in my catalogue raisonné on Pontormo, led to lengthy telephone discussions and many fruitless expeditions. It is an extremely important painting, one that was offered as a gift by Florentine republicans to François I and has a certain similarity with Bronzino's *Christ*. Vasari described it thusly: "The figure of Lazarus, whose spirit as he returned to life was re-entering his dead flesh, could not have been more marvelous, for about the eyes he still had the hue of corruption." It was because of this painting that I found myself with Carlo at the Musée

des Beaux-Arts in Nice in 2005. We did not find the long sought-after painting by Pontormo, but instead a painting by Bronzino that been forgotten. Works of art are capricious in how they appear. Though I discovered a masterpiece by Pontormo's pupil, I still do not have a single credible candidate for the painting described by Vasari. In the meantime, I try to put into practice a principle adopted by every Eye: keep moving around and always accept invitations to view paintings, even if they turn out to be mere daubs.

Sometimes the works we are invited to appraise are extremely interesting, even if they do not correspond to the hopes of those who extended the invitation; art dealers and collectors always have a penchant for the sensational. The difficulty, then, is finding a way to communicate a finding that is not in the financial interest of the owner, though it may have great value in terms of knowledge. For example, a dealer with a fashionable Paris address whom I had met with some years ago was convinced that he had laid his hands on the veritable holy grail of art history, *Christ Supported by Nicodemus*, a simple composition of two figures against a neutral background that, to specialists in sixteenth-century Florentine art, is the stuff that dreams are made of. Many examples of the subject have come down to us, all of which seemed to be derived from a lost work. Something about their style is reminiscent of the Italian mannerist Rosso Fiorentino, and this dealer thought that he had stumbled on the archetype. He flatly refused to believe that it was anything else. Rosso, a Florentine as his name suggests, was a contemporary of Pontormo, but left his hometown at an early age for Arezzo, then

Città di Castello and then Rome, which he was forced to flee when the city was sacked in 1527. From there he moved to Venice and finally Fontainebleau, where he supervised the decoration of the new palace of François I. He gave birth to a curious school, the First School of Fontainebleau, which combined Italian with Northern European influences. In the late 1990s, I discovered a painting of fascinating perversity that I had attributed to Rosso, something that caused considerable controversy but that, in the eyes of the art dealer, marked me as an art historian prepared to consider challenging propositions. Having failed to have his discovery acknowledged, the art dealer invited me to view it. This very odd work could not be attributed to Rosso, but I felt it should be attributed to the painter and sculptor Baccio Bandinelli (1493–1560), an ardent supporter of Leonardo da Vinci, famous for having cut Michelangelo's cartoon of the *Battle of Cascina* to pieces. A painting by Bandinelli would certainly not have the same market value as a work by Rosso, but it was rare, and of interest to art historians. The dealer refused to listen to me. He decided to call on another expert for an opinion, in this case, Carlo Falciani, who found the dealer's claim so preposterous that he refused to view it alone. He wanted to reexamine it with me. People who call upon us for opinions can be very disagreeable, even threatening, when we disappoint. They feel that if we are prepared to travel to see a painting in person, it is because we must have doubts about it. They remember only the phrase, "It is an interesting work," with which we begin a list of objections they promptly and purposefully forget. Carlo left it to me to repeat what I had been telling the

dealer from the outset. And so I told him, frankly, there was no possibility that the painting could be by Rosso. To which he responded, "Monsieur Costamagna, everyone knows that you know nothing about Rosso."

Why, then, had he asked me to come? It was a great loss to art history that, instead of being sold, the painting was returned to the storerooms, where it will remain until the owner can find a less scrupulous expert, one prepared to endorse his hypothesis.

Such visits can be even more awkward, as was the case when I viewed a fake Pontormo painting in a gloomy apartment on the Rue du Faubourg Saint-Honoré. In order to get out of a difficult situation, I told the collector-dealer that I found the painting doubtful and suggested he seek advice from the other great Pontormo specialist, Janet Cox-Rearick. He did not say a word, but I could tell from the way he looked at me that he was suggesting a tacit arrangement existed between us. It was at this point that the clients, two Spanish gentlemen, intervened. They thanked me for coming, told me that it did not matter, then added that they had also brought along a painting they'd sent me a photograph of some months earlier, about which they would welcome my opinion.

I remember the photograph well. I had casually glanced at it before adding it to the pile of pictures on my desk waiting to be classified, guessing—without elaboration—that the painting came from the circle of Allori, Bronzino's finest pupil. Since it was full of curious details and had been significantly repainted, I had decided to postpone a more detailed

examination until later. I had not replied to the letter. The painting was presented to me, and I held it on my lap to examine it. The dim lighting in the apartment meant that I had to contort myself this way and that—one could create an extraordinary photographic exhibition of the acrobatic poses adopted by art historians while they study paintings. I could make out at least four different paint layers, indicating that it was a fragment whose imperfections had been obscured by repaintings. And since these had not lasted, the repaintings had been the subject of more recent restorations. Suddenly, my eye alighted on a perfectly preserved hand, one that could only have been the work of a great artist. I looked up, and saw the shock spread across the faces of the three waiting figures as I announced, without preamble, "Gentlemen, this is a Bronzino."

This discovery took place some time after that of the *Christ*. In the circumstance, it was a profound relief. The collector-dealer himself did not seem displeased by this turn of events, which compensated for the awkward scene earlier. The painting of Saint Cosmas, with another side panel depicting St. John the Baptist, flanked Bronzino's great masterpiece, the *Deposition*, which once graced the chapel of Eleonora of Toledo in the Palazzo Vecchio and is now in the Musée des Beaux Arts in Besançon. When the painting was given by Cosimo de' Medici to Cardinal Granvelle, chief counselor to the Holy Roman Emperor Charles V, a more sober autograph copy replaced the original in the chapel. The magnificence of Bronzino's work no longer corresponded to the reformist zeal of the times. At this point the side panels

depicting *Saint Cosmas* and *St. John the Baptist* were replaced with panels by the master himself depicting an *Angel* and the *Virgin of the Annunciation* flanking the autograph copy. The panel of *Saint John the Baptist* resurfaced in 1952, thanks to the keen eye of Federico Zeri. As for the *Saint Cosmas*, long since lost, I had just discovered an important fragment. It has since been restored and is now in perfect condition, a priestly figure against a dark background (the lower part of the panel was unfortunately cut), and was exhibited in Florence, after being restored, not far from the Nice *Christ* at the 2010 exhibition.

The history of rediscovered paintings can be extremely complex, explaining why they have gone unnoticed for so long. It is thanks to our knowledge of sources and our sensitivity to the stylistic peculiarities of their painters that we find them again. Bronzino's *Saint Cosmas* was hidden beneath successive restorations that had completely disfigured it. Sometimes, a surprising choice of technique has caused other works to languish in oblivion.

Shortly after this discovery, one of my Italian friends—though an art historian, she is an archivist rather than an Eye—shared with me a far-fetched hypothesis. While visiting the home of two friends, who were auto mechanics and collectors of curios, she had been shown a strange canvas that reminded her of the portrait of Dante painted by Bronzino early in his career, and mentioned in Vasari's *Lives*. Bronzino had been asked to decorate the lunettes in the bedchamber of a Florentine banker, Bartolomeo Bettini, who had distinguished himself during the Siege of Florence. However,

while in Bronzino's time walls were decorated with a fresco technique, canvas supports were then generally used only for processional banners or temporary decorations. There was little chance that this was an original work, but my friend insisted that I pay a visit to the mechanics. They were wonderful people, she said, and I was the only person who could help them with their painting.

Some months later, I found myself on a hill overlooking Florence. The two Italians did not live in the sort of house that I had imagined for mechanics but in a large, renovated villa ringed by cypresses with a view of the surrounding valleys. It was the kind of property that only two prosperous automobile dealers can afford. The couple, collectors rather than connoisseurs, acquired according to their whims and predilections. The canvas was rolled up and we took it out onto a terrace to examine it in daylight. The portrait immediately struck me by how closely it resembled Vasari's description. In 1532, when the disastrous reign of Alessandro de' Medici was at its height, Michelangelo, an ardent pillar of Republican resistance against the conservative armies of Charles V, expressed his gratitude to Bartolomeo Bettini's service to the Republic by giving him a sketch of *Venus and Cupid*, intended for his bed chamber. Michelangelo left it to Pontormo to execute it in a painting, and Pontormo in turn commissioned his pupil Bronzino to paint portraits of the three great Tuscan love poets, Dante, Petrarch, and Boccaccio, to adorn the lunettes.

The Dante on the canvas, wearing a red robe and crown that contrast with the black sleeves and collar of his tunic,

his face and hands very white, is seated like a giant on a hill, looking away from Florence toward a bay. The background is a shimmering sun announcing Paradise and a volcano that recalls Mount Etna, no doubt symbolizing Hell, with tiny figures burning in the flames. *The Divine Comedy*, that great work of Tuscan epic poetry, provides the link between the Florentine genius and the genius of the ancient Romans. The decisive element in this allegorical portrait, in my opinion, is the use of *figura serpentinata* ("serpentine figures") used to depict Dante—a technique invented by Michelangelo for the statues in the Medici chapels conceived during the Siege of Florence, and one he used in decorating the bed-chamber of Bartolomeo Bettini. The style of the figure was as Vasari described. In fact, there was every reason to think that Michelangelo might have personally indicated to Bronzino the pose he should use for Dante.

Moreover, what had first seemed to mean incongruity was actually an argument in favor of the couple's painting. The canvas support made it possible to understand why the other lunettes, if indeed they were ever painted, had been lost. They had not been frescoes, as we had assumed, but were probably painted on a delicate support medium. From these observations, I concluded that, with the exception of ephem-era, this painting of Dante, to the best of our knowledge, was the first work on painted canvas in sixteenth-century Florence.

This discovery had much greater impact since the sub-ject was already well known. The National Gallery of Art in Washington has a version in oil on panel. The problem with

this painting, attributed to Bronzino, was that its rectangular shape meant it couldn't have been used to decorate a lunette. By emphasizing the delicate execution of the tiny figures visible on the mountain representing Hell, with subtle shades of reds to which Bronzino added pink and white, I was able to prove that the Washington painting, less well executed, was a later atelier copy of this early work by Bronzino. The discovery was unanimously acknowledged by specialists. However, unlike the discoveries of *Saint Cosmas* or the Nice *Christ*, it was not without its disappointments. Given its canvas medium, the condition is poor. Even after restoration, the painting no longer arouses the aesthetic shock it must surely have generated when first painted. One can admire the subtle use of color, the intelligence of the composition, but it is merely a beautiful memory. Nonetheless, when not on loan to museums, it now takes pride of place in the living room of the Italian couple. While it would be of interest to an institution only for its exceptional historical value, in a private home it makes a beautiful decorative piece.

When we discover paintings, it is important to protect our sources. We must respect the wishes of the private individuals who contact us if we want to continue to have access to all paintings not housed in museums. New discoveries are usually published to coincide with an exhibition, and always with the consent of the owners, and it was at one such event that the public was able to see Bronzino's painting for the first time.

In the early 2000s, I was contacted by a Swiss lawyer from Geneva, who claimed to have a painting by Pontormo

and wanted to know whether I would come and examine it. Since I always refuse to accept airline tickets when invited to see a painting, as it might make the owner feel that I owe him something, the visit had to be postponed until winter, when, en route to a ski resort, I was able to stop in her hometown. She and her husband led me into the vaults of a large Geneva bank situated near the lake. The building boasted a vast marble lobby, with exquisitely designed furniture, and a magnificent staircase that led to the offices on the upper floors, and down to the vaults in the basement. An employee of this very Swiss bank had taken the work from the safety deposit box and placed it on an easel in a small salon. I did not need to look at the painting for more than a few seconds to be convinced that it was indeed Pontormo's work. It was a *Portrait of a Young Man* of modest dimensions, painted on tile, a rare medium at the time but one that had been used by Andrea del Sarto. The boy, about ten years old, is dressed in black and framed against a dark background; the true subject is his face, more especially his eyes. It unquestionably had all of Pontormo's characteristic traits, particularly the broad brushstroke that became his trademark after the Siege of Florence. I did not immediately share my thoughts with the owner. I wanted to linger a little longer over this extraordinary work.

This portrait was not unknown to me. I had seen a photographic reproduction at the Longhi Foundation while I was preparing my catalogue on Pontormo, and I had made the terrible mistake of rejecting it because I felt it looked strange. It had last been publicly exhibited in Florence in 1956 as

belonging to the collection of Alessandro Contini-Bona-cossi, the art dealer associated with Longhi. He possessed an extremely important collection of paintings. After the death of Contini-Bonacossi, his family had come to an agreement with the Italian government, donating a number of master-pieces to the Pitti Palace in exchange for the right to sell the remainder of the estate on the international market. Stanley Moss, an art dealer and also a poet I had met during my early trips to New York, had handled the sale, but he could not find out who bought this particular portrait, since it had been sold before Contini-Bonacossi died. Therefore, it had been impossible for me to form a precise opinion about the painting, and I listed it among the uncertain works in the cat-alogue raisonné. The painting, as it appeared in photographic reproduction, led me to question Longhi's attribution. I sus-pected—erroneously, I must admit—that he had allowed personal interest to cloud his judgment. In the poor-quality snapshot, the painting seemed too strange to be a Pontormo, and I saw it as a work by his eccentric student Jacone. But this proved to be false logic. Unlike me, Longhi had had the advantage of seeing the painting.

After a moment, the woman ventured a few words. "I don't wish to interrupt you," she said very politely. "But to judge by the look on your face, you seem very taken by the painting."

"It is one of Pontormo's masterpieces," I said simply.

The lawyer had no intention of selling it. Her father, who had recently died, had bought the *Portrait of a Young Man* some years earlier. She had inherited it in the division of the

estate. I declined to give her an estimate as to its value. As an Eye, I cannot pronounce on issues that concern the art market. I cannot deliver expertise, because, as a curator, I am rightly forbidden from producing a document that would fuel speculation and prevent a museum from acquiring such a painting at a reasonable price. Since I had included the picture in the catalogue raisonné as not being a Pontormo, I confined myself to confirming its authenticity, and gave her the name of Janet Cox-Rearick, who, as an American academic, would be able to issue the certificate. I also told her that if she considered selling the painting, I would be grateful if she would let me know. The Louvre might be interested in acquiring a painting of such quality and exceptional condition, as might the Metropolitan Museum, which sadly does not have a Pontormo painting in its collection. This concluded our business.

Some years passed, and the Geneva lawyer got in touch with me. She had recently separated from her husband and wanted to sell the painting without delay. I think she had investigated the market value of the painting and the price she had been quoted had turned her head. "By Monday," she said, "If you cannot find a buyer, I will sell through Christie's." It was Friday.

When a work as important as this resurfaces, my first duty is to try to place it with a museum. To do so would have required me to immediately contact the director of paintings at the Louvre, or his counterpart at the Metropolitan. But no institution can make such decisions in such a short time: future acquisitions have to be presented to a committee and

funds raised beforehand. It was then that I thought of a collector friend, Aso Tavitian.

Here was a man with his own network, his own lawyers, someone able to move quickly and make a fair market offer. It was imperative that the painting end up in good hands. A direct sale to a collector would save everyone money, since it would obviate the need to pay the fees charged by auction houses.

Aso Tavitian, an Armenian from Soviet Bulgaria, the child of a modest family whose parents had lost everything when they fled their homeland to escape the Armenian genocide, had been a gifted young man, traveling through the diaspora. After studying in Lebanon, he immigrated to the United States, where his flair for mathematics and a scholarship to study at Columbia University led him to make his fortune. He now owns a mansion just off Fifth Avenue, opposite the Metropolitan Museum of Art. It's an imposing residence in the French style popularized by Mansart, which Tavitian renovated and redecorated after his wife was struck down by a heart ailment. Before her death in 2002, Tavitian had been largely focused on his pioneering software technology business but he quickly educated himself in art history, hung the walls of his home with paintings and is today an utterly unique collector.

Tavitian, unlike many American art collectors who have little knowledge of their subject, buys only according to his taste, but he surrounds himself with art historians whose opinions he values. Tavitian is the only collector of paintings of my acquaintance to buy unattributed paintings because he finds them intriguing. As he shows us around his resi-

dence, moving from room to room, he stops in front of the paintings and puts us to the test. He waits for our attributions. For the most part, these are works by great masters, and the test is not too demanding: Parmigianino, Rubens, Van Dyck, Watteau, David, or Gros. But in the stairwell, he had hung a *Head of a Young Girl* that is extremely puzzling. The first time he showed it to me, I said, "I cannot pinpoint the period, let alone the place." His face lit up. "No one knows who painted it," he said. "For me it's Number 295." This was the lot number when he had acquired it at Sotheby's. The anecdote goes to show that Tavitian is not only attracted by famous names. He is one of the rare collectors who is interested in anonymous works. Over the years, we had become friends, so I was pleased to be able to steer the painting toward his collection.

To facilitate such a transaction—something that, in my case, stems only from a desire not to lose a work and to ensure that it remains in the hands of people who appreciate it—requires mutual trust. The Swiss lawyer, unfortunately, was an exception. She may have believed that I had a financial stake in the deal, and my friend's name, with its curious consonants, may have been confusing. I truly believe that she was panicked by the nature of the transaction and eventually contacted Christie's. Tavitian managed to buy the painting nonetheless, for precisely what he was prepared to offer, which meant that the Swiss lawyer simply managed to cost herself the ten percent sales commission to the auction house. In order for us to practice our professions, it is essential that people realize that an Eye does not work for money.

Most of us ensure that works of art fall into the right hands. The commissions that are an occasional taint on our profession result from the greed of a scant few. Fortunately, they are not representative of the profession. Tavitian thanked me and he organized a dinner to celebrate his new acquisition. Among the guests were the director of the National Gallery in London, the director of the Frick Collection in New York, an eminent New York art historian, an art dealer, and a few family members. Such events are extremely important, demonstrating that the interests of major galleries and of private collectors do not always conflict.

As far as the history of art is concerned, the matter ended here. But there is an epilogue that directly concerns me since after the sale I was summoned to appear before a court in Geneva. The lawyer's brother, having heard of the exorbitant profit his sister had made on the sale, demanded a redistribution of the assets of their father's estate. The lawyer had secured the painting in the division of the estate on the strength of my note in the catalogue raisonné attributing it to Jacone, though she hoped that she might sell it as a Pontormo. Things were not so simple, however. In her statement to the judge, the sister explained she and her brother had each taken a painting as part of their inheritance, the paintings probably having been acquired for a derisory sum by their father. According to her, they had each had ulterior motives: she had taken the Italian portrait, hoping it might be a Pontormo; her brother had taken a Spanish painting, believing it to be the work of Diego Velasquez. He was not as fortunate as his sister: his painting is by the workshop of

the Spanish master. The lawsuit between brother and sister is still ongoing, but the initial judgment sided with the brother. Whatever the outcome, the important thing as far as I am concerned is that this superb *Portrait of a Young Man* now hangs in the library of a remarkable collector.

For art detectives like us, those moments when we have to deal with the market require swift action, while the study of the works presented to us—many of them daubs—is more akin to watching and waiting. It is not without interest, but it requires patience and a passion for the profession if one is to get something out of it. Sometimes luck can play a part. The adventure I am about to relate leads me to believe that there is a surprising kinship between Eyes and great art dealers. The rediscovery of a Salviati *Madonna and Child* attests as much.

A Parisian expert asked if I would give my opinion of a work that, in composition, closely resembled a famous Salviati painting that hangs in Windsor Castle. Were we dealing with an original or a studio copy? The Windsor painting is on a dark, nebulous background, whereas the *Madonna and Child* shown to me by the expert was set against a landscape of Roman ruins, fantastical mountains, and atmospheric views. The landscape was magnificent, and this alone gave one a sense that the *Madonna* was a youthful work of Salviati. It could be compared to other known and documented landscapes. In my opinion, there was no doubt that it was an original, and in a flush of enthusiasm, I immediately told the expert so, forgetting that such a reaction could increase the selling price. The expert had shown the painting to others

who had stated, in good faith, that they believed it to be a copy. It is purely a matter of one's eye. By simple comparison, we can sense which paintings are copies. However, people tend to assume that when one version of a work exists in an important collection, it is necessarily the more important. What then can one say when it is part of the English royal collection? The dark background in Queen Elizabeth's painting was easily explained. When several clients wished to commission the same subject from a celebrated painter, the atelier would produce a series in order to satisfy the demand. Most were set against dark backgrounds, ideal for display in private galleries, and requiring less time to execute.

The Salviati painting had gone to England while it was considered a copy. Then, some time later, I received a call from John Morton Morris, director of Hazlitt, Gooden & Fox, the oldest art dealers in London, one which has the famous royal warrant "By Appointment to Her Majesty the Queen." "My dear Philippe, I have discovered a painting that I feel sure you have never seen," he said, and briefly described it to me. I replied that, on the contrary, "I saw it three years ago in Paris!"

At the mere mention of the subject, I knew to which painting he was referring. Great English art dealers generally seek to acquire paintings before they are publicly known. Since they are searching for those rare works that have not been offered for public sale, thanks to their scouts, they often find the most interesting paintings.

"In any case, I'm delighted, I'm glad it has ended up in your hands."

It is true that I was sorry that the French state would not have the opportunity to buy such an exceptional painting, since it would have been perfectly at home on the walls of the Grand Galerie du Louvre next to other sixteenth-century Florentine and Roman paintings. But those people who had labeled it a copy made it possible for the painting to be exported. It is much easier and cheaper for the state to acquire a painting that cannot be exported than one that is available on the international market. In John's hands, however, I felt sure the painting would eventually hang on the walls of a great museum.

In this particular case, it was extremely important to submit the work to X-rays and other scientific tests to determine the nature of Salviati's painting, and whether I was right. Although I was firmly convinced that it was an original, a scientific test would make it possible to confirm my intuition. By the use of infrared reflectography, it became clear that the painting had numerous pentimenti or alterations. The posture of the feet, the hands, and the faces had been altered several times. Since black lead absorbs light, this technique also made it possible to clearly see the preparatory drawings, which bore the hallmarks of frantic creative activity. The artist had carefully thought it through, and had had many moments of hesitation. When the results of these tests on the painting were compared to the version in Windsor, we had a pleasant surprise. Infrared reflectography showed an extremely worn painting, executed in a single stroke without corrections. There was every indication that the painting with the landscape was the original, and that in the Queen's

collection was an autographed replica, also by Salviati's hand since both dated from his youth, at a time when he had no studio and was forced to make copies itself.

Had the painting in Windsor belonged to a private collector, the discovery of Salviati's *Madonna and Child* would have seriously impacted the value of the collection. Since the Royal Collection cannot be sold or transferred in any way, the question did not arise; nonetheless, the version of the *Madonna and Child* on the dark background has lost some of its prestige.

I did not immediately publish my discovery. I was waiting for an academic event to justify the writing of an article so as to avoid destabilizing the market. Sooner than I could have expected, the opportunity arose when in 2005 David Franklin, the curator of Italian paintings at the National Gallery of Canada, and the author of a monograph on Rosso Fiorentino, who was in the process of mounting an exhibition in Ottawa about the sixteenth century, asked me whether I had an unpublished painting I might submit for the occasion. I responded that there was a hitherto unknown Salviati still on the market in London. French museums, often justifiably, decline to exhibit paintings that are for sale, since the very fact of exhibiting them increases their value and makes it even more difficult for institutions to acquire them. This, however, was not an issue for the Canadians, who like British or American museums are not afraid to engage with the art market. I referred the curator to the art dealer—curiously they did not already know one another. The painting was included in the Ottawa exhibition, and I was tasked with

writing the catalogue note. On the day of the opening, the painting was hanging in the gallery, and at the exhibition entrance, a vast banner announcing the show reproduced a beautiful detail from the painting. While in the catalogue there was no sight of the *Madonna* or my catalogue note, elsewhere, the walls of the gallery, the airport, and the main thoroughfares of the city were plastered with reproductions of the *Madonna*. Franklin had decided to acquire the painting as soon as the exhibition was over. While he had no qualms about advertising locally—he needed to raise funds and prepare for future campaigns—outside of Ottawa, no one could know; it was important not to raise the price, even if it meant leaving the painting out of the exhibition catalogue. The Ottawa museum acquired "my Salviati" for 4.5 million U.S. dollars, but I must confess a hint of irritation when a Canadian art historian called to tell me that a local newspaper had presented the museum's new Salviati as a great discovery by its curator.

Somewhat shocked, I immediately telephoned Mina Gregori and quickly sent her an article for *Paragone,* which I wrote in two days based on my catalogue note. When it later appeared in *The Burlington Magazine*, David Franklin was forced to acknowledge the article, and consequently the fact that "independently of Michael Hirst, Philippe Costamagna, a French connoisseur, had already come to a similar conclusion." It was cold comfort, especially since Franklin credited the attribution to his former teacher in London, Michael Hirst, who had a famously poor eye.

I later learned that the Salviati painting had come from

the collection of the aristocratic Corrèze family. It is impossible to know how many intermediaries there are between the seller and the final buyer. Collectors of art tend to jealously guard their possessions, and one cannot force one's way into a private home and demand an inventory. Therefore, unless one frequents art dealers, it is very difficult to know where to find the paintings in private collections. This is why an Eye who wishes to add to the sum of knowledge must be a keen diplomat, rub shoulders with art dealers, be alert to moments when collections are inherited, even at the risk of getting mired in murky waters, as happened to me with the Pontormo portrait in Geneva. These days, I have no real interest in multiplying my publications; instead what interests me is discovering paintings that will change public perceptions—those masterpieces lying dormant in private collections and in the storerooms of galleries and art dealers that are simply waiting to be identified.

An Angel
and Other Discoveries

I t is always difficult to decide whether an attribution is a "great discovery." Opinions differ; art historians will not see things in the same light as the general public. An attribution can represent a step forward for art history, and yet, justifiably, go unnoticed by the world at large. As, for example, when Daniele Benati—one of the most promising art historians of the younger generation—visited the Musée des Beaux-Arts in Ajaccio in 2010 at my invitation, and put a name to a seventeenth-century *Madonna and Child* that for years experts had been unable to attribute. Benati had only to take one look at it and exclaim, "Oh! What a magnificent Van Gembes." I had never heard of this artist. He was unknown to everyone except Daniele and a few specialists of his particular period and the seventeenth-century School of Ferrara. Jan Van Gembes, born in Mechelen in Flanders, traveled to Ferrara to dedicate himself to painting, and was given the Italian name Giovanni Vangembes.

This little anecdote raised a smile even in the academic

community, but in my opinion, Benati's attribution was a genuine discovery. To come out with a name unknown to almost everyone is always a considerable feat, especially when, as in this case, it is accompanied by the presentation of a perfectly reconstituted body of work. It was enough for Benati to show me his collection of photographs for his attribution to seem self-evident.

Such discoveries are a source of immense pleasure for the art historian. Zeri spent his entire life doing similar things, thanks to the keenness of his eye and the force of his personality. Without making a single "great discovery," he nonetheless towered over all of us. There are those discoveries that invariably make waves merely by being linked to a great artist. Benati could not have attributed a painting to Leonardo da Vinci without immediately being challenged. But in this case, no one raised an eyebrow. His discovery certainly did not get the attention it deserved, but would it be of interest to the general public? This is why many art historians have tried their hands at the three greatest painters of the Renaissance, namely Leonardo da Vinci, Raphael, and Michelangelo. They fire the imagination. But few of us have seen our efforts crowned with success. This kind of research often turns into a police investigation. I would like to start by quoting two examples that involved Sylvie Béguin. It is my way of paying homage to her.

The first occurred a few years before 1983 and the great exhibition commemorating the fifth centenary of Raphael's birth. At that time, experts had pored over all his documented works, hoping to discover some lost piece. Cecil

Gould, curator of Italian paintings at the National Gallery in London, went through inventories of Rome's collections that had been systematically plundered by French revolutionary armies when they entered that city in 1797. In the Borghese collection, there was a famous portrait of Pope Julius II, one of two pendants by Raphael, the other being the legendary *Madonna of Loreto*, also called *The Virgin with a Veil*. Thanks to the inventory numbers that had been written directly on the surface of the paint, Gould was able to authenticate the *Julius II* in his collection as an original, and he applied the same process to different versions of the *Madonna of Loreto* and ascertained that the original was in the possession of the Musée Condé in Chantilly. It was not a priori a superior painting; however, it can be said that, after restoration, it was revealed to be better than its rivals. This meticulous study of the archives led specialists to search for other lost paintings. Among these works whose fate was thrown into chaos by the political upheaval of the late eighteenth century were two fragments of an altarpiece by Raphael, an angel and a demon being trampled underfoot by a saint. Raphael was very young, perhaps only sixteen when he painted them. The work was intended to decorate a chapel of Sant'Agostino in Città di Castello, and dedicated to the patron saint of the town, Saint Nicolas of Tolentino. It was Saint Nicolas who was depicted with the devil at his feet, next to three angels; above him God the Father is placing a crown in his hand, while on his left are the Blessed Virgin Mary and Saint Augustine, the patron saint of the church. Despite such formidable protection,

the painting was significantly damaged in the earthquake of 1789.

Those parts of the work that could be recovered were cut up and sold to Pope Pius V, who placed them in his collections. It was here that French soldiers found the fragments, five in number. They were then stored at the church of San Luigi dei Francesi, between the Pantheon and Piazza Navona, whence they were to be transported to Paris. But King Ferdinand of Naples, who captured the city with his troops, did not give the French authorities time to carry out their plans. The Cavaliere Marcello Venuti, a Neapolitan nobleman commissioned by the king to recover looted art, repatriated everything he could find to the galleries of the Museum of Capodimonte, facing Mount Vesuvius. The two upper parts of the altarpiece are there to this day: God the Father and St. Augustine. The lower parts, depicting the angels and the demon trampled by St. Nicolas, were dispersed. When Sylvie was preparing the exhibition, the first *Angel* was at the museum of Brescia. The other two fragments had disappeared.

It is at this point that we enter the realm of the fantastical. In 1981, a taxi driver in Strasbourg was summoned to a notary's office, where he found two supercilious women, dressed in the sober style of the provincial bourgeoisie, waiting for him. Their father had just died. His will made mention of a third heir, a natural son whose existence he had never disclosed. I have no idea who was more surprised, the two women on discovering they had a brother, or the taxi driver on finding out that he was to share a substantial inheritance

with two upper-class women. What I do know is that the two women were not at all dismayed by the prospect. Their father had owned a small collection of Old Masters, primarily French paintings. They palmed off on their half-brother those works they believed worthless, giving him a number of paintings about which he knew nothing. The taxi driver's response should be an object lesson to any novice in such a case. Rather than calling on an expert, he sent photographs of his inheritance to the Musée des Beaux-Arts in Strasbourg. Among them was a photograph of an angel signed by Perugino, who taught Raphael, which was deeply unappealing. It was far from being the most beautiful work of the lot. The curator might have referred him to a reliable expert, but he did not know what to make of the strange painting and, as a precaution, forwarded the photograph to Michel Laclotte, then chief curator of the Department of Paintings at the Louvre. He in turn forwarded it to a young curator in his department who had worked with him on a small exhibition at the Palais de Tokyo, "Perugino and his pupils." He decided, rightly perhaps, that it was best that he conserve his diplomatic skills for more important paintings, and could afford to delegate when it came to breaking the news that this work was inferior. As it turned out, the young curator was pregnant at the time. On the day she began her maternity leave, she forwarded the photograph of this strange angel to Sylvie Béguin, asking if she would take the time to write to its owner, to whom she had not been able to communicate her impressions. The photograph joined one of the piles on Sylvie's desk. There it lay, forgotten, until she received a phone

call from Cecil Gould, who had just identified the *Madonna of Chantilly*. He reminded her that two of the five fragments from the *Altarpiece of St. Nicholas of Tolentino* that appeared in the inventory of San Luigi dei Francesi were still missing, and he suggested to her that together they might look for them in French collections. The angel would be easily recognizable from his curious position, his eyes gazing heavenward.

According to the story as told to me later, Sylvie immediately interrupted him: "I think I've found it, I've found it."

I can picture her hanging up the phone and racing along the corridors of the Department of Conservation at the Musée du Louvre—her small quick steps, her blond chignon bobbing, her bouncing gait—and bursting into the office of Michel Laclotte, brandishing the photograph from the Strasbourg taxi driver.

In the car on the way to Strasbourg—they set off immediately, as far as I remember—Sylvie explained that, though completely repainted, the angel might hide a fragment of the famous *Altarpiece of Saint Nicolas of Tolentino*. If so, there would be grotesques in the background, a pattern of small decorative figures. Michel Laclotte must have been utterly bemused, but there was nothing to be lost by making the trip. When they arrived in Strasbourg, they tracked down the curator of the Musée des Beaux-Arts, who took them to the owner of the painting. Sitting around a Formica table in the kitchen of a spick-and-span apartment, they waited for a few moments while the taxi driver fetched a package wrapped in newspaper. The angel appeared. "That's him! That's him!" Sylvie probably said exultantly. The taxi driver

would undoubtedly have no idea who she was talking about, since the work that had been entirely repainted, and was quite hideous.

They persuaded the driver to let them take the painting to Paris for scientific testing. The angel appeared to be set against a black background, but infrared reflectography revealed that, beneath this, was precisely what Sylvie had predicted. In the restoration, the mouth on the restored work was too fleshy, his eyes too exaggerated. Perugino's signature was a forgery. Under the layer of black paint were the typical Raphael grotesques in his characteristic blue. The Louvre bought the painting from the taxi driver for a price commensurate with an early work by Raphael. It was not the sum one might expect for a masterpiece from the artist's mature period, but it was more than enough for the taxi driver to buy several apartments in Strasbourg. Though deeply frustrated, his two sisters did not have the audacity to file a lawsuit, given their profound dishonesty in the original division of their father's estate.

Though there were many quincentennial retrospectives of Raphael throughout the world, the Louvre was the only museum to be able to loan a newly discovered painting to the greatest museums in London, Rome, Florence, Urbino, Madrid, Washington. Through the period, Sylvie Béguin gave lectures to publicize the *Angel* that the academic community had dubbed "Sylvie's angel." The attribution was unhesitatingly accepted, even though the occasional twinges of jealousy prompted some caviling. Sir John Pope-Hennessy, head of the Department of European Painting at the Metro-

politan Museum of Art, could not help but whisper cattily, "It may be a Raphael, my dear, but a baby Raphael."

We never discovered how the work came to be in Strasbourg. It had probably been brought to France by an officer in the French army and fell into private hands before finally resurfacing as part of this curious inheritance. The black background can be explained by the fact that in the nineteenth century, fragments were repainted to be hung in galleries where possible. As for the fake signature, it was probably added since no one knew who had painted the work. The restorer, recognizing it as a work from the studio of Perugino, but overlooking Raphael, had inscribed the master's signature. It became the eleventh Raphael painting to adorn the walls of the Louvre.

Pope-Hennessy quickly had his revenge when he managed to lay his hands on a painting that Sylvie had spent half her life searching for. In the wake of the Second World War, the French state conducted a sweeping inventory of artworks in its possession. Sylvie, who was starting out her career, was interested in those sixteenth-century Italian works that had been lost and likely found their way to France. Of the books that proved helpful, one was an overview by Salomon Reinach, a noted archaeologist, founder of the École du Louvre, and a great art lover. His *Répertoire de peintures du Moyen Âge et de la Renaissance 1280–1580* (A catalogue of paintings of the Middle Ages and the Renaissance, 1280–1580), was published in six volumes between 1905 and 1932. His passion for art won him admittance to many private collections and made it possible for him to establish the list of

the most important artworks in French hands, accompanied by engravings of each. It is a source widely used by art historians. Among the many engravings was a painting whose subject particularly caught the eye of Sylvie: it depicted Venus recumbent, with a stream of urine falling on her belly from the penis of a cheeky cherub. For years, Sylvie had been amused by this image and viewed every painting of Venus she could. Since Solomon Reinach had simply said that the work was in the hands of a private French collector, but did not mention the name, it was an arduous search.

For years, Sylvie Béguin traveled the highways and byways of France. She told anyone who would listen that she was desperately searching for a large sixteenth-century painting depicting Cupid urinating on Venus—which provoked much hilarity. The painting was signed by Lorenzo Lotto, an artist whose unorthodox works linked him to the same school of thought as Pontormo. Lotto produced a number of curious works, such as the *Portrait of a Gentleman in his Study* in the Gallerie dell'Accademia in Venice, which has been the subject of many articles. It depicts a young man sitting at a table, his hands resting on a large open book, surrounded by curious objects: dried flower petals, an enigmatic note, a blue tablecloth reminiscent of the cloak worn by the Virgin, a small lizard. The colors are metallic, artificial. The painting fascinates art historians and people of culture more generally, because the identity of the sitter and the story behind it is unknown. In his novel *Bomarzo*, the Argentinean author Manuel Mujica Láinez imagines that the portrait is of Pier Francesco Orsini, Duke of Bomarzo, a mer-

cenary endowed with a great fortune, who, upon the death of his wife, commissioned the so-called Park of the Monsters, strange sweeping gardens much admired by the surrealists. Manuel Mujica Láinez later adapted his novel as an opera, whose production at the Teatro Colón in Buenos Aires was banned because of the sexual depravity of the character of Duke Orsini, which shocked the military regime.

Gradually, art specialists began to take an interest in Sylvie's search. They were fascinated, because it was difficult to imagine what the work would actually look like. One day, Sir John Pope-Hennessy called his French colleague, and, in silken tones, he said, "My dear Sylvie, I have found your *Venus*."

He had just acquired the painting for the Metropolitan Museum. The Venus in the painting had the air of a courtesan, with a mane of Titianesque blond hair, crowned with a gold tiara studded in pearls, and swathed in a sheet that serves as a veil reminiscent of the shroud of the Virgin. Her body is strewn with pale pink rose petals. One hand coquettishly half hides her breast, while the putto pees on her with a twinkle in his eye. Cupid's stream passes through a laurel crown from which hangs an incense burner. The décor is crude. A red curtain suspended from a branch shields them from prying eyes. Under Cupid's feet, one can make out a patch of grass.

The erotic aspect of the work is obvious, but it is more difficult to put it into a specific context. It was obviously commissioned for someone who intended to hang it in a private space, a boudoir or a bedroom. To hang such a painting anywhere else would have caused a scandal. While the veil

that Venus wears might suggest she is a married woman, the manner in which she is depicted would be more fitting for a prostitute. Is it possible that the painting was a gift to a newly married couple as a poisoned chalice? There are myriad hypotheses.

Unfortunately for France, the much sought-after painting had left the country shortly after the publication of Salomon Reinach's catalogue, and ended up in a private Swiss collection. In 1986, John Pope-Hennessy acquired the painting on the American market when it resurfaced. As is often the case, it was the art market that made the rediscovery possible, although it is also possible to make spectacular discoveries in public collections, as with the Nice *Christ*.

The third great discovery I would like to mention—perhaps the most famous of the last century—occurred on December 16, 1959. Roberto Longhi, on a brief visit to Paris, was in Michel Laclotte's office at the Inspectorate of French Museums studying a pile of photographs of paintings in provincial galleries that Laclotte had gathered over the previous months. Longhi lingered over a scene depicting the *Flagellation of Christ* in the batch of pictures from the Musée de Rouen. The Drouot auction house had come into possession of the painting when it was sold by the Parisian collector Jean Descaussin in 1950. The Rouen museum had then acquired it at a public sale, and added it to its collection under the name Mattia Preti, a seventeenth-century Neapolitan artist of the school of Caravaggio.

The following day, Roberto Longhi, Michel Laclotte, and another art historian, André Berne-Joffroy (who had

just published a book on Caravaggio), climbed into a car. Laclotte recounts the story in his autobiography, published in 2003, in terms that would fire the imagination of any admirer of Longhi. After they arrived at the Rouen museum, Longhi apparently launched into a lengthy disquisition, gesticulating and turning the painting this way and that, before eventually drawing his companions' attention to grooves in the paint layer. These could be seen by holding the painting under a beam of light shining at an oblique angle. As far as Longhi was concerned, this was as good as a signature. Since Caravaggio did not make preparatory drawings on the canvas, he traced the outline of the figures into the paint layer, something that was clearly evident in this work.

André Berne-Joffroy's account is slightly different. Perhaps the incident he describes preceded the wild gesticulations Laclotte remembers? After looking at it from a distance, Longhi then approached the painting, asked for some water to rub the ear of one of the executioners, and having removed the dust, turned to them and said, "Messieurs, this is a Caravaggio."

Berne-Joffroy insists that this is how it happened. According to him, Longhi knew from the moment he first silently contemplated the painting that he had found a canvas by the artist he most admired. Wiping the dust from the ear was merely a theatrical flourish, a conjuring trick before he made his pronouncement. Obviously, Longhi must already have formed an opinion before asking for the bowl of water. As incredible as it may seem, the Eye *knows* at first glance, and only afterward explains his intuition with concrete evi-

dence. That evidence might be the ear or the incised lines in the paint, or both, it makes no difference. The ear was part of a set of criteria, as were the lines made by the brush handle. Had these details not been present, Longhi might have had doubts. That is not to say that his attribution was based simply on an ear, or a line in the paint layer, but these clues confirmed his intuition.

In the article for *Paragone* in which he recounts the discovery, Longhi argues that the painting had been part of the collection of Scipione Borghese, Caravaggio's patron, before disappearing sometime around 1693. This, in my opinion, is mere supposition. We do not know what that painting looked like, nor do we have an inventory number. Nonetheless it is indicative of the form an opinion takes when it comes to being published. Longhi's attribution was based on Caravaggio's techniques and the power of the painting. The rest was merely a means of justifying a controversial attribution, since there were no fewer than two competing versions in Europe depicting the same subject. There is nothing in Caravaggio's biography to corroborate or refute either. We have no signature, no provenance. What supports this attribution is an understanding of Caravaggio's technique and thought processes. Despite these disadvantages, the attribution has won a growing number of supporters. The painting was exhibited in Paris in 1965, in Cleveland in 1971, in Naples in 1985, with a catalogue note by Mina Gregori, which she insisted on writing personally. For Michel Laclotte, who was in the midst of making a complete inventory of holdings in provincial galleries at the time, the discovery was proof of the value

of the project, and demonstrated to French art historians the importance of an approach, then still contentious, that followed the method of his teacher, Roberto Longhi.

Despite the painstaking work done by young curators since the Second World War, it is not impossible that some masterpieces have slipped through the net. The Nice *Christ*, discovered in 2005, is perhaps the best example. The fact remains that now the focus of our research has shifted. It is more far-flung. These days, the prime locations for such discoveries are small museums in the former Soviet bloc, private collections in America, the English castles. It is a list that also includes former palaces of the Maharajas and luxury hotels throughout the world. In the industrial age of the nineteenth century, vast swathes of cultural works were exported, and not just to the United States. But this is something we are only beginning to realize. In the storage rooms of museums in Baku, Azerbaijan, and in Almaty, Kazakhstan, where I organized an exhibition of French art, I found a number of Italian paintings that deserve close study and should be better known. Historians of Western art did not expect to find an important sixteenth-century painting from Ferrara in the collection of Sir Ratan Tata (grandfather of the Indian industrialist of the same name), housed in the former Prince of Wales Museum in Mumbai. As in the United States, wealthy merchants in other industrialized countries felt the need to enhance their prestige by creating art collections from works gleaned during their travels in Europe, and by donating artworks to local galleries. In the United States, great works still waiting to be discovered hang on the wainscoted walls

of Newport residences. Even in France, it was not until 2013, during the refurbishment of the Ritz Hotel on the Place Vendôme, that an inventory revealed that a superb oil painting hung on the wall of the Coco Chanel Suite was *The Sacrifice of Polyxena*, by Charles Le Brun, the great painter to Louis XIV. The picture is now owned by the Metropolitan Museum of Art. Despite the fact that the paint layer bore the artist's monogram, it had inexplicably remained unknown to art historians when it was at the Ritz. In short, the Eye must be prepared to be surprised, and prepared to travel to the more remote, far-flung places in the world.

In English castles, we have been fortunate to discover rich collections. They have been passed down through the generations almost untouched, following the line of succession: according to primogeniture, such collections, together with the castle and its lands, are inherited by the eldest son. For the most part, these collections have been little studied because of the difficulty of access. The lords reside there, and they are often only opened to the public during the summer months. Even when they are officially open to the public, one sometimes feels like an intruder. During a visit to the Duke of Buccleuch's castle in Scotland, I found it difficult to study Leonardo da Vinci's *The Madonna of the Yarnwinder*, which had been the sole reason for my journey. It is often cited as an original, and I wanted to form my own opinion on the matter. Tours are conducted in small groups, with the guide briskly ushering visitors from room to room. I had to tour the castle three times and negotiate with the ladies guiding the tours in order to be allowed to study the painting at my

leisure. "What do you want?" they asked me.

"Simply to know whether it is a genuine Leonardo or a fake."

To my great embarrassment, a week later, *The Madonna of the Yarnwinder* was stolen by thieves posing as tourists. Needless to say, I was absolutely blameless for the heist, which ended in the painting's return several years later. Besides, in my opinion, this work, which now hangs in the National Gallery of Scotland, is a contemporaneous copy. Another comparable work by Leonardo da Vinci, the so-called *Landsdowne Madonna*, remains in private hands, but it is not clear which might be the original.

But let us not forget the most ancient places where discoveries are to be made: churches still conceal some pleasant surprises. Whether in great cathedrals or remote chapels, we continue to make discoveries. I know this from personal experience: there are many reasons that can bring a religious work to the most surprising place. Such was the case with the church in Vico, a small village in Corsica, where I have been visiting my friends the Biancarelli family ever since I was a child. The church has always had a rich collection of old paintings because Monsignor Casanelli d'Istria, a native of the village and bishop of Corsica during the Second Empire, borrowed works from the museum in Ajaccio that had formerly belonged to Cardinal Fesch in order to decorate the church of his native village. One has only to step through the door of this great neo-baroque church to find a setting worthy of any lavish Italian church. One day, with my Corsican friends, while visiting the church for the umpteenth time, I noticed

a beautiful panel that had been turned to face the wall in the sacristy. It bore a number that looked to me like an inventory number. Examining the panel, it became clear that it could only be for a painting: and it was indeed a painted work, though the surface was mottled with white patches where the varnish had suffered from a form of mold called *chanci.* Despite the condition, I could tell it was *Saint Jerome,* and recognized it as a sixteenth-century Florentine painting from the background landscape. I immediately thought of Vasari, because of his rather hard style: the sharp features of the face were visible beneath the layer of crumbling varnish. I wetted the tip of a finger and applied it to the surface. Happily, the white patch faded, because *chanci* dissolves with water. Taking a basin and a sponge, I cleaned the painting completely, then, stepping back, realized that my first impressions had been correct. All of us were very excited, and we immediately went to see the local mayor.

The municipality was able to raise the funds required to restore the painting. Once the repainted areas were removed, the gaps filled, and worn patches made good as far as possible, the resulting painting, though somewhat weathered, was a beautiful discovery. And a painting by one of the most important figures of sixteenth-century Italian art at that. Vasari was an exceptional draughtsman and one of the greatest decorators of Florence. This was typical of the sort of discoveries to be found in places that, though isolated, are familiar and not close at hand. Once you know that various churches in Corsica were endowed with more than five hundred paintings taken from the Fesch Collection, and that no

one has ever conducted a systematic inventory of them, you realize that there may be further wonders hiding in the rocky crannies of the island.

Such adventures and discoveries have a romantic charm, and it is hardly surprising that people take great pleasure in retelling them. And I believe that this is also the aspect of our profession that most intrigues the general public. But do not think that the primary vocation of an Eye, his daily routine, entails the search for great discoveries. Federico Zeri possessed one of the keenest eyes for Italian art of the twentieth century, and yet never made a great discovery. Roberto Longhi was already a famous and highly esteemed historian before he discovered the *Flagellation of Christ*. His most enduring legacy that reflects his intelligence and his dedication are not his attributions but his monograph on Caravaggio. The greatest honor an Eye can aspire to remains the esteem of his peers.

Risky Business

O ur profession leads us to produce papers that we hope will enhance the sum of knowledge: those articles detailing attributions we have mentioned. In doing so, we enjoy the rights that come with intellectual freedom, including, first and foremost, the right to be wrong. In principle, our position as academics shields us from the potentially serious financial consequences that such errors can lead to on the art market. Nonetheless, as we have seen, art dealers continue to tempt Eyes, hoping to use their prestige to reassure their clients and incline them to pay exorbitant sums. The documents that dealers seek from an Eye are of a very different nature to those he usually produces, and dealers are willing to pay handsomely for them, but they amount to a legal commitment. These documents are termed *appraisals* and, in principle, should only ever be issued by established experts. Unlike an Eye, the job of an appraiser is to make it possible for major auction houses like Christie's and Sotheby's to sell paintings certified by the most prestigious name possible. Their working methods are entirely different from ours. They may well have a keen eye, but more

often than not, they simply review existing published studies and scientific tests in order to decide whether a painting can be definitively attributed to the purported artist, as the auction houses fervently hope. The documents they produce earn them a percentage of each transaction. However, it is also true that they are taking a considerable risk. In 2010, when the German forger Wolfgang Beltracchi was arrested, the curator of the Pompidou Center, who had been taken in by several fake Mondrians, was able to avoid allegations of complicity by proving that he had acted in good faith. However, the expert appraisers, who had also been duped and had also in all likelihood acted in good faith, were compelled, in other cases, to reimburse significant sums of money.

Lawsuits have become so commonplace in the years since then that one cannot help but wonder whether some collectors take a perverse pleasure in them, the thrill of the trial prolonging the heady intoxication experienced in the sales room. For this reason, such experts must be insured; otherwise, they risk bankrupting themselves. The same holds true for the Eye: if we make a written commitment to an art dealer or a buyer, they are entitled to sue us if we have made an error. This is perhaps also why, for the most part, we avoid doing so, especially because we deal with paintings that may be valuable, indeed extremely valuable, whose market value could change a hundredfold on the strength of our appraisal.

Nevertheless, it has happened that art historians make appraisals. These practices marked the beginning of the end of the profession of the Eye. It began with Berenson providing written attributions to Joseph Duveen asserting authorship

based solely on his conviction so that the dealer could sell his paintings. These appraisals have been justifiably criticized, all the more so since some of Berenson's attributions now seem inconceivable. He has been criticized for penning inflated appraisals for Duveen and for offering substandard advice to Isabella Stewart Gardner on many occasions, persuading her to pay small fortunes for works of little value, some of which were even suspected of being forgeries. That said, all of the investigations undertaken into the matter have tended to exonerate him. In the case of the *Portrait of Philip V*, which Berenson attributed to Velázquez, though it had been long thought to be a copy or a forgery, scientific tests carried out in 2011 demonstrated that it was neither. That there were suspicions about his attributions does not mean that he was dishonest. He simply placed himself in a position where his personal interests conflicted with his professional appraisal. To some extent, confidence in his eye has thereby suffered. Berenson's published lists of authenticated paintings and their whereabouts, which eschewed the reason-based justification so crucial to art history methods, but which he nonetheless included in his key books, have led some to dismiss them as mere compilations of his appraisals, forgetting that these in turn are a reflection of his opinion. By studying his photographic library and retracing the classification of the photographs on which he noted his attributions by hand, it is obvious that he believed in these attributions, even when they seem questionable. Berenson had a passion for attribution, and the eloquence of his view of Italian art as a whole, and the organization of his photographic library containing

those attributions made for Gardner, does not lead one to conclude that he intended to deceive her. Even if we no longer understand some of his decisions, taken out of context, it is important to remember that the sum of knowledge today is not that of Berenson's time; it has developed, and we cannot now judge his intentions simply on the basis of certain errors. In fact, those casting aspersions on Berenson's integrity, something that has happened only recently, have been motivated by observing the practices of contemporaries far less scrupulous than Berenson. The dual role of Eye and appraiser opens the door to all sorts of excesses. It is a role that has continued through Longhi, who would write appraisals on letterhead stationery that Alessandro Contini-Bonacossi would then show to potential customers.

It seems clear that, since Berenson's time, the Eye is the only art historian who can enrich himself. The well-lined purses, lavish lifestyles, flamboyant events, opulent collections—all traits recalling those of the great art dealers— have fueled gossip by malicious people, who may simply be jealous. All sophism aside, the Eye should not open himself up to criticism by offering appraisals. The moment an art dealer can approach a buyer and say, "Look, I have a letter here from Roberto Longhi," the art historian crosses the line that separates him from the appraiser, and accusations of venality are bound to arise. The line to take is this: the appraiser and the private buyer turn to art historians when they need to catalogue a piece for an auction, but as a matter of professional ethics the art historian should not become an appraiser and should leave to others the business of preparing appraisal

documents and collecting commissions. This, fortunately, is quickly becoming the norm. To prevent the process of making attributions from turning into an echo chamber for the art market, *The Burlington Magazine*, the prestigious art history journal, requires that any article concerning the attribution of a painting currently in private hands must come with an assurance that the painting will not be sold within the next three years. In doing so, the distinction between appraisal and attribution is guaranteed, at least one may hope so.

To better understand the potential challenges to an Eye's integrity, it is worth considering their foremost tempters, those art dealers whose actions can threaten the reputation of the greatest among us, and have led to the ruin of many.

To begin with, one cannot deny their extraordinary instinct, their flair. They move between estate sales, public and private auctions, household clearances, and flea markets where paintings are presented in bulk, and are quick to identify those works worth snapping up. They assess the condition. They can tell when a painting is beautiful; they can also tell whether it is bankable. An ascetic saint in monk's robes with his eyes rolled heavenward does not sell as easily as a Cleopatra tossing a pearl into a cup (a scene whose fascination has never palled). They can discern the century and the school, and often they may have an idea as to the artist. But in this they are frequently mistaken, since they are intent on linking paintings to great masters. Their intuitions need to be corroborated by someone who has studied the artist, ideally the author of the most recent catalogue raisonné, if one exists. The more important the Old Master, the fewer Eyes

an art dealer will find prepared to commit themselves. We are intimidated by what is at stake financially. We are not trained to have an opinion on the financial value of artworks and are disconcerted to realize they can be worth twenty, thirty, even forty million euros. To commit ourselves would mean assuming responsibilities that have nothing to do with knowledge, and, with some exceptions, we do not like to get involved. This is doubtless another reason for my perverse taste for minor artists. But then again, sometimes one is bound to make discoveries, and it is impossible to shirk the pressure of these requests all one's life.

Over and above the remarkable cases I have mentioned, a number of art dealers have shown me works they hoped were by Pontormo, Bronzino, Salviati. Often, it was my duty to disillusion them, demonstrating that they did not have a Pontormo but a Jacone, not a Bronzino but an Allori, that the drawing they believed was by one of these great masters had been sketched fifty years after that master's death. This should not matter, since the drawing or the painting remains the same, but for an art dealer, a name can change the price dramatically. It is an absurd logic. A work by Jacone may be exceptional. It does not matter. In comparing a Jacone to a Pontormo, a buyer will see the price gain a zero or two. Hence their poor opinion of Eyes: some of us have bowed to the senseless logic of the market and unscrupulously feed it. It is true that at flea markets or in the basement of the auction rooms at the Hôtel Drouot amid the bric-a-brac and jumble, a trained Eye may discover unexpected masterpieces. Such finds have become so mythic that an Eye will often say,

"If I'd seen it in Drouot or at the flea market, I wouldn't have looked twice," or, "I probably walked straight past it at the Hôtel Drouot."

In 1998, while I was researching the works of Bronzino at I Tatti, an English appraiser showed me a painting that had been brought to him by a young couple who had paid a pittance for it at a flea market. The couple were splitting up, and wished to sell it. The expert realized that he was in the presence of an extremely important sixteenth-century work, *Saint John the Baptist Drinking from a Spring*, in which the saint is gazing at the viewer, bringing to his lips a cup of water. It is a classically Florentine subject. Being a specialist in drawing, he thought it might be by Pontormo: one of his most dazzling red chalk drawings in the Uffizi in Florence handles the same subject in a similar way. But looking at the photograph, I felt a shock. It was one of the purest and the most extraordinary works by Rosso Fiorentino. This was the first that I ever attributed to him. It was an exceptional work. Though other experts did not agree with my assessment, the treatment of the tapering hands, the bubbles on the surface of the water spreading around his sharp, almost hooked feet, his unsettling gaze as he stares between individually painted strands of hair, made it clear to me that it could only be his work.

People who buy at flea markets or at the Hôtel Drouot, like heirs and occasional buyers, do not always have a clear idea of the works they are acquiring, works that can be extraordinary. If they are steered toward a bad purchase and they realize it, they have to quickly decide what to do. In

1993, a remarkable painting was offered for sale at Drouot-Nord, in the Goutte-d'Or district, a subsidiary of the auction house that chiefly sells televisions and household appliances. The painting was withdrawn at the last minute by its owner, because the auctioneer realized, perhaps from the startled look on the face of a prospective buyer, that he was about to bring the hammer down on an unusual transaction. In fact, in the art world, word of the work quickly spread, suggesting that the painting, *Saint John the Baptist in the Desert*, was a masterpiece by Georges de La Tour. Dealers and collectors jostled to acquire it. It was said that some New York art dealers had booked flights on the Concorde so they could arrive in Paris on time. But the owner withdrew the painting from the sale and it was auctioned instead through Sotheby's in Monte Carlo. It was a mistake on his part. The element of surprise would have caused a flurry of excited speculation at Drouot. But once the excitement was past, the painting ended up selling for a normal price. Regional authorities were able to acquire it for the Musée Georges de La Tour at Vic-sur-Seille in northeastern France.

I myself go to Drouot as seldom as possible because, for obvious reasons, I do not want to feel the urge to collect common to all Eyes. This great auction house opened during the Second Empire, on the Rue de Richelieu near the Grands Boulevards, at the initiative of the Parisian departmental council known as the Société de Commissaires-Priseurs. In addition to catalogued sales, on any day of the week, I find more than twenty halls—if one includes the annex on Rue Doudeauville—where auctioneers conduct clearance sales on

behalf of private individuals, with no prior expertise, and no catalogue. If one wants to know about the lots on offer, the only way is to physically search through the wicker baskets there put on display just one day before the sale. A torrent of objects flows into the auction rooms all year long, and flows out at the same rate. It is utterly unlike the major British and American auction houses with their carefully agreed calendars. It is not difficult, therefore, to imagine that, with a little luck and a very keen eye, one might cheaply acquire paintings that would sell for millions at Sotheby's or Christie's in London and New York.

The Hôtel Drouot has thus become the central hub of the art market in France. Yet at the same time, it can be an extremely dangerous place. The fantasy of getting a bargain can become a drug. There one can see throngs of people, some in rags, others with pearl necklaces. The art dealers are represented by their scouts. On a whim, bidders can send prices spiraling out of control. From time to time, one will encounter art historians, spending money like water. They are casting themselves in the roles of Berenson, Longhi, or Zeri when they assembled their collections. But though they may have their tastes, they do not have the same means. Which is why the Hôtel Drouot can be the ruination of a man.

On the other hand, it is too easy to be moralistic about the market. It has brought so many remarkable works to light that when someone offers to show us a painting, we must know how to respond graciously, otherwise no one would ever show us anything. It is impossibly idealistic to suggest that an Eye could basically stay silent, simply thank the owner

of a painting, and then write an article for the benefit of the art community without informing the owner of its contents. The owners have a crucial stake.

There are two main scenarios with which I can find myself confronted. In the first, the artist is not whom the art dealer claims. This kind of situation is not awkward, especially if the new attribution does increase the value of the work. The dealer owes me nothing; I have not told him what he wanted to hear, but I have given him my opinion. In the second scenario, the painting is genuinely that of a great artist, thus meaning it has great financial value, and, whether it is by the artist the dealer suggested or another major artist, I am suddenly balancing on a tightrope over an abyss. Because, after all, to provide a service of this nature requires a fee. This is negotiated on a case by case basis, depending on the situation. And indeed it works differently for Eyes who are neither academics nor curators. Independent Eyes seek only to preserve their reputation. There is no reason for them not to earn a commission, on the condition that they declare it to the tax authorities. For Eyes who are academics or curators, the problem is a thornier one. The university could charge commissions, but their moral compass dictates that they serve the state that provides their funding. More often than not, they will put dealers in touch with public galleries who, in their view, will make good use of money. But in England and the United States, academics often act in the same way as an independent Eye. When I attributed paintings to Bronzino or Pontormo, Janet Cox-Rearick accepted liability, producing the appraisal documents I declined to

write and taking a commission. Personally, as with any Eye who is also a curator, I am strictly bound by the terms of my employment with a museum. Our duty is to use our skills to enable museums to acquire works at the lowest possible price. The ideal solution would be to buy the work as though it were an unremarkable painting, and only attribute it to a great master after the fact by placing a plaque on the frame. But since art dealers are suspicious of such encounters, the solution is almost never that simple. Most of the time, we honestly communicate the nature of our findings before the sale. We do so without charge, and in exchange, as part of the negotiations, we argue in favor of selling to a public museum, which would mean financial concessions on both sides: the museum pays more for the work than it would have if the Eye had not communicated his findings to the dealer, who in turn agrees to sell at a preferential rate. Over many such agreements, art dealers can make great concessions. A *Portrait of François I as St John the Baptist*, painted by Clouet in 1518, was donated in 2005 by the sons of Daniel Wildenstein, one of the most famous dealers in Old Masters of the twentieth century, to the French state as a gesture of gratitude. It is only the latest in a long series of gifts by which national collections have been enriched.

Our attributions can mean that paintings sometimes fetch astronomical sums, making it difficult for them to be acquired by public institutions. Therefore, we must be extremely circumspect when we publish, and ensure that the work in question has already fallen into good hands. We must also take circumstances into account. In times of

economic crisis, public galleries cannot release large funds, whereas in more favorable circumstances, it may be possible. When a museum is not in a position to proceed with a purchase in a timely fashion, it must withdraw. Barbara Piasecka Johnson, a young Polish woman who became famous when, as the primary beneficiary of her husband's will, she became the sole owner of the Johnson & Johnson pharmaceutical empire, took advantage of an economic crisis to buy two drawings by Raphael, snatching them from under the noses of several major museums. The drawings, from the collection at Chatsworth House, including the *Head of a Young Apostle*, which served as a preparatory study for *The Transfiguration* in the Vatican, had been put up for sale at Christie's London by the Duke of Devonshire, who needed money to maintain his stately home. In 1984, when it was sold, the eventual price of 3.3 million pounds made it the most expensive Old Master drawing ever sold at auction. When in turn Barbara Piasecka Johnson was in financial difficulties, having bought the shipyards of Gdansk, the *Head of a Young Apostle* once again went under the hammer, and was bought by the J. Paul Getty Museum in Los Angeles. We can only be thankful that such a work is now part of the collection of a great museum. One always hopes that masterpieces will eventually end up in public galleries and museums. This is not to say that every work that goes on sale should go to a public institution. The art market is a good thing: works are bought and sold, and this in turn piques the curiosity of art lovers, and ultimately leads to new discoveries.

There are also cases of more or less honest art dealers

and corruptible art historians. I will mention only the most famous cases, those dealing with works by Leonardo da Vinci, Raphael, and Titian, who are not just the most valuable artists but also those who have most frequently been copied over the centuries. Every collector was desperate to own works by them. In the seventeenth and eighteenth centuries, when scouts sent by princes and cardinals could not find them, they brought back copies. These copies were often more expensive than famous paintings by contemporary artists. Faced with a nearly infinite number of copies, there is an almost irresistible temptation for an art dealer to claim that he owns the original and that the painting hanging in a gallery is merely a copy, and to seek out an art historian who will support his claims; the ploy is all the more simple since, in their lifetime, the artist's ateliers will have produced copies of their most successful works.

This was how Carlo Pedretti, one of the foremost contemporary experts on Leonardo da Vinci, managed to ruin his reputation by publishing appraisal documents that were simply specious. He attributed a series of works—all of which, strangely, belonged to private collectors in Switzerland—to the greatest of Italian masters: a portrait of Isabelle d'Este, a "big sister" of the *Mona Lisa*, but also a naked Mona Lisa, and amusingly, an angel with an erection. It is not difficult to imagine that Leonardo means gold to the unscrupulous appraiser. Pedretti, who died a day short of age 90 in January 2018, was motivated not by hunger for knowledge but by the need for money, and a taste for publicity. The University of California, Los Angeles, bestowed on

him the Armand Hammer Chair in Leonardo Studies. Since Pedretti, despite his fantasies and his slapdash methods, was nonetheless a great art historian who contributed profoundly useful and reputable knowledge to the field, his name represented an invaluable guarantee for an art dealer who had not been forewarned. Now, any work that bears his appraisal is problematic.

It would be easy to think that Pedretti ruined his life's work. But that is not true. Surprising as it may seem, his appraisals provided fodder for headlines in the international press and provoked knowing smiles from his colleagues, who nonetheless have carried on using his research. It would seem that the risks of the profession are not so high after all. None has held it against Pedretti when his attributions were not confirmed, or even when they have been refuted. The art dealer knows that he is only buying a rumor. Pedretti's crime was simply feeding the dream machine, giving the genuine impression that he believed in what he was doing, all the while satiating the demands of his lavish lifestyle.

In my own case, those who may envy me have no problem in falsely claiming that I have accepted secret payments from art dealers for my attributions of works by Pontormo and Bronzino. But a reputation for acting in good faith can only be earned over time. For me, what matters is finding a Pontormo or a Bronzino. Certainly, it is easier to find them in museums, as I did in Nice, but they are well worth taking an extra risk. The Eye who spends his time only in respectable institutions, who would not think to cultivate a relationship with art dealers and turn the situation to best advantage,

would not be worthy of the energy spent on his training. An Eye will never be above suspicion.

The problem of figures like Pedretti is that they encourage others who are attracted by researching the sensational, since it entertains the public and is much reported in the media. In 2012, the publication of a cache of purported Caravaggio drawings sparked incredible upheaval. We know that Caravaggio, though born in Milan, where he trained with artists who were ardent draughtsman, forsook drawing. We do not possess a single sketch by his hand, and in his paintings, we clearly see that he painted directly on the canvas, without preparatory drawings. This, however, did not prevent two self-appointed experts—unknown in the field of Caravaggio studies and the art world in general—from using the collection of Lombard drawings from Milan's Castello Sforzesco in this connection. By shifting around a series of sheets, some of them by Caravaggio's master, Simone Peterzano, and by creating with considerable theatrical skill photo montages that superimpose drawings by hands and from eras manifestly different from those of Caravaggio's paintings, they managed to get their "find" widely reported in the most prestigious Italian newspapers. Their claim was to have rediscovered a cache of drawings executed by Caravaggio as a young man, which he had then carried with him throughout Italy. Given Caravaggio's tumultuous life, we know that is impossible. The men in question consulted no recognized authorities, they trumpeted their theories with the sole purpose of establishing a reputation and making money. The story was repeated endlessly. Even *La Tribune de l'Art*, a website for which I have

much respect, felt forced to cover the story, if only to refute it. Not a single art historian believed in the find. But such is the media's demand for sensational material about our profession that spurious ideas that do not warrant ten seconds of attention monopolize the efforts of the community for weeks on end.

In public, an Eye is forced to play a paradoxical role. He is expected to demonstrate a passion for the unknown, to produce sensational news stories, all the while adhering to a professional code of ethics. The Eye will always be a demonic figure. Even if he were beyond reproach, people would fault him. Perhaps it is this strange paradox that explains the appeal of figures like Berenson, Longhi, and Zeri. However much they may have been discredited, they remain the most fascinating art historians. They are the legends of our profession. Deep down, the greatest temptation an Eye must confront comes from the general public.

The Many Lives of the Eye

Anyone can experience an aesthetic shock. It is comparable to other emotions, like nostalgia or pleasure, whereas the gene possessed by an Eye, if there is one, is a mystery. An art historian may feel moved. But however brilliant, however romantic he may be, he will not be able to identify the source of his emotion, and if he can distinguish between a work of the fifteenth and the nineteenth centuries, that is simply a matter of education. One need only have spent time in galleries and museums to be able to recognize a Raphael, a Poussin, a Vermeer, a Delacroix, a Manet, a Mondrian or a Matisse, but the Eye alone can enter into the work. However, I believe that this perception that the Eye possesses exists in a variety of professions. I believe we are born with an eye, and it is shaped by culture and education. A great photographer or a respected fashion editor would probably have been an equally great connoisseur of art. Conversely, Zeri would probably have had much fun advising Valentino. Here we will discuss the many lives of the Eye.

Obviously, if Eyes are crucial in the world of Old Masters, they are also indispensable in the field of contemporary

art. They divide broadly into two categories who work hand in hand, critics and gallery owners. I have a much greater admiration for the latter. Critics are not only able to see, like any Eye, but they analyze, theorize, and draw conclusions. Through their writings, they help an artist to sell and to achieve recognition, but they are often afraid of being out of touch and overlooking artists who deserve recognition. Gallery owners focus on what is essential, which is to exhibit works; they devote their lives not to writing but to supporting artists who might otherwise languish in anonymity. Like everyone else, they attend the key events of contemporary art, like the Venice Biennale, where artists invited to show in the pavilions sometimes spring extraordinary surprises. But they are also willing to pick up rough diamonds in the most unexpected places, which sometimes entails taking a real risk. They are passionate about their work; they are not afraid of coming up against hard times.

One afternoon in 1986 or 1987, I had the good fortune to meet two of the most import gallery owners of the last century. Beneath a little pergola in Madrid, in the company of an artist and a collector, Ileana Sonnabend and Leo Castelli told us how they got started in their profession.

That morning, I got up early to admire Tiepolo's frescoes in the Royal Palace, as Ileana Sonnabend had done years before. This was the start of our conversation, and I was soon able to ask all sorts of questions about her past. Leo Castelli, her partner, whose father was a Hungarian Jew, came from a wealthy Trieste family. He and Sonnabend met in Paris during the interwar years. Sonneabend came from a wealthy

Romanian Jewish family. It was not long before they lived together, and moved into the Ritz, where they kept up a lavish lifestyle. Their days were spent with avant-garde artists and writers; they were on first-name terms with almost everyone who was anyone since Paris, being the capital of art at that time, attracted young talent from Europe and the world. In 1939, everything changed. The Nazi machine roared into life and it was time to leave. They left. They moved to the United States. Life cannot have been easy for them when they arrived in New York, and Castelli enlisted in the U.S. Army, serving in southeast Asia. When everything had calmed down, they were granted U.S. citizenship in exchange for their years of service in the defense of the United States. Thanks to treaties between her adopted country and the Soviet Union, Sonnabend was even able to repatriate some of the family property. Having never worked a day in their lives, they were now forced to earn a living and decided to devote themselves to the only thing they truly knew, and opened an art gallery. A few days before their first exhibition, the couple found themselves in the company of Robert Rauschenberg, whose work was the subject of that show, while his partner regularly interrupted their conversation, bringing cups of tea. Rauschenberg had been telling them for weeks they should see his partner's works, that he, too, was a talented artist. But nobody made the effort.

At some point—I don't quite remember how—Castelli and Sonnabend finally ended up in the studio containing the paintings of the twenty-four-year-old artist. I cannot remember whether it was him or her, but he or she experienced one

of the biggest shocks of their life. On the wall hung a painting of an American flag. An object familiar to everyone, but executed with great care. Red, blue, and white, made using a mixture of pigments and molten wax, were applied in thick layers to strips of newsprint. Despite its symbolic character, it felt like pure substance; it demanded to be touched, every inch of it scrutinized. The young artist who had painted it was Jasper Johns. Sonnabend and Castelli decided to cancel the planned Rauschenberg exhibition. Their gallery opened in 1958 with a solo exhibition by Jasper Johns, his first, exhibiting a series of works he had done since meeting Rauschenberg, and which made him the greatest American artist of the twentieth century.

Although on the day we talked in Madrid, the two gallery owners were tossing out dates and events, just listening to them it was still possible to sense the shock they had felt thanks to their eye. Sonnabend and Castelli had felt a shock merely by looking, a shock that was more than aesthetic: they saw that Jasper Johns's work was fundamental. One might be forgiven for thinking it is conceptual—and it *is* conceptual—but before there is thought, it first passes through the eye. They immediately understood that this was among the greatest work of the twentieth century. Presumably what they felt was similar to how Carlo Falciani and I did when we recognized the lost Bronzino *Christ* in Nice. The rush of excitement must surely be the same regardless of the nature of the discovery. I can only imagine what Christopher Columbus felt on first seeing America, or Albert Einstein working out the theory of relativity.

Even though it is not my area of expertise, like any Eye, I would claim that my eye is sufficiently acute to recognize whether a contemporary work of art is significant. I have an interest in contemporary creativity that seems to me indispensable for someone attempting to understand the art of past centuries. Unfortunately, in much contemporary creative work, the eye is secondary to intellectual activity. Even in the case of an extraordinary work, like Jasper Johns's *American Flag*, the stakes are not entirely artistic. When faced with Jasper Johns, the couple recognized his significance for the modern art world: after Malevich's *Suprematist Composition: White on White* and Marcel Duchamp's urinal, was it still possible to create something revolutionary, or did we have to accept that everything had already been said? Despite what seemed like a dead end, creativity discovered new strength, unimagined resources, and the work of Jasper Johns was one of them. In a very troubled world, where it seemed that everything had been said, the eye had to find something new to add, something that could not merely be reduced to technique, subject, or idea. With all due respect to those who like the formula, while a painting by Bernard Buffet may be extremely aesthetic, and his technique impeccable, what exactly does it contribute to the history of art? What, then, is the relationship between the eye of the gallery owner and the eye that makes an attribution? The question is not easy to answer. I can say that filling out the corpus of minor Old Masters is hugely enjoyable, but it is an academic enjoyment. The paintings of a minor master, even when ugly, can still be pleasing, whereas the paintings by

second-rate artists after 1918 are often poorly executed and painful to look at. Such paintings are daubs, and daubs do not add to the development of art, often offend the aesthetic senses, and are financially worthless, so gallery owners take no interest in them; on the other hand, it is understandable that they are filled with wonder when they stumble upon something remarkable. Since the First World War, there are no schools, at best there are *trends*; talent is more individual, more unpredictable.

For example, in the 1970s, it seemed that painting had definitively become a secondary pursuit, but since the 2000s, it has made a comeback. Those artists who wished to paint needed to find an original way to combine a technique that is age-old with the expectations of originality that characterize public interest in contemporary art. As an example, one of the figures of this renewal whose work I particularly love, Olivier Masmonteil, devotes himself exclusively to landscape painting. In 2011–2012 he painted a series of very small canvases, twelve inches by twelve inches, each representing a different place. These are fairly traditional landscapes, executed with a photographic eye for details, but the originality is linked to his hectic life as a traveler, and the process by which the works are created. It comes, in fact, from the juxtaposition of a variable number of these tiny canvases. It is the curator, the gallery owner, or the private collector who, each time, creates the meaning of these works of art. Faced with an exhibition, that is to say, a wall covered with dozens of these diminutive landscapes, we move from the salt deserts to the mountains of Japan to seascapes. It is

work that is very exciting to the eye, very reliant on photography, and in the end just as conceptual as works that are classified as such. So I admire the eye of the gallery owners who make it possible for such works to exist. I admire their commitment.

Among them, one might cite Emmanuel Perrotin, who deserves mention for his remarkable intuition. He will exhibit any form of art in his galleries in Paris, New York, and Hong Kong, as long it brings something new to the art scene in terms of spirit or creativity. One of his guiding principles for exhibitions is that the public must take pleasure in them. This reflects a sensibility that has always existed, and is certainly not specific to contemporary art. It may be found in the ludic nature of the capitals on Roman pillars or the teeming canvases of Hieronymus Bosch and the followers of Caravaggio with their focus on the comedy of the everyday. To do this, Perrotin travels widely, exercises his eye everywhere and he is prepared, when necessary, to make sacrifices. What other gallery owner would gladly have played along with Maurizio Cattelan by wearing the unforgettable costume for *Errotin, le vrai lapin?* This curious candy-pink outfit was commissioned by the Italian artist from a costume designer at the Rome film studio Cinecittà to resemble a sex toy, with two large protuberances on the thighs, the body tapering as it rises up the torso, and a cap of a lighter pink, from which dangle a pair of ears. For a week, Perrotin lumbered around in this unwieldy costume to the amusement of small groups of visitors, who quizzically contemplated the white cotton rabbit's tail between the buttocks. Five years later, Cattelan would

achieve true fame when he created his fallen Pope, a life-sized effigy of Pope John Paul II, molded from wax like a figure at Madame Tussauds and writhing on the floor clutching a large crucifix. A meteorite has just struck the pontiff and ice splinters are strewn over the red carpet. *La Nona Ora* was sold for eighty thousand dollars at the time, and was recently resold for three million dollars, though this meant no additional profit to the artist. Such a meteoric rise is typical of the artists discovered by Perrotin.

He has demonstrated an eye and a passionate gift for artists who have since become major figures. His first exhibition in France in 1996 was of the dreamlike installations of Japanese artist Mariko Mori; he also represents Jean-Michel Othoniel, who became a quasi-official artist when, using glass spheres, he created a new entrance for the Palais-Royal Métro station on the Place Colette, only a few steps from the Ministry of Culture. Similarly, the multicolored works of Takashi Murakami caught Perrotin's eye, at a time when no one else was interested in them. In fact, it is hardly surprising, since these slightly artificial fantasies were entirely in keeping with Perrotin's ebullient personality.

A great gallery owner has an eye, but he also has intuition. An artist does not necessarily need to have an eye. His role is that of creative genius. The paintings of Matisse, whom I consider the greatest painter of the twentieth century, are pure creative genius. And yet in certain art forms, such as photography, having an eye is crucial; it is what distinguishes a good photographer from a bad one. When viewing a scene, a photographer's eye instinctively chooses the best way to

frame it. There are Eyes who work quickly, like Robert Capa, and all great war photographers. For them, the initial shutter release is in the eye, and operates based on intuition rather than memory. The eye immediately recognizes that what it is seeing, at this moment, is exceptional. Other photographers stage their work, using carefully crafted details. The eye does its work, the photographer senses that he must press the shutter release at this precise moment; it is only afterward that the photograph is revealed. A photographer's eye works in two separate stages. The greatest photographers are not simply those who press the button at the right moment but those who have the skill to choose and crop their shots, those who do not keep everything but pare down their images to present only the best. In hindsight, we realize that even fashion photographers like Benno Graziani, the great society photographer for *Paris Match*, had an exceptional eye. When one lines up a series of his photographs, each has something unique about it. They captured a moment one saw in the pages of the magazine with its images of actress Catherine Deneuve, John F. Kennedy, and Oleg Cassini, couturier to Jackie Kennedy, or Brigitte Bardot or Gianni Agnelli, the legendary head of Fiat.

Similarly, we can now see that no one has ever photographed Paris in the way that Henri Cartier-Bresson did. It was his eye that made it possible to capture the world of Bonnard and Matisse on film. It is extremely difficult to explain what distinguishes a great photographer from a merely ordinary one. In painting, one can rely on technique, but in photography, it truly is the eye that captures a moment.

Indeed Cartier-Bresson always refused to work in color. That, he felt, would have made him an *artist*. He wanted to be something else. Take his photograph *Rue Mouffetard, Paris (1954)*: a small boy swaggering down the street, proudly carrying two bottles of wine. A split-second later, that triumphant smile might have disappeared. Of course, not everyone can be a Cartier-Bresson or a Brassaï. Many photographs, pleasing as they are, are merely the result of chance circumstances rather than the photographer's work. Anyone can take a good photograph if they have luck on their side. Over time, we learn to select, to have a clearer view of photographic production. Although these celebrated photographers, some of the greatest witnesses to the twentieth century, did not see themselves as artists, today we recognize their genius.

When painters revolted against the photograph, in a sense, they may have been revolting against the eye. This merely serves to show the crucial role of the eye in the work of an artist. Photography revolutionized painting because it could capture the raw reality painters were striving for. The very raison d'être of Impressionism stems from the birth of photography. Painters no longer needed to represent reality; instead, they painted their emotions. But even in this, they could not break free of the eye. The first intimations of abstract art also derive from photography. In 1889, the Eiffel Tower—that enduring monument conceived as a temporary construction—was photographed from every angle by Henri Rivière: what is striking are the abstract details in which diagonals, invariably moving out of the frame, constitute strange networks of lines, volumes and spirals.

Cinema, which one might be tempted to define as the art of telling stories, depends on the eye, especially in those moments of radical transformation. *Le Mépris* (*Contempt*), Jean-Luc Godard's 1963 Technicolor masterpiece of the nouvelle vague, owes as much to photography as it does to painting. It is constructed around moments and images: Michel Piccoli climbing the stairs of the Villa Malaparte, atop which Brigitte Bardot lies on her stomach, her nakedness hidden by a detective novel, surrounded by warm colors and overlooking the sea. It is the filmmaker's eye that moves and surprises us. The eye is in the detail: Michel Piccoli in the bath wearing a hat, Brigitte Bardot in a black wig. It is *our* eye that sees. The filmmaker needs to make us see. In doing so, he triggers something that affects not only our aesthetic sense, our tastes, but appeals to our intellect. In the end, the plot melts away behind the game of looking. What is truly revolutionary about Godard is that, although we are looking at a succession of images, what we *see*, above all, is a film.

We cannot know the limits of the eye. It evolves according to technical and aesthetic transmutations. The video artist, a figure that appeared at the turn of the 1980s, is one of the most recent mutations. The objective of the video artist is to make a work in which narrative is not a principle element. It is sometimes said that video artists are trying to produce the works that artists of an earlier age would have made had they been able to represent motion. The eye has thus integrated a fourth dimension, time, to its ability to perceive length, breadth, and depth.

There are, then, a range of professions in which the eye plays a role. What distinguishes a good graphic designer from a bad one is his eye. I do not know whether a designer's eye works in the same way as that of an art historian. But it is certainly true that we all work on instinct. A page layout depends on visual ideas, on flashes of inspiration. The attribution of a painting also takes place in a flash. We stand in front of a work. *Boom*, we suddenly, instinctively know the artist who painted it. It is only afterward that we verify. We always verify, but the attribution came in a flash. It is something akin to a revelation. The case of the Bronzino *Christ* in Nice is akin to the story of the French playwright Paul Claudel's mystical conversion as he stood behind a pillar in Notre-Dame Cathedral on Christmas day, listening to the choir sing Vespers: "In an instant, my heart was touched, and I believed," he wrote.

To have an eye is to react. Like doctors who diagnose symptoms in a patient. Like fashion editors who only have to watch a catwalk show to make something happen. They see dresses pass by and then send them out into the real world. This is how fashion is made. Because fashion trends do not come from designers alone, but from the eye and the vision of fashion editors. Anna Wintour, the famously spiteful editor-in-chief of *Vogue*, the grande dame who was the inspiration for *The Devil Wears Prada*, gets to call the shots in the fashion world because she has an exceptional eye.

The curator, relatively speaking, plays only a small role in contemporary art. It is his eye and his alone that makes decisions when it comes to hanging an exhibition. If he does not

have the eye, visitors to temporary exhibitions may entirely miss the intent of the organizer. The images will not speak to them as they should. It is easy to tell an exhibition that is not well designed from one hung by a curator who aims to please the eye and give a twist to the usual layout of an art show. Though the designer is aware of the didactic nature of an exhibit, and its role in educating visitors, he also puts himself in their place and ensures that the flow of the display is pleasing. The chief aim is to show works, to engrave them into the minds of visitors, since the descriptions of the works are in the gallery texts affixed to the wall, or in the catalogue. An intelligent hanging should make it possible for the visitor to move through the exhibition without requiring any explanation. Hanging artworks is a way of transmitting one's knowledge to another.

As a museum director, curator, and exhibit designer, I always try to apply this principle. My aim is for the novice passing through to understand simply by seeing. As director of the Musée de Beaux-Arts in Ajaccio, Corsica—a museum that owes much to the imperial House of Bonaparte—I have tried to go a step further. Cardinal Fesch, uncle of Napoleon Bonaparte and perhaps the greatest art collector of all time, acquired some sixteen thousand works in France and Italy. On his death, most of the collection was broken up and sold, but a thousand paintings were returned to his hometown of Ajaccio. For the reopening of the museum, in 2010, I recreated a gallery to resemble those of the Roman Catholic cardinals of the eighteenth century: paintings hung close together, without consideration for subject matter or period.

It is perhaps thanks to my eye that I was able to imbue the space with an atmosphere, to make the paintings work together. This recreation is perhaps my finest piece of work as an exhibit designer; it is also the room that visitors to the museum find most striking.

I Admit I Was Wrong

The words "I Admit I Was Wrong" provided the title for Federico Zeri's last autobiographical work. In *Confesso che ho sbagliato*, published in 1995, Zeri does not admit to mistakes, nor cast doubt on any of his attributions; he simply suggests that he could have had a different career. He wonders whether, in an ideal world, he might have had another vocation. And what is presented as a confession quickly becomes a blistering attack on the art history *establishment*: Longhi, the university systems, Italy's ministries, the indolence of the country's politicians in addressing the deterioration of cultural patrimony—in which he himself played a role. In taking a stand as a public personality, he plays with the figure of the disillusioned art historian who haunts Italian cinema. He paints a rather moving self-portrait, though the book is not without humor. He says that during his life, his "pessimism with regard to the greater part of humanity has only increased," and deplores the moral and financial scandals that have marked Italian history. Eventually, he paints himself as the great man in retirement, cherishing a seclusion from which he emerges only with great reluctance, prefer-

ring to read, to study, to categorize, to carry on his detective work rather than expose himself to the dissipations of society. His disillusionment brings to mind the art history professor played by Burt Lancaster in Luchino Visconti's *Conversation Piece*, whose life is changed when he agrees to share his Roman palazzo with a vulgar young marchesa and her companions, whose lives he cannot begin to understand. Or the tragic end of Steiner, the distinguished intellectual envied by Marcello Mastroianni's character in Fellini's *La Dolce Vita*, who kills his two children before putting a bullet in his brain. His sudden, brutal action is the result of a snide quip by a drunken poet, "You are a true primitive, as primitive as a gothic spire. You're so lofty that you can't hear any voices up there."

I do not have the pretensions to iconoclasm of Federico Zeri. I do not think an Eye should live with remorse about having made a radical mistake. It is all a little too melodramatic for me. I naturally realize that I might have, like him, done something more with my passion for gardening, for places of harmony and solitude. It would have brought me great satisfaction and some distress since plants are willful and rarely do what we would like them to. But, basically, I believe that I was too passionate about painting to do anything else. The question that I ask myself is very different. Since I have had the privilege of making a living from my passion, has my life been a selfish one, or have I in some way been useful to society?

I did not wait until I was writing this book to ask myself the question. It is one that I have always posed, one that

any art historian should ponder in times like ours which are so marked by individualism. A physician does not have this problem. He knows what he contributes to society; he does his best to heal people from sickness and suffering. For me, it is only by becoming a curator that my profession and my training have finally come to fruition.

Many people do not understand the language of culture and museums. Using culture as a force for social cohesion can give meaning to our work. Through the works of art in our galleries, we can open the minds of young people and assimilate those on the margins of society. Once they have learned how to approach a work of art, different audiences can take as much pleasure from a visit to a museum as they might a sports match or television series. Obviously, I know art historians who are soccer fanatics, and others who enjoy American television. That is not the point I am making. Personally, I had a *Desperate Housewives* period, though I quickly abandoned the series because I could not bear the sanctimonious moralizing where any eccentricity is systematically censured. Then I moved on to *Game of Thrones*, which is sheer bliss for the latent child in me, but which also manages through its spectacular imagery to chronicle the rise of Western culture. The culture of a country, an awareness of history, literature, and also painting—something less often taught in schools these days—create a common ground of emotions and ideas that serve as the basis for Western democracies; they open us up to others and preserve us from sectarianism.

A museum curator should meet with people in prisons, in hospitals, in disadvantaged neighborhoods. Municipal

authorities now understand that museums can play an educational role that extends beyond their status as repositories and places of preservation, that museums do not simply exhibit curios from the past but instill values and ideas. In Ajaccio, the museum has become one of the hubs of cultural activity, together with cinemas and libraries, and it is now possible, indeed it is expected, that it will forge new links with contemporary creators. Exhibiting Jeff Koons or Murakami at Versailles gets people talking about art, which is in itself a success. But if the works of the most famous artists today are familiar and much talked about in Paris or Versailles, that is far from being the case in provincial towns, where the work of contemporary artists tends to be rejected, generally in favor of works by local painters and sculptors. I say painters and sculptors rather than artists, because such audiences are often limited by a traditional concept of art, and inexplicably oblivious to art after Duchamp. In collaboration with Anne Alessandri, the director of the Corsican branch of the Fonds régionaux d'art contemporain, which directs regional holdings of contemporary artworks throughout France, I organized a 2013 exhibition on passions, bringing classical paintings together with contemporary artworks in a way that was unsettling. But it was designed to show that the violence and the extreme feelings of these works arose from a search for an ideal. We succeeded in attracting even the most recalcitrant museumgoers: teenagers. There on the walls they could see aspects of an everyday world in which violence is commonplace and trivialized, images in which we hoped they would find meaning. They came again and again.

These then are the reasons that make me believe I have made a social contribution, and persuade me that I was not mistaken in my vocation.

However, the reader might feel that, with these prevarications, I am trying to avoid tackling the more prosaic subject of this chapter. The sort of unequivocal mistake that has to be discussed in this book. A reader might expect me to discuss errors of attribution, principally my own. Don't worry, I will. I am not ashamed, because mistakes made in good faith—and I have made my fair share—can still add to the sum of knowledge. There is no need for embarrassment. As for the most egregious errors, I can discuss them without personal regret because they do not involve me, and they are extremely dangerous for our profession.

As a general rule, a good art historian must learn to doubt, to be skeptical, otherwise he is doomed to repeat errors: those of others, if he accepts their opinions without consideration, and his own, if he is overconfident in his intuitions. If we begin looking at things the wrong way, we persist, and we can only see incorrectly. This has happened to me with minor paintings. For example, I had convinced myself that a particular *Madonna* was by the artist termed the Master of the Kress Landscapes after works in the Kress collection, whom we now know to be Giovanni di Lorenzo Larciani. However, Carlo Falciani proved to me that it was not by Larciani but by an equally obscure artist, the anonymous sixteenth-century artist known as Maestro di Serumido—both Florentine eccentrics dear to Zeri. In order to avoid such errors—which are not of huge consequence—it is important to work with

other art historians. It is also important to learn to wait rather than rush to publish, to take the time to allow one's opinion to mature before sharing it. If he holds to this rule, an art historian will rarely make a serious error, especially if his opinions affect only the art community.

The biggest blunders I have made concern two portraits by Pontormo: the *Portrait of a Young Man*, discovered in Geneva, and another *Portrait of a Man* in a private collection. Roberto Longhi was the authority in this field, but, somewhat arrogantly, having read his articles on the two paintings, I thought he had misjudged them. He had seen and attributed both of the portraits in person. Misled by the poor photographic reproductions, I thought that his attribution of them should be treated with skepticism. Chiefly, I felt that he had not taken sufficient account of Pontormo's circle, the throng of eccentric minor painters whose role Zeri had brought to light. Had I seen the paintings in person, I would not have made the mistake, but visiting them was problematic and I did not realize that the qualms I felt were merely due to poor photographs and repaintings. Such errors have a financial impact that is beyond the purview of the art historian, but must be taken into account. In my case, the errors should probably be put down to youth, stemming from a desire to make my mark, to carve my niche.

When I finally came face-to-face with the portraits, my error was patently obvious. This prompted two things. Firstly, I decided never again to offer a categorical opinion on the basis of a photograph. I may doubt someone else's attribution based on a photograph, but I will not call it into question

unless I have been able to examine the work for myself. Secondly, my mistake, blatant as it was, had another positive effect: that of highlighting Pontormo's relationship with his circle. Until I published my catalogue, Pontormo was considered to be a solitary artist, with no students other than Bronzino, working outside the studio system. By associating him with Jacone, Foschi, and the other minor Florentine artists in my articles, and indeed going so far as to prove the existence of an atelier, I helped to put an end to that myth. I had been wrong about the portraits, but I had provided a more accurate view of his working practices. My mistakes also helped to boost confidence in my opinions. The fact that I had relegated the portraits and later acknowledged them was proof that I worked in good faith.

More often than not, one can sense an error in reading an article, when it becomes mired in explanations and dubious justifications. In such cases, a researcher will often begin to cite exceptions. The hunger to announce a major discovery, one inevitably linked to a major artist, and the need to rally the media can lead an art historian down a path from which there is no return.

In 1995, at a cocktail party opposite the Metropolitan Museum of Art on Fifth Avenue, hosted by the French cultural attaché in New York, an American art historian, Kathleen Weil-Garris Brandt was entranced by a cherub in a fountain in the lobby of this splendid mansion. The statue had been brought from Florence via London in 1902, at the request of architect Stanford White. It was going to adorn the home of Payne Whitney, a magnificent townhouse facing

Central Park to be decorated in an eclectic neo-renaissance style. Today, the former residence of the philanthropist and scion of the Whitney family houses the offices of the French Embassy's cultural division as well as the beautiful Albertine bookshop showcasing French literature in New York. The authentic Renaissance putto had always been presented as being by an anonymous hand. A few days after the cocktail party, following a press conference on January 23, 1996, the arts pages of American newspapers trumpeted the headlines.

Kathleen Weil-Garris Brandt, *The New York Times* declared, had just discovered a Michelangelo in a New York townhouse. It was the only work of the great master ever discovered outside Europe, she argued, and managed to mobilize a number of American art historians prepared to join her in announcing that this was a juvenile work by Michelangelo, unquestionably the property of the French government but located on U.S. soil. Although the director of the Department of Sculptures at the Louvre at that time would have been the first to celebrate if there had been even the slightest chance that the story was true, Jean-René Gaborit felt obliged to cast doubt on the opinion and its sensationalist handling. When he told her, "Dear Kathleen, this work cannot possibly be by Michelangelo," she excitedly exclaimed, "Precisely. This is not the Michelangelo that we know."

The director of the Louvre's Department of Sculptures could not find a single work by Michelangelo with which to compare the *Cupid*. So much hype was generated by the story that French authorities finally agreed to put the controversial piece in the Metropolitan Museum of Art with the words:

"Michelangelo, on loan from the French government—Ministry of Foreign and European Affairs." In 2000, at the Louvre exhibition devoted to the supposed Michelangelo putto—renamed *The Manhattan Cupid* for the occasion—the curator of the Louvre advanced the hypothesis that the putto could just as easily be the work of one of the other young sculptors active in Florence at the time of Lorenzo the Magnificent, or one of many "Michelangelesque" sculptors later in the sixteenth century. The marble face of the cherub has been partially re-sculpted, making any judgment difficult. Weil-Garris Brandt believes that the body has the characteristic features of Michelangelo's sculpted works. Certainly in the lobby of the French cultural building, in the dim lighting, with a glass of wine in hand, the musculature would have looked different, and may fleetingly have hinted at an unsettling, astonishing discovery. Had Weil-Garris Brandt been prepared to hold her fire before calling in the media, she might have had more thorough consultations with other-minded colleagues, but she was swept along by her initial statement and has tied herself in knots attempting to justify her position.

Even if today there are art historians—among them some of the greatest Michelangelo specialists—who are inclined to agree that it is indeed a work of the young artist, in her rush to cause a sensation, Weil-Garris Brandt did not adhere to the ethics of the profession. Worse, she defied many of her peers by claiming that it would take a generation to finally understand her attribution. It is true that sometimes a refusal to recognize an attribution is prompted by reasons external

to the study of the works.

The evolution of the profession today has meant that the great Eyes we have talked about are increasingly rare. Berenson, Longhi and Zeri had a thorough knowledge of art from the Trecento to the nineteenth century. These days we are increasingly limited by circumscribed fields of research. Perhaps contemporary Eyes dare not fulfill the roles they once did, maybe because they are comfortably ensconced in the groves of academe. Following Roberto Longhi, I am one of those who works at the intersection of the two different fields, but there are not many of us. We perform a function that is recognized only by Italian universities who believe that connoisseurship is the philology of art, the fundamental science of art history. When one talks about attribution in France, one is talking about something that is the preserve of museums. The French art historians who knew Longhi were all museum curators. University professors sometimes consider that French art historians should stick to defending the rhetorical tradition of commenting on and discussing paintings through lectures. In such a view of art history, there is no place for the Eye.

We have reached a crossroads. The Eye must recover the nobility of our métier that has been lost. To investigate, to be possessed of genius, to know how to persuade—these may seem disturbed objectives when considered from the outside. But to be an Eye is to devote oneself to a real profession, one based entirely on memory and the exercise of memory, rooted in a profoundly academic tradition, and destined to advance the sum of knowledge. Like the University of Flor-

ence, the Sorbonne and other universities that understand connoisseurship should offer their students courses in training their eye. This would allow them to choose whether to work in public museums, in education, or in the art market. Otherwise, students have no choice. The gap between these professions in many countries is too wide, and universities look down on specific programs like the École du Louvre, confident that they alone are capable of producing ideas, and leaving the École du Louvre to train curators and private institutions to train appraisers. And what is the role of the Eye in all this? An Eye can be trained only by force of will. I lay claim to the legacy of Giovanni Morelli, a tradition rooted in scholarship, fully engaged with its time and society, in which the discovery of the Bronzino *Christ* fits perfectly. Without the Eye that made this discovery, the general public's view of Bronzino would possibly still be that of a court painter. The city of Nice has done much to herald the discovery, and the local population has been captivated by the sensational aspect of the find.

I firmly believe that, outside of art history, we all have an eye. A single eye like a cyclops? No, we are not cyclopes doomed to a tragic fate. In art history, we have two eyes: an eye that perceives the aesthetic, and the eye that comes with our profession. A gallery owner sees the beauty in the work, but an art dealer also sees the value; the filmmaker and the photographer have an aesthetic eye, and one specific to this art; and a fashion editor has an eye to discern the aesthetics of a garment and envision how it will function on the street.

But what of the Eyes I have been discussing? Are we not cyclopes who see only one thing, the aesthetics of the work, oblivious to all other contingencies? We allow ourselves to be blinded by its beauty.

The eye looks. We see, though we do not all see the same thing. Though I myself was born with an eye, I became an Eye. I learned to see. As if from blindness, I acquired great vision. My gaze, however, focuses only on what is essential. What is most beautiful about my profession is that I see the light behind the darkness. I am an Eye so that others can see.

Acknowledgements

This book was written in collaboration with Samuel Monsalve, whom the author would like to thank for his literary work, his patience, his persistence, and his spirit of research that allowed it to see the light of day.

I would also like to express my gratitude to Charles Danzig for his confidence, his advice, and his encouragement.

I would like to thank Anne Fabre de Chefedebien, who has advised me throughout my career and with whom I am currently discussing very different, Napoleonic issues.

I would like to thank Michel Laclotte for his support, as well as Jean-Christophe Baudequin, Agnès Costa Webster, Carlo Falciani, Jak Katalan, Catherine Monbeig Goguel, Christian and Nathalie Volle, and Andrea Zanella for their help and Marie-Laure Mattei Mosconi and Marie-Jeanne Nicoli for their support.

Translator's Acknowledgement

The translator would like to thank Christian Rutherford for his invaluable help in translating *The Eye*.

PHILIPPE COSTAMAGNA is a specialist in 16th century Italian painting and director of the Musée des Beaux-Arts in Ajaccio, Corsica. He is the author of a book on the Florentine Renaissance painter Pontormo.

FRANK WYNNE is an award-winning translator from French and Spanish and the author of *I Was Vermeer*, a non-fiction book about art forger Han van Meegeren.